SARTRE'S
TWO ETHICS

SARTRE'S

TWO ETHICS

From Authenticity to Integral Humanity

THOMAS C. ANDERSON

OPEN ✹ COURT

Chicago and La Salle, Illinois

OPEN COURT and the above logo are registered in the U.S. Patent and Trademark Office.

© 1993 by Open Court Publishing Company

First printing 1993

Printed and bound in the United States of America.

Library of Congress Cataloging-in-Publication Data

Anderson, Thomas C., 1935–
 Sartre's two ethics : from authenticity to integral humanity /
Thomas C. Anderson. p. cm.
 Includes bibliographical references and index.
 ISBN 0-8126-9232-2. — ISBN 0-8126-9233-0 (pbk.)
 1. Sartre, Jean Paul, 1905– —Ethics. 2. Ethics, Modern—20th
century. I. Title.
 B2430.S34A753 1993
 171'.2—dc20 93-23370
 CIP

For Kay
who has chosen the better part

CONTENTS

ABBREVIATIONS OF FREQUENTLY CITED WORKS OF JEAN-PAUL SARTRE

ASJ	*Anti-Semite and Jew*
BN	*Being and Nothingness*
CDR I,II	*Critique of Dialectical Reason*, vols. I and II
D	"The Last Words of Jean-Paul Sartre," published in *Dissent*
DF	"Determinism and Freedom." This is the only portion of RL (below) published in English.
EH	*Existentialism and Humanism*
FI, I, II III, IV	*The Family Idiot*, vols. 1, 2, 3, and 4
MR	"Materialism and Revolution"
NE	*Notebooks for an Ethics*
O	"Jean-Paul Sartre et M. Sicard: Entretien," published in *Oblique*
ORR	*On a raison de se révolter, discussions*
RL	Lecture given in Rome, May 1964, available at the Bibliothèque Nationale, Paris
SBH	*Sartre by Himself*
SM	*Search for a Method*
SP-*L/S*	"Self-Portrait at Seventy," in *Life/Situations*
TE	*The Transcendence of the Ego*
WIL	"What Is Literature?"

Full information on these works is given in the bibliography. Minor alterations have been made to some of the English translations.

structure at least, had not essentially changed from the 1940s. I now know this to be false. Although there was no way I could have been aware of it at the time, it turns out that my earlier work consisted almost entirely of an exposition of only the first of three ethics Sartre attempted. From interviews he gave toward the end of his life, we can now see that Sartre's first ethics should be understood as one stage in the ongoing development of his thought on morality, a development which continued right up to his death. An adequate treatment of his ethical views, therefore, must not only incorporate the hundreds of posthumously published pages of Sartre's writings on his first ethics, but must also include an explication of his second ethics, the one he worked on after he had discarded his first attempt. And all of this must be situated within the general framework of the overall evolution of his thought and work.

In what follows, then, I seek to present Sartre's views on morality as he himself offered and defended them over many years, with all of their changes and developments. My goal is to let Sartre speak for himself about his ethics (plural) as much as possible. Because, as William McBride has recently reminded us,[3] Sartre's ethics are inexplicably bound up with political theory, my presentation will necessarily include some discussion of issues usually treated under the latter heading. However, my focus will not be on matters such as the nature and origin of political society, the nature of, and justification for, law, legal authority, the State, the relation of law and morality, and so forth. I intend to concentrate on setting forth the moral values, norms, and ideals Sartre proposes for his various ethics, and, equally important, on explaining the rationale he offers to ground such values, norms, and ideals. This means, and I want to stress the point, that I take Sartre seriously as a moral philosopher. This is not simply to say that I take seriously the moral judgments and evaluations he makes about particular issues. Nor is it only to say that I take seriously, as I do, his moral critique of the sociopolitical structures of our time, particularly those of Western society. When I say I intend to study Sartre as a moral philosopher, I mean that my primary aim is to set forth the general structure and basis of morality as he conceived it at various periods of his life, that is, to describe the values or norms on which he based his moral evaluations, and to discover the reasons he used to justify such values and norms.

After his death some in the French press called Sartre the moral conscience of our age, perhaps because he so frequently offered

moral critiques of the actions and policies of his own and other societies. Initially, my own interest in Sartre came from my admiration of his willingness to commit himself in the streets for those moral causes and ideals he believed in. Later, I also found much of his moral indictment of Western capitalism insightful and appealing. Always I tried to discover the values in the name of which Sartre judged and acted, and the reasons which convinced him of their legitimacy. Sartre never claimed that his positions on ethics were intuitively obvious or self-evident. Like every good philosopher, he *argued* for his beliefs and, consequently, I intend to approach his work as a straightforward attempt over a lifetime to construct and defend a coherent and meaningful ethical stance. Anything less would be a disservice to a person I consider to be one of the most powerful and influential moral thinkers of our century.

I would like to acknowledge the assistance of many in the preparation of this book. My research on Sartre's second ethics would never have gotten off the ground without the generosity of Elizabeth Bowman and Robert Stone. Financial aid from the American Council of Learned Societies and the National Endowment for the Humanities enabled me to spend time in Paris in research at the Bibliothèque Nationale. I owe particular thanks to Michel Rybalka and Mme. Mauricette Berne of the B.N. for their assistance, which enabled me to gain access to Sartre's manuscripts. Thanks, too, to the Marquette University Committee on Research for financial support and to the Marquette Philosophy Department for reduced teaching loads. I also want to express my appreciation to all my friends in the Sartre Society of North America for their constant stimulation. I am especially grateful to the efforts of Hazel Barnes, Thomas Busch, Thomas Flynn, and William McBride who read my manuscript and offered helpful suggestions for its improvement. Special mention must be made of Ms. Barbara Sparks and Ms. Kathy Anderson for their skilled work on the preparation of this manuscript. Finally, I can never adequately express my gratitude to my wife Kathryn, to whom this book is dedicated, for her invaluable editorial assistance, but especially for her unfailing good humor and encouragement.

Selections from my article, "The Obligation to Will the Freedom of Others, According to Jean-Paul Sartre," Chapter 6 of *The Question of the Other, Essays in Contemporary Continental Philosophy*, edited by A. Dallery and C. Scott, are used by permission of the State

1

Introduction

Section 1. General Remarks on Sartre's Moral Thought

It is, or should be, well known that Jean-Paul Sartre's thought developed from an abstract, incomplete, individualistic conception of human reality, human freedom, and their relation to the world, to a significantly more concrete and richer understanding of the human being, its freedom, the power of circumstances, and the sociopolitical character of human existence. After all, the later Sartre often referred to that development.[1] Much less recognized, however, is the parallel progression of Sartre's moral thought from an early, abstract, idealistic ethics of authenticity to a more concrete, realistic, and materialistic morality. Yet one could expect that important differences in Sartre's conception of human reality and its relation to the world would give rise to different ethical theories, since ethics, for him, was fundamentally humanistic. That is, his intent was always to construct a morality that was true to the human condition; human reality provided the basis, measure, and goal of his ethics.[2]

In the light of the evolution of his thought, then, it should not be particularly surprising to discover that at the end of his life, as he looked back over his career, Sartre stated that he had worked on a number of different ethics, three to be exact.[3] The first, which he labeled *idealistic*, was written in the mid and late forties and was the one promised at the end of *Being and Nothingness* (1943) and based on its ontology. It was never completed and remained largely unpublished in his lifetime. The second, dating from the mid sixties, after the *Critique of Dialectical Reason* (1960), and called *realistic* and *materialistic*, was also never finished, though parts of it were publicly presented and published in his lifetime. Sartre's third morality, entitled "Power and Freedom," was begun in the seventies.

Because of his blinding stroke in the mid seventies, it consists almost entirely of tape-recorded interviews with an ex-Maoist, Benny Lévy. Unfortunately, practically none of them have been made available, and now, almost two decades after they were recorded, there is serious doubt whether the interviews will ever find their way into print.[4]

This book, then, will set forth and compare Sartre's first two moralities, since material pertaining to both of them is available in sufficient quantity. Sartre has many scattered statements in his early published works about the foundation and general structure of his first ethics. Most important, thanks to Arlette Elkaïm-Sartre, his adopted daughter, we now have two of his notebooks, entitled *Notebooks for an Ethics*, written in 1947–48, that were part of it. Material pertaining to the second ethics is presented in various published interviews, speeches, and essays of Sartre's from the mid sixties to the mid seventies. It is also concretely embodied, he says, in his lengthy study of Flaubert. Its most important single source, however, only recently available, is the handwritten notes of a lecture on ethics that he gave in Rome in 1964. Enough can be found in these resources to enable us to obtain a good deal of information about the second morality, although there is less available material directly pertaining to it than to the first. (The Rome lecture, for example, is less than one-tenth of the length of the *Notebooks*.)

Besides the fact that we have a lot more material to work with, there are other reasons why at least half of this work is devoted to Sartre's first ethics, even though he himself went beyond it. For one thing, a great deal of secondary literature has been addressed to it. In fact, practically every book and article so far written about Sartre's ethics has, whether its author knew it or not, dealt with his early morality.[5] Yet not one of these authors includes a detailed examination of the *Notebooks for an Ethics*, and my exposition will rely primarily on that posthumous work. Doing so will not only give us a fuller understanding of that morality than can be gained from any other works of Sartre, it will also enable us to resolve some of the major issues of contention that have arisen among the commentators concerning the nature and content of that early ethics. Another rather straightforward reason for undertaking a detailed study of the first mortality is simply that it is a coherent ethical theory that deserves to be studied and evaluated in its own right. Even if Sartre had never written anything but his first ethics, it would still be of

major interest because it rests on the well-known and highly controversial positions set forth in his monumental work of phenomenological ontology, *Being and Nothingness*. So many critics have claimed that it is impossible to construct an ethics on that foundation that it is instructive to see how Sartre accomplished it and exactly what kind of an ethics he did erect. Finally, even though he went on to work on two other moralities, Sartre himself stated at the end of his life that the third ethics he was then engaged in did not involve a wholesale rejection of his early moral thought but was rather a return to, and "enrichment" of, it.[6] In fact, Sartre claimed that *all* personal development involves both a conservation and a transformation of one's early thought and experiences in light of his or her later thought and experiences. Human growth is cyclical in nature; it includes a continual return to one's past and an integration of it into a larger synthesis with one's present in the light of the future.[7] Accordingly, Sartre's second (and third) ethics inevitably includes the first, transformed and amplified. Thus, a knowledge of the early morality is necessary for a complete understanding of those that follow it, because they evolve from and include it in some modified form, and also because their own unique features can be discerned only by comparison with it.

When it comes to the second ethics, my exposition of it, as I've said, will be based primarily on the written notes of a 1964 lecture of Sartre's which has not been available to most writers on his ethics. Since only a small portion of these notes has been published, and there do not seem to be any immediate plans to publish the rest, I will undertake a detailed analysis of this extremely important work. We shall see that, although there are elements of continuity, the second ethics departs from the first in significant and interesting ways. As I stated above, I believe that the primary reason for this is that by the 1960s Sartre had introduced major modifications into his ontological view of human reality, including human freedom and its relation to others and to the world. The second ethics is, in fact, rooted in the ontology of the *Critique of Dialectical Reason* rather than that of *Being and Nothingness*, and thus a general review of the *Critique* will precede my exposition of it. I should add that this review will consider both *Critiques*, the first published in Sartre's lifetime, the second mostly unpublished until after his death. The second, in fact, appears to be the immediate neighbor of the Rome lecture. Few have studied *Critique* II, and among those that have no

one has approached it in terms of its relation to the second ethics.

One of the questions Sartre scholars presently wrestle with is the extent to which his ideas have continuing relevance in the light of the collapse of the Soviet Union and the attendant discrediting of Marxism. My own view is that Sartre's particular brand of Marxist existentialism, which at least from 1960 on was never closely linked with Soviet foreign or domestic policy nor to any party, is still extremely valuable for understanding and evaluating the history of this century, including the history of both capitalism and communism. However, that is not my concern here. The purpose of this work is to set forth and compare Sartre's first two moralities and to situate them within the overall evolution of his ethical thought. I believe that the fundamental principles and general structure of these ethical theories are not intrinsically dependent on Marxism or on any other particular sociopolitical ideology of our time, and so are not made obsolete by recent history. My thesis is that Sartre's ethics are grounded rather on his ontology, and to substantiate this I will spend almost as much time presenting the ontological positions that are their bases, and on their development, as on the ethics themselves. Sartre's views on ethics did change in important ways during the course of his life, primarily because his understanding of the nature of human reality and its relation to the world changed considerably. Of course, historical circumstances were important factors affecting Sartre's modifications and formulations of his ontological views. No doubt his own personal history, part of the general history of this century, aided him in coming to a more complete and accurate understanding of the "universal human condition." Nevertheless, it is the latter that supplies the philosophical basis of his ethics. Accordingly, I will begin this study with a review of positions Sartre adopts in his earliest philosophical works, works that predate the writing of his first ethics but that, nevertheless, supply much of the foundation of that early morality.

Section 2. The Foundation of a "Realistic" Ethics?

In the second volume of her autobiography, Simone de Beauvoir recounts the excitement that gripped Jean-Paul Sartre when he first heard of phenomenology. While they were sitting at a Paris cafe, his

friend and former classmate, Raymond Aron, told him that a phenomenologist could talk about everyday objects and "make philosophy" out of them. "Sartre turned pale with emotion at this. Here was just the thing he had been longing to achieve for years— to describe objects just as he saw and touched them, and extract philosophy from the process."[8] This same excitement about phenomenology as a philosophy of the world is present in Sartre's early philosophical works, *The Transcendence of the Ego* and "Intentionality: A Fundamental Idea of Husserl's Phenomenology." In his conclusion to *The Transcendence*, Sartre criticizes those who reproach phenomenology for being an idealism, that is, "for drowning reality in the stream of ideas." "On the contrary," he asserts, "for centuries we have not felt in philosophy so realistic a current. The phenomenologists have plunged man back into the world"(*TE*, 104–5). Similarly, in "Intentionality" he contrasts the "digestive" philosophy which believes that all objects of experience are "contents of consciousness" with Husserl's phenomenology that holds, Sartre says, that consciousness is outside itself in the world among things: "it is not in some hiding-place that we will discover ourselves; it is on the road, in the city, in the midst of the crowd, a thing among things, a man among men."[9]

Thus, in both essays, Sartre emphatically rejects philosophies which would detach or isolate the human being from the world by imprisoning it within its private experiences of internal mental entities. And in both essays, it is his acceptance of Husserl's phenomenology that enables him to break with traditional philosophies of immanence (and even with Husserl himself insofar as he remains within them). As Sartre sees it, Husserl's insight that all consciousness is consciousness of something means that consciousness itself is nothing more nor less than intentional acts intrinsically related to objects which are not it. The entire reality of consciousness is to be related to the world. All content is on the side of its objects; consciousness itself is empty. In "Intentionality" Sartre writes, "consciousness is purified, it is as clear as a strong wind, there is nothing in it, but a movement of escape, a sliding outside itself."[10] Similarly, in *The Transcendence* he empties consciousness of everything except intentional acts of various kinds. It possesses no ego, or substantial thinglike I, at the origin of these acts, no states (love, hatred, and so forth) nor actions (doubting, reasoning, meditating) nor qualities. The me (*moi*), with its states, actions, and qualities, is

an object among objects with the same essential character as any other object in the world, and the relation between the me and the world is one of interdependency.

The upshot of this for ethics is briefly stated by Sartre in the concluding pages of *The Transcendence*: "ethics finds its bases in reality. . . . No more is needed by way of a philosophical foundation for an ethics and a politics which are absolutely positive" (*TE*, 105–6). This ethics, he explains, will not try to escape from the world by seeking some "inner life" or self within consciousness, for there is no such life or self. It will turn its attention to "real problems" of men in the world.[11]

Of course, Sartre's statement that nothing more than his phenomenological analysis is needed to supply the philosophical foundations of an ethics based in reality is an exaggeration. It will not be his last. In fact, the foundation he has set forth so far is terribly abstract because it is so incomplete. His phenomenological analysis has discovered the intrinsic relation of an empty consciousness to its objects, not the intimate interrelation of humans and world that he claims. Contentless, intentional conscious acts are not a human being, even though Sartre often uses those terms interchangeably. Nor are the objects of this consciousness simply equivalent to things in the real world. This is especially clear when Sartre distinguishes the transcendental consciousness, which is nothing more than a web of intentional acts, from the self (*moi*) with its psychic and physical characteristics. The latter, he says, is an *object* which transcendental consciousness constitutes by reflecting upon and uniting its acts into a single entity with which one, then, identifies his or her self.[12] This object-I, often equated with the body, is, Sartre claims, essentially like all other worldly objects and is dependent on them as they are on it. The interesting point is that this constituted psychophysical self, although an object rather than a free subject, bears far more resemblance to a concrete flesh and blood human being than does the web of contentless, intentional acts that comprise the transcendental consciousness that constitutes it! Correspondingly, the world, meaning that realm of things in which the psychophysical me is immersed, is much more concrete and real than are objects of a transcendental consciousness, for, after all, such objects can be anything that is able to be thought or imagined, no matter how abstract or fictitious. In other words, in spite of his intent, Sartre in these very early works has not grasped the concrete reality of man in

the world that he wants to make the foundation of ethics. Moreover, one wonders if he recognizes how abstract his proffered foundation, consciousness and its objects, is. The fact that he so often uses the terms *consciousness* and *man, objects* and *world* interchangeably suggests that he does not. A look at Sartre's other early philosophical works will also support this conclusion.

Sartre's writings in phenomenological psychology (*Imagination, The Psychology of Imagination,* and *The Emotions*) have no explicit remarks about ethics. They do, however, contain notions which are central to Sartre's early ontology and the ethics based on it. One such notion is the freedom of consciousness, indeed, the identification of consciousness with freedom.

In his first published book, *Imagination*, Sartre sharply distinguishes between consciousness and things and states categorically "it is an ontological law that there are only two types of existence, thing in the world and consciousness."[13] Phenomenological analysis reveals, he says, that the fundamental difference between the two is that consciousness is "pure spontaneity" while things are "pure inertia." *Spontaneity* is Sartre's term to indicate the dynamic, active character of consciousness, as in *The Transcendence* where he identified consciousness entirely with intentional *acts*. Things, for their part, are described as inert, passive entities whose being is not the product of consciousness. This Sartrean brand of Cartesianism, like his ancestor's, seems to grossly oversimplify the real. To divide it into just two types of entities does not do justice to organic things, which are both active and inert, nor to social and political communities and structures, and Sartre himself will come to recognize this.

Equally significant is the fact that Sartre identifies the spontaneity of consciousness with its freedom, as in the following passage:

> That exists spontaneously which determines its own existence. In other words, to exist spontaneously is to exist for oneself and through oneself. One reality alone deserves to be called "spontaneous": consciousness.[14]

Similar statements are made in *The Transcendence of the Ego*: "the transcendental sphere [consciousness] is . . . a sphere of pure spontaneities which are never objects and which determine their own existence" (*TE*, 96). Inasmuch as it determines its own existence, consciousness is cause of itself, Sartre says, and so it is free. Those who imagine that spontaneous acts of consciousness could be caused

by an ego, or an unconscious, or by objects, make these acts passive, but a passive spontaneity is a self-contradiction. Thus, Sartre argues, "nothing can act on consciousness" (*TE*, 82). "It determines its existence, at each instant, without our being able to conceive anything *before* it. Thus each instant of our conscious life reveals to us a creation *ex nihilo*" *(TE,* 98–99). Needless to say, such a position flies in the face of many of our ordinary experiences, especially those of perception and emotion, which appear to involve some passivity on our part. (Actually, Sartre does concede that, in comparison with acts of imagination, acts of perception have a somewhat passive character, but he never explains how any passivity can be compatible with consciousness' pure spontaneity.)

Perhaps the radical nature of the early Sartre's conception of consciousness is most clear in his account of emotion.[15] Surely, in ordinary experience it appears that emotions are often caused by perceived or imagined objects. I feel fear, for example, because I suddenly see or imagine a frightening object. Sartre, however, claims that it is the other way around. Because I fear, an object appears to me as frightening. By my emotions I confer the appropriate qualities on the world, qualities such as cruel, terrible, gloomy, joyful. (Of course, this must be done unreflectively, Sartre says, since I am certainly not explicitly aware that I am doing so). Thus, emotion is not a passive disorder caused by something outside of our consciousness, Sartre insists; it is a particular kind of consciousness. Like perception, imagination, and thought, emotion is a type of conscious *act*. As such, it is a form of spontaneity and free.[16]

Make no mistake about what Sartre has done here by identifying consciousness with spontaneous acts. By allowing no passivity or receptivity to consciousness, he has made every conscious act, acts of seeing as well as dreaming, acts of desire as well as anger, acts of feeling as well as choice, self-caused or free. Rather than distinguishing between conscious acts (e.g., choices) that are free and those (e.g., perceptions, some emotions and desires) that are not, he claims freedom for all.[17] Thus, from his earliest works, Sartre has saddled himself with a conception of consciousness that is, I submit, exceedingly abstract and unreal, for it is not a *human* consciousness or freedom, or is at best only one aspect of human consciousness and freedom that he describes. Equally abstract is his bifurcation of all of reality into just two regions, the self-caused spontaneity that is consciousness and inert things, which cannot act on that spontaneity.

We will see that this division and this conception of consciousness continue in *Being and Nothingness*. It should come as no surprise that an ethics built on such foundations will turn out to be so abstract and unreal that Sartre will later label it *idealism*.

Before turning to the early Sartre's major work in phenomenological ontology, there is one other notion that he introduces in *The Transcendence of the Ego* that is central to his first ethics: namely his distinction between pure and impure reflection.[18] When consciousness reflects on itself and persuades itself that it possesses a permanent thinglike structure (an ego), which is there no matter what its particular conscious acts may be, it engages in impure reflection. It constructs the ego, Sartre suggests, in order to hide from itself the spontaneous freedom that it is and to overcome the anxiety which accompanies the recognition of such monstrous freedom. Adopting Husserlian terminology, he refers to impure reflection as the "natural attitude," implying that it is the normal or usual condition of consciousness. He adds, however, that the effort of consciousness to hide from itself in an ego is never successful, since the very nature of consciousness is to be, at least on a nonreflective level, self-conscious. Consciousness is always nonreflectively aware of its true nature as an egoless free spontaneity of intentional acts whose entire reality is to be in relation to objects. This is true even when it practices impure reflection. (Obviously, we have here all the ingredients for what will be called bad faith in *Being and Nothingness*.)

In pure reflection, on the other hand, consciousness grasps itself accurately as an egoless, contentless web of spontaneous acts intending various objects. Pure reflection is absolutely essential, then, if one is to grasp consciousness (or *man*, for, as I said, Sartre uses the terms interchangeably) as free and immersed in the world. It is essential, in other words, for attaining the foundation for the positive, realistic ethics Sartre says he favors. Pure reflection will, indeed, be a central concept in the *Notebooks for an Ethics*.

2

Human Reality and Freedom in *Being and Nothingness*

Since I intend to show that the development of Sartre's ethical thought from abstract to concrete is based upon the evolution of his conception of human reality and freedom, the next two chapters will be devoted to the major work of his early ontology, *Being and Nothingness*. We shall see that, although Sartre took some steps in it toward a more concrete understanding of *man*, on balance the notions of human reality and human freedom that he presents there remain almost as unreal or abstract as those of his earlier works.

Section 1. Human Reality: Consciousness: Freedom: Nothingness

The sharp division of all reality into just two realms, consciousness and nonconscious things, originally introduced in *Imagination*, is continued in *Being and Nothingness*. In his introduction Sartre also repeats the description of consciousness set out in his earlier works. "The first procedure of philosophy," he writes, "ought to be to expel things from consciousness and to reestablish its connection with the world" (*BN, li*). Thus, consciousness is again described as nonsubstantial and contentless ("total emptiness," *BN, lvi*). It is nothing but intentional acts that are totally in relation to objects. At the same time, it is nonreflectively, nonpositionally self-conscious; otherwise "it would be a consciousness ignorant of itself, an unconscious—which is absurd" (*BN, lii*). As before, conscious acts are described as "all activity, all spontaneity" (*BN, lix*). Nothing can act on them whether it be "a motivation" or "the unconscious" or "the physiological" (*BN, lxiv*). It is contradictory, Sartre repeats, to admit any element of passivity into consciousness' spontaneity. Thus

it is "self-determining," "cause of itself," "self-activated." It is "a being whose existence posits its essence" (*BN, lv*), one which makes itself the kind of consciousness it is—a perceiving consciousness, imagining consciousness, an emoting consciousness, and so forth.

The realm of nonconscious things is again said to be passive and inert, but Sartre amplifies his description of this region of being, now called *being-in-itself*.[1] Being-in-itself is said to be so identical with itself, so filled with itself, that it is totally undifferentiated and thus can enter into no connection or relation with any other being. It is a full positivity of being which contains no nonbeing, and its being is in itself, not a part of, nor derived from, consciousness. Sartre implies that these conclusions are the result of a phenomenological description of the appearance of being in itself. However, many of them seem to be derived from a deductive conceptual analysis of the abstract nature of pure being.

In any case, after describing these two regions of being in his introduction, Sartre acknowledges on the very first page of his first chapter of *Being and Nothingness* that, in speaking of consciousness and being-in-itself, he has been dealing with "abstractions." The concrete is the "specific union of men with the world," and it is this totality that he says he intends to describe. In spite of this, in pages immediately following, in which he argues that man is free and that man is the source of nonbeing in the world, he focuses not on man as a concrete psychophysical organism but simply on man as conscious. The result is that he comes not only to identify man and consciousness, as in his earlier works, but man and freedom, and even man and nonbeing!

The following is a brief summary of Sartre's reasoning. The world of our experience is made of both being and nonbeing. Each thing is what it is and is limited by *not being* any other thing. Obviously, being in itself, full positive being, cannot be the source of the nonbeing in our world. Rather, it is through man, Sartre says, that "nothingness comes to the world." Without much argument, he maintains that *négatités* like absence, change, otherness, repulsion, regret, destruction, and so forth "derive their origin from an act, an expectation, or a project of the human being" (*BN*, 24). Moreover, "they all indicate an aspect of being as it appears to the human being who is engaged in world" (*BN*, 27). Since it is through man that nothingness comes to the world, it must follow that human reality "carries nothingness within itself" and "must *be* its own nothing-

ness" (*BN*, 28). Human reality also shows itself to be other than being by the fact that it can detach or disengage itself from being by imagining the nonreal, by questioning and by doubting, and, in fact, by thinking objects—since grasping what something is also involves grasping nonbeing, what it is not.[2] (Note that these all involve human reality only as consciousness.) Insofar as man detaches himself from or denies the world, he is able "to put himself outside being" (*BN*, 24), which means that he is free. Sartre then identifies man's nothingness with freedom: "the being of man insofar as he conditions the appearance of nothingness . . . this being has appeared to us as freedom." He goes even further and *identifies* human reality and freedom: "there is no difference between the being of man and his *being-free*" (*BN*, 25).

Ultimately, the ontological foundation of man's freedom and nothingness is located in the prereflective cogito, that is, in consciousness insofar as it is necessarily nonreflectively conscious of itself. It would take us too far afield to present Sartre's argument for this in detail. I will simply note that because consciousness is always present to itself prereflectively, it cannot coincide with itself in complete self-identity like being-in-itself. In order to be present to itself, it must have a "fissure" within itself which shatters its identity, Sartre contends, yet this fissure cannot be some thing or being which destroys its unity. The fissure must, therefore, be nothing, an empty distance within consciousness which allows it to be for itself, or self-conscious.

> The being of consciousness qua consciousness is to exist at a distance from itself as a presence to itself, and this empty distance is Nothingness. (*BN*, 78)

This nothingness is the ultimate foundation of man's freedom, for it keeps him from being totally self-coincident like a thing. "Man is free because he is not himself but presence to himself" (*BN*, 440). In other words, human reality can detach itself from and transcend what is, "put itself outside of being," precisely because it is not locked into simply being what it is. Just as he identifies consciousness and man with freedom, so now Sartre identifies them with this nothingness at the core of prereflective consciousness. Consciousness, being-for-itself, is, he writes, "an emptiness, a nothingness which is distinguished from the thing only by pure negation" (*BN*, 176). He adds, I myself am that consciousness, that nothingness:

> I . . . am the nothingness, the absence which determines itself in existence from the standpoint of this fullness [of being-in-itself] . . . The knower is not. . . . He is nothing other than that which brings it about that there is a being there, a presence, on the part of the known. (*BN,* 177)

The same is said of human reality.

> The nothing is human reality itself. . . . this nothingness as the absolute nothing which is left outside the totality [of being]. . . . is not anything except human reality apprehending itself as excluded from being and perpetually beyond being. (*BN,* 181)

The identification of consciousness and of man with nothingness is the startling culmination of Sartre's project, begun in *The Transcendence of the Ego,* of removing all content (all being, in that sense) from consciousness or human reality. Of course, he does not mean that man or consciousness is literally nothing, for he frequently refers to both as *beings* which are nothing. Being-for-itself is being, after all. I believe Sartre's shocking statements are primarily meant to emphasize the irreducible difference between the being of being-in-itself (full, inert, massive, positive) and that being that is nothing but nonsubstantial, contentless, spontaneous, free self-conscious acts. Nevertheless, his claim that consciousness is only such acts and his identification of free, spontaneous "nothingness" with human reality are extremely problematic. Still, it is consistent with the fact that, in addition to the places where he explicitly identifies them, Sartre frequently throughout *Being and Nothingness* speaks indiscriminately of man, or human reality, and consciousness as if they were simply interchangeable notions.[3] Of course, they are not, and at times he shows he knows that. I turn next, then, to places where he does recognize that human reality is more than a spontaneous free consciousness or nothingness.

Section 2. Human Reality: Freedom and Facticity

a. Bad Faith

Early in *Being and Nothingness* an initial step is taken toward a more complete description of man in the section devoted to bad faith.[4] It includes clear statements by Sartre that show he recognizes that

human reality is not equivalent to human consciousness; for example, in one place he says consciousness is "not the totality of the human being" but the "nucleus" (*BN*, 70). Throughout the section he insists that a human being is both a free consciousness (usually called *transcendence*) and facticity, the latter referring to what an individual is and was. Facticity, Sartre says, is a mode of being-in-itself and he links it to the body.[5]

Now, the very possibility of bad faith, according to Sartre, rests on this duality within the human being. In general, the individual in bad faith denies one of these dimensions of his or her reality and identifies his or her self with the other. But that is not the whole story, for what makes such denial bad faith, instead of ignorance or a simple mistake, is that the individual is lying to him- or herself. The person is lying precisely because he or she cannot be unaware, even without reflection, of the twofold nature of his or her being. As we have seen, consciousness for Sartre cannot be prereflectively unconscious of itself. It is, he says, totally "translucid."[6] The person, for example, who has performed nothing but cowardly acts cannot honestly assert that he is not a coward, for he is always prereflectively aware of his cowardly behavior. Yet it is not that simple, for if he simply asserted that he is a coward, that too would be bad faith for it would deny the free, transcendent dimension of his reality, namely, that he is not a thing fixed in cowardice like a cabbage is rotten. Again, the person in bad faith lies to himself about the twofold dimension of human reality as both freedom and facticity at the same time that he is prereflectively aware of being both.

However, in almost the same breath that Sartre says that a human being is a combination of freedom and facticity, he also asserts that *consciousness* is this very combination, once again, therefore, identifying man and consciousness. Thus, he repeatedly identifies consciousness' lucid prereflective awareness of itself with *man's* awareness of these two dimensions of his being.[7] Take the example of the coward. If he were simply ignorant of his facticity, of his past and present cowardly acts that are part of his in-itself dimension, or if he were unaware of his freedom to transcend the past, he would not be in bad faith when he asserts, "I am not a coward" or "I am a coward." Such assertions are in bad faith precisely because he is (prereflectively) aware that he is a coward (in terms of facticity) but is not a coward (in terms of freedom). Now it is one thing for Sartre to assert that consciousness is prereflectively translucid to itself; it is quite another

for him to claim that *man* is always prereflectively conscious of his being, of both his facticity (including his past acts) and his transcendence. Yet this is precisely what he does by denying that an individual human being can be fundamentally unaware of, or mistaken about, what he was, is, and could be.[8]

Even though Sartre himself does not point them out in this section, the ramifications of these conceptions for ethics are staggering—as commentators have noted. For one thing, one can never plead that she is or was ignorant, deceived, or simply mistaken about her true reality. One can never truthfully say that she was not conscious (prereflectively) that she was free, or that she was unaware of her facticity. To make such a claim, either to oneself or to others, is a lie and bad faith. Furthermore, bad faith is not only fully conscious; it is a free decision. "One puts oneself in bad faith," Sartre says; it is not something that is forced upon one from outside.[9] Thus, my responsibility for being in bad faith is total, for I both choose it and am perfectly aware (prereflectively) that I am doing so.

On the other hand, if bad faith is a free decision, this must mean that it is not necessary nor inevitable. It is surprising how many have missed this positive side of Sartre's analysis. It is true that he claims in these pages that both good faith and sincerity (attempting to be what one is) are themselves forms of bad faith.[10] Yet it is equally true that he also speaks of the possibility of other alternatives. The most important such statement is a footnote that he places at the very end of the chapter in which he affirms it is possible to "radically escape bad faith. But this supposes a self-recovery of being . . . [which] we shall call authenticity, the description of which has no place here" (*BN*, 70). (Apparently a treatment of authenticity belongs in ethics, not in a work of ontology.) In fact, early in his discussion, in speaking of the two dimensions of human reality, Sartre writes, "these two aspects of human reality are and ought to be capable of valid coordination" (*BN*, 56). Exactly what this valid coordination would be, this alternative to bad faith, which is called *authenticity*, is not spelled out, but it would have to involve one's willingness to admit that he or she is both freedom and facticity. That brings me to my final observation about bad faith.

As Sartre describes it in Part I of *Being and Nothingness*, bad faith seems to refer primarily to the relationship individuals have to themselves. It is not first and foremost a social, let alone a political, notion; it is a lie *to oneself* about the dual structure of his or her

being. It follows that authenticity, the escape from bad faith, will also primarily involve a relation to one's self, not to others nor to the sociopolitical structures and institutions of society. Note that in the above text, Sartre says it is "a *self*-recovery of being" [my emphasis]. Any detailed analysis of authenticity will have to wait, however, until we discuss the first ethics. *Being and Nothingness*, as a work of ontology, contains no treatment of it. Even Sartre's discussion of bad faith is undertaken from an ontological rather than a moral perspective, for it is designed to show that human reality is a combination of both freedom and facticity.

b. The Contingency of Human Reality

Another place where Sartre clearly acknowledges that a human being is more than a spontaneous free consciousness is in his discussion of the contingency and facticity of being-for-itself.[11] At first he addresses these notions in very general terms, by acknowledging that human beings are not the cause or foundation of their very presence in the world nor the total cause of the concrete situation in which they are. The fact that I am at all is gratuitous, contingent, not necessary. Likewise, I am not the total foundation of *what* I am. I did not freely choose to be born white or middle class or whatever. These contingent dimensions of my being Sartre identifies with my facticity, my in-itself dimension, and with my body which he defines broadly to include all that I am and have been.[12] My body, Sartre says, includes my birth, race, nationality, physiological structure, class, my character, and my past. Because I am bodily, I experience myself not as an acosmic consciousness but as an individual consciousness concretely situated in the world. My body is my "standpoint" in the world, the particular "center of reference" (*BN*, 326) from which I experience the world. As is well known, Sartre rejects any dualism between consciousness and its body, insisting instead that "consciousness exists its body" (*BN*, 329) and is "wholly body" (*BN*, 305). Because of this, I find myself experiencing the world in certain specific ways, for example as visible, textured, shaped, and so on, and I find myself in turn to be a visual, tactile, auditory consciousness. But if consciousness exists its body according to Sartre, what has happened to its alleged structure as pure spontaneous (free) activity containing no passivity? Sartre does admit that consciousness' awareness of the world changes as its bodily situation in the world changes (for example, I see things as yellow because I have jaundice;

an object appears smaller as I retreat from it), and he further admits that some changes in the body are caused by objects in the world.[13] Yet if consciousness is its body, this would seem to admit a causal "conditioning" (*BN*, 328) of it by the world that is incompatible with its pure spontaneity.

Sartre's response to this problem is as ingenious as it is questionable. He distinguishes again between my (or being-for-itself's) freedom and facticity. My facticity is the body which I am. Yet, as free, I transcend what I am toward objects in the world and toward my possibilities. To do so is to escape, surpass, wrench away from, nihilate (all Sartre's terms) what I am.[14] In other words, as transcending consciousness I am free from the factual dimension of myself and am not causally affected by it. Insofar as it exists its body, consciousness is "conditioned" by worldly objects, this Sartre admits; but insofar as consciousness is free transcendence, it is not, he insists.

Note, then, what Sartre has done. He has admitted that my freedom is only one aspect of my self or consciousness or being-for-itself. Neither I nor consciousness is just a totally self-caused spontaneity or pure freedom. This is a significant departure from the position he enunciated in the introduction to *Being and Nothingness* and in earlier works.

I might add that another, extremely abstract way Sartre seeks to preserve consciousness' freedom from the causality of its objects is by insisting that the relation of consciousness to beings is fundamentally negative, a nihilation.[15] Being-for-itself is not being in general nor this or that particular being. Furthermore, consciousness of something fundamentally involves "not being that being. This is precisely what we mean by 'to be conscious *of* something'" (*BN*, 174.) This negative relation, Sartre says, preserves consciousness from being affected by the beings it is aware of, yet even here he admits that my (or consciousness') facticity does to some extent limit the way I know the world. My facticity, for example my past, "qualifies" and "fixes" me in certain ways, giving me "roots" that explain why I focus on certain objects rather than others.[16] Thus, once again he grants that there is more to me (or to consciousness) than pure spontaneity or freedom.

In spite of this admission, however, when we turn to the final part of *Being and Nothingness*, we find Sartre both minimizing human facticity and continuing to identify human reality with freedom.

Section 3. *Being and Nothingness'* Final Treatment of Freedom and Facticity[17]

In many ways, the over one hundred pages of Part IV, Chapter One, of *Being and Nothingness* are the culmination and summation of the entire work. Not only is Part IV the last major section of the book (only a brief ten-page conclusion follows it), its first chapter also contains a number of valuable summaries by Sartre of all that he has presented in the preceding four hundred pages.[18] It also includes his most extensive treatment of freedom, facticity, and the relation between them, and a number of very clear statements about human reality and freedom. It seems safe to consider it Sartre's final thought on these ontological matters in this work.

Early in the chapter Sartre presents again his most common argument for the freedom of consciousness, an argument he repeated in numerous works throughout his life.[19] Consciousness is free because it can transcend what is and grasp what is not, in this case nonexistent goals or ideals. Since every act, Sartre argues, "is a projection of the for-itself toward what is not, and what is can in no way determine by itself what is not," it follows that "no factual state, whatever it may be (the political and economic structure of society, the psychological 'state,' etc.). . . . can determine consciousness" (*BN,* 435–36). Consciousness' freedom, its ability to go beyond what is and grasp what is not, is referred to as its "detachment" or "withdrawal" from being, its "negating" or "nihilating" of being, or even stronger, its "permanent possibility of effecting a rupture" with being. And Sartre proceeds to identify this freedom with the freedom of human reality. "My freedom," he writes, "is not a quality added on or a *property* of my nature. It is very exactly the stuff of my being" (*BN,* 439). It is, as we saw, rooted in man's presence to himself; it is the nothingness "at the heart of man which forces human reality to *make itself* instead of *to be*" (*BN,* 440). Sartre continues,

> nothing comes to it [human reality] either from outside or from within which it can receive or accept. Without any help whatsoever, it is entirely abandoned to the intolerable necessity of making itself be—down to the slightest detail. Thus freedom is not a being; it is the *being* of man—i.e., his nothingness of being. (*BN,* 441)

Because it is the very being of man, Sartre concludes, "Man can not

be sometimes slave and sometimes free; he is wholly and forever free or he is not free at all" (*BN*, 441).

To defend this incredible claim, which is directly contrary to what he said when discussing consciousness' relation to its body, he goes on to reject any attempt to make man partly free (e.g., in his will) and partly determined (e.g., in his passions). We cannot accept such a conception, he says, because "such a trenchant duality is inconceivable at the heart of the psychic unity." By the psychic unity, I take it, he means consciousness. In other words, Sartre's argument that *man* cannot be partly free and partly determined rests on his identification of man and (spontaneous) consciousness!

The following texts make it clear that that is what he is doing. Sartre reiterates that

> it is impossible for a determined process to act upon a spontaneity, exactly as it is impossible for objects to act on consciousness. Thus any synthesis of the two types of existence [free and determined] is impossible; they are not homogeneous.

He immediately applies this argument to man and in doing so effectively equates man with consciousness:

> This decision shows that two solutions and only two solutions are possible: either man is wholly determined (which is inadmissible, especially because a determined consciousness—i.e., a consciousness externally motivated . . . ceases to be consciousness) or else man is wholly free. (*BN*, 442)

But if man is "wholly free," if he is only what he makes of himself "down to the slightest detail," as an earlier text said, what has become of his human facticity?

There are many places where Sartre appears to deny, or at least ignore, its reality. For example, in one summary of his view of freedom he states that there is "no given in human reality in the sense that temperament, character, passions, principles of reason would be acquired or innate data in the manner of things" (*BN*, 476). Rather "human reality," he asserts, is "act," and "wholly choice and act."[20] Again, "Whatever our being may be, it is a choice" (*BN*, 472). We exist only by choosing ourselves, he explains, and even our emotions and passions (including sexual passion) are freely chosen, as are our psychological characteristics.[21] I might add that emotions, passions, and psychological characteristics are said to be free for the same reason that all conscious acts are free; namely, because they are

intentional. They aim at nonexistent goals and so involve a rupture with, or negation of, the given state of affairs.

Yet earlier we saw Sartre admit that part of every human being is his or her facticity, for example his or her biological structure, race, nationality, character as well as habits and past experiences. He also admitted that one's situation in the world was contingent, that is, that I am not the foundation of my very presence in the world; for example, I do not choose or cause myself to be born a Jew in an anti-Semitic society. How then can a person be wholly free, wholly choice, and act, whose choices make him or her all he or she is?

To his credit Sartre does not dodge this objection, which he labels that of *common sense*. He confronts it head-on in a section labeled "Freedom and Facticity: The Situation."

In some passages there, Sartre appears to give power to facticity to limit or condition human freedom. He admits that the beings of the world, "brute existents," as well as my own facticity, especially my body and my past, supply something to the particular situation. Accordingly, he defines the situation as an ambiguous phenomenon inasmuch as it is the common product of the in-itself and freedom, and, he adds, it is impossible to delineate precisely what comes from the in-itself and what from freedom.[22] His example is well known and illuminating. In one sense it is my free choice to climb to the mountaintop that causes a crag in my path to appear as an obstacle, yet it is also the fact that the crag is twenty feet high that makes it an obstacle. Similarly, it is both because my body is weak and frail and because I choose to attempt to scale the crag that it is an obstacle.

In addition, on a more abstract level, Sartre repeats the point he made earlier in *Being and Nothingness*. Freedom literally adds nothing to the full positivity of being except nonbeing, which carves up being into a world of beings. In other words, all content in the beings of our experience comes from the fullness of being in itself.[23] Yet if *all* content in the objects of our experience is from the side of being, then it would seem that our freedom would be limited and conditioned by that which being supplies. More concretely, in speaking of perception, Sartre says that although I can focus on certain qualities of an orange peel, for example, and bring them to the fore while pushing others into the background, it is not up to me or my freedom to decide what qualities are present in the first place: "I cannot make the orange peel cease being green" (*BN*, 188). "Reality in itself is there at hand, with its qualities" (*BN*, 509). In

other words, I cannot arbitrarily by my free choice cause objects to possess certain characteristics. I cannot, for example, make a rock something edible; its qualities do not allow it. Does it not follow, then, that my freedom is limited, even conditioned, by that which things supply to my situation?

In the final analysis Sartre answers no and gives the following reasons:

1. In the first place facticity (meaning here both the facticity of my own being and that of my situation in the world of other beings) is an absolutely necessary condition for freedom. Real freedom demands that I be located in a world of really existing things that separate me from my goals, while also offering the possibility of attaining them. Otherwise, my mere wish or dream would suffice for me to attain my ends, and choice would be unnecessary and impossible. In other words, "if no obstacle, then no freedom" (*BN*, 484).

2. Of course, the foregoing observation hardly proves that freedom is not limited by the particular situation in which it exists and the objects which it confronts. Sartre's next point directly addresses that issue. No matter what its facticity or situation, freedom always nihilates, denies, detaches itself from it by intending nonexisting ends. This is, again, Sartre's basic argument for the freedom of consciousness, of the for-itself, of man. Sartre makes this argument in *every single case* as he discusses, one by one, the various structures of facticity (my place, my body, my past, my environment, my objectification by others).[24] The fact I go "beyond" these structures toward goals which are not "is enough to insure its [the for-itself's] *total* independence in relation to the structures which it surpasses" (*BN*, 520) [emphasis mine].

3. Even though I am not the sole source of my facticity nor of the objects I face in the world, it is my freely chosen goals which confer meaning on them; I give them their "coefficient of adversity." For example, my shortness is simply what it is, a factual state of affairs. If I desire to be a professional basketball player, it becomes a serious liability; if I want to be a jockey, it can be an advantage. In both cases my chosen goal creates its meaning as a value or a disvalue. Thus Sartre writes, "Human reality everywhere encounters resistance and obstacles which it has not created, but these resistances and obstacles have meaning only in

and through the free choice which human reality is" (*BN*, 489). More succinctly, "freedom creates the obstacles from which we suffer" (*BN*, 495).

With these arguments Sartre effectively minimizes any limitation of freedom by facticity. This explains why throughout his discussion he continues to insist that freedom is "absolute," "total," "infinite," and "without limits," and that "the only limits which freedom bumps up against at each moment are those which it imposes on itself."[25] Totally ignoring any contribution from facticity itself, Sartre asserts, "I alone [NB] decide the meaning of the past" (*BN*, 499) and of all the elements of my situation. Other persons, for example, can impose on me certain determinations and meanings that I cannot control or even grasp as they do. Yet, Sartre insists, these determinations are only external, not internal, limits or restrictions of my freedom, because, again, my freedom by seeking nonexistent ends transcends every structure imposed on me by others. Furthermore, it is my free choice of my ends that causes my being for others to take on the meaning it has. Thus the other, Sartre asserts, cannot himself act on the content of my situation nor cause even a partial change of it. He affects my situation *only* through my free choice by which I accept or reject the objectification and meaning he imposes on me. Again Sartre concludes that every freedom is "totally independent" of the determinations given it by others. Freedom is "total and infinite," because its only limits are those it imposes on itself by its free choices.[26]

Perhaps the early Sartre's extreme view of freedom is most obvious in his conclusion to the section devoted to freedom and facticity. There he states,

> there is no priviledged situation. We mean by this that there is no situation in which the given would crush beneath its weight the freedom which constitutes it as such—and that conversely there is no situation in which the for-itself would be *more free* than in others (*BN*, 549).

Every situation, no matter what its limitations, has "infinite possibilities of choice" (*BN*, 522) Thus, the infamous statement, "the slave in chains is as free as his master" (*BN*, 550). This does not mean that the slave can do or attain all the things the master can, but that by his chosen projects (and he has many [infinite?] possibilities) he can freely bestow all kinds of different meanings on his captivity.

Statements such as these, however, ignore the fact that elements of the situation itself (in this case the slave's chains) can severely limit choices. They ignore the point, conceded elsewhere, that the situation, and *a fortiori* its meaning, is a joint product of freedom and the brute given.[27] Surely, like the rock in Sartre's earlier example, the slave's chains limit the possibilities and goals he can choose, and hence the meaning he can give to his captivity. In spite of what Sartre claims, slaves do not have the range of choices and thus the degree of freedom that their masters do; human beings are more free in some situations than in others. (In fairness, I should add that Sartre will later explicitly repudiate these early statements.)

Section 4. Conclusion

In the final analysis, I believe that the freedom Sartre so emphasizes here, a freedom which he designates as absolute, total, and infinite because it transcends and escapes one's facticity, no matter how repressive, and because it can confer all kinds of different meanings on that facticity, even if it can not change it, is only a freedom of consciousness. Sartre makes it clear that the freedom at issue is not the freedom *to attain* the goals one wants, for there are, he admits, many factors which can restrict that freedom. However, "success [in attaining goals] is not important to freedom" (*BN*, 483), he states, for it is freeedom *of choice,* the freedom to select among possible goals, that he is concerned with. It is the freedom to transcend what is by grasping what is not.[28] But, to repeat, I believe that this freedom is at most a freedom of consciousness, not the concrete freedom of a situated human being.[29] It may be true that the slave in chains can imagine and choose the not now existing goals of liberation or vacation at the seashore, and thereby in some sense transcend, negate, disengage himself, and escape from his present bondage—but only in thought, not in reality! I would even question whether the ability of consciousness to intend nonexistent goals is necessarily free at all. Experience seems to show that fear, anger, ignorance, mental deprivation, not to mention techniques of indoctrination and brainwashing, may *force* one to consider certain goals rather than others. Sartre's basic argument to support his view is that being, what is (which includes psychological states, one's situation, all one's facticity, past and present), cannot cause nonbeing, what is not

(nonexistent goals). Yet this seems little more than a verbal ploy, for nonexistent goals are not simply nonbeing or what is not. They are different types of beings, imaginary or possible beings, rather than real or past beings. Thus, Sartre's argument essentially boils down to a claim that one kind of being (real being) cannot cause another kind of being (imaginary or possible being)—but that needs to be demonstrated. The fallacious character of Sartre's argument is most glaringly evident in his claim that all emotions and passions are free simply because they are intentional, that is, aimed at nonexistent goals. I am willing to grant their intentionality; fear, for example, is fear of something; sexual desire is desire for a sexually attractive person or object. Still, it is, I submit, frequently contrary to ordinary human experience to claim that such emotions and desires are freely chosen rather than conditioned responses provoked by perceived or imagined objects. One often experiences fear, whether she chooses to or not, for example, in the face of an advancing threat; one often is aroused, whether he chooses to be or not, by a sexually appealing person. (Of course, one's *behavior* in response to these emotions, desires, and objects may still be free.)

I will conclude this chapter with two remarks. In the first place, given Sartre's insistence on absolute and total human freedom, it is no surprise that he believes that each individual's responsibility "is overwhelming since he is the one by whom it happens that there is a world. . . . He must assume the situation with the proud consciousness of being the author of it. . . . since nothing foreign has decided what we feel, what we live, or what we are" (*BN*, 553–54). Yet once again he completely ignores the role of facticity, of the being of objects, and of others in making one's situation and one's being what they are. Secondly, Sartre's views of freedom could lead to a quietistic or Stoical ethics. If human reality is freedom and human freedom is total, absolute, and unlimited, if all situations are equivalent in freedom, then there is no reason to change the concrete conditions in which humans live, even if they appear terribly oppressive. Along the same line, if it is a human being's freely chosen goal that alone is responsible for the meaning, including the adversity, of things, then if he or she wishes to change that meaning and make his or her situation less adverse, he or she should simply choose a different goal. If my poverty is an obstacle to my living the life-style of the rich and famous, all I need to do is choose instead to

live an ascetic life and my poverty will become a positive benefit to me. No need to attempt the more difficult, risky, and perhaps unsuccessful task of changing the system in order to eliminate poverty. "Conquer yourself, rather than the world," the Stoics advised, but note that there too the term *self* seems to refer more to consciousness than to one's physical being which is conditioned and limited by others and by physical objects.[30]

I hasten to add that I do not mean that Sartre himself, even at this early stage of his career, would be completely comfortable with the passive, Stoical kind of ethics I have just outlined. Nevertheless, I believe that his exaggerated conception of human freedom, his extremely abstract understanding of human reality, and his neglect and/or minimization of the power of facticity lead in that direction. Further support for my viewpoint will come from an investigation of the early Sartre's analysis of human relationships, which I undertake in the next chapter.

3

Human Relations and Ethics in *Being and Nothingness*

As every reader knows, in *Being and Nothingness* Sartre dwells on the negative side of human relationships. In great detail he describes a number of human interactions and shows that in every case, even that of love, they involve attempts at domination and subjugation of one party by another. "Conflict is the original meaning of being-for-others" (*BN*, 364), he writes, and again, "the essence of the relations between consciousnesses is not the *Mitsein*; it is conflict" (*BN*, 429). Such a position obviously has grim implications for ethics. If one of its tasks is to offer guidelines about the way human beings should behave toward each other, and if Sartre's ontology has already determined that human relations are essentially conflictual, then what is left for ethics to do? At the most it might be able to suggest ways to lessen or to live with the inevitable hostility.

The picture Sartre paints is undeniably bleak, yet, as we shall see, towards the end of his discussion he does hold out a slight glimmer of hope that things could be different. My presentation of his views will constitute the first two sections of this chapter. First, I will describe the fundamental ontological structure of human relations according to Sartre; second, I will review his descriptions of particular concrete relationships.

Section 1. The Ontological Structure of Human Relations: Alienation, Degradation, Conflict

Sartre's first mention of conflict occurs when he is voicing his disagreement with Hegel and Heidegger whom he interprets as

holding that all consciousnesses are ontologically one. On the contrary, he insists, "No logical or epistemological optimism can cover the scandal of the plurality of consciousnesses. . . . So long as consciousnesses exist, the separation and *conflict* [NB] of consciousnesses will remain" (*BN*, 244). His overwhelming desire to reject any kind of ontological monism that would nullify individually distinct consciousnesses also leads him to assert that the fundamental bond between consciousnesses is negative: "it is necessary above all that I be the one who is not the Other, and it is in this very negation . . . that I make myself be and the Other arises as the Other" (*BN*, 283). Again, "the For-itself which I am simply has to be what it is in the form of a refusal of the Other" (*BN*, 283). Although there is, Sartre claims, a "bond of being" between myself and Others, it is only one of "internal negation." This means that the Other is present to, and affects, a consciousness in the very depths of its being, but it is present negatively, as that which that consciousness fundamentally is not. To the core of my being, I am qualified as a self who is no other self; indeed, I am my own self only by not being the self of any Other.[1] This negative dependency of consciousnesses on each other is what Sartre calls the *bond of being* or "synthetic connection" (*BN*, 252) between them. However, it involves such a fundamental denial of each Other that it is difficult to see how it is in any sense a positive union or "unitary bond of being" (*BN*, 284) between them. When we come later to Sartre's treatment of concrete human relations, we will see that none of them do, in fact, consist of a real union between consciousnesses. I might add that throughout his career Sartre has great difficulty in admitting any positive ontological bond or union among human beings—until just before his death!

The other major reason for the early Sartre's negativity about the structure of human relationships is psychological or epistemological in character. That is, it is rooted in the way consciousnesses, or subjects, are aware of each other. Any face-to-face encounter inevitably grasps a subject as an object, Sartre says, and this is a "degradation" of her as a subject. It is a "radical metamorphosis" of her for it reduces her to a thinglike in-itself.[2] It is in this sense that the Other is my "original sin" (*BN*, 263). Sartre also speaks of objectification as an alienation, and even an enslavement, of a conscious subject. This is because I cannot control the way the other sees or evaluates me; that is up to his freedom. Indeed, I cannot really

know how the Other judges me, for my being-for-Others is radically different from my being-for-myself.[3]

Since the other subject can alienate, enslave, and degrade me, "my constant concern is to contain the Other within his objectivity," Sartre states, "that is, to keep him under my control." Thus, "my relations with the Other-as-object are essentially made up of ruses designed to make him remain an object" (*BN*, 297). Of course, he or she is attempting to do the same to me; hence, struggle, conflict in that sense, is inevitable.

There is, however, one positive feature to all of this negativity, Sartre says.[4] By my internal negation of the Other, I "reinforce" my own selfness. I am conscious of myself as myself precisely by being conscious of not being the Other. I am also aware that my being for myself is fundamentally different from my being for the Other. Though being an object radically modifies my consciousness, it does so, Sartre asserts, "not in what it is for itself but in its appearance to the Other" (*BN*, 242).

> Even if I could see myself clearly and directly as an object, what I should see would not be the adequate representation of what I am in myself and for myself . . . but the apprehension of my being-outside-myself, for the Other; that is, the objective apprehension of my being-other, which is radically different from my being-for-myself, and which does not refer to myself at all. (*BN*, 273)

My prereflective self-awareness is apparently not affected, neither increased nor diminished, by the Other's view of me as an object. Sartre does state that it is only through the Other that I can attain any idea of how I appear to others, e.g., as jealous, rude, kind. Still, since I cannot be an object for myself, nor concretely apprehend (intuit) my objective qualities, the Other's knowledge of me "does not serve as a regulative or constitutive concept for the pieces of knowledge (*connaissances*) which I may have of myself" (*BN*, 275).

Thus, the relation between consciousnesses is described so negatively by Sartre, that there is a radical "gap" between my being-for-myself and my being-for-others. As a result, the Other's awareness of me cannot help me attain greater awareness of myself as I am for myself. Not only does my lucid prereflective self-awareness have no need of him, he only apprehends me as an object, never as the subject I am: "the very being of self-consciousness . . . is pure interiority [and] . . . therefore, is the radical exclusion of all

objectivity" (*BN*, 241). In fact, no matter how much I am objectified or degraded by Others, I never lose my deep awareness (here, called "comprehension" [*BN*, 291]) of myself as a subject according to Sartre. This awareness is precisely my motivation for making and keeping the Other my object.

Besides their negative character, the other thing that is striking about Sartre's treatment of human relations in *Being and Nothingness* is how abstract it is. Not only does he continually refer to such relations as relations between consciousnesses or for-itselfs, rather than between human beings; these relations occur almost exclusively on a psychological plane. For example, when he speaks of a subject being alienated, degraded, or enslaved by another, such slavery or degradation does not involve physical possession or abuse or domination. It refers, as we have seen, to the fact that I, a subject, am seen as an object and my objectness is dependent on another's freedom. Similarly, Sartre speaks of consciousness coming to self-awareness by negating, even wrenching away from, the Other and recognizing that it is not the reified object which the Other makes of it but a free subject. But, again, the self-recognition of one's freedom does not necessarily involve any real social and political liberation from the Other. Recall in this connection that in the previous chapter Sartre claimed that the Other could never provide an internal limit or restriction of my freedom because I alone freely decide the meaning of whatever objective determinations he imposes on me. Yet this freedom is purely psychological—not social or political. Simply because the slave can freely choose the meaning of his slavery in no way frees him from its limitations and restrictions, including its restrictions on his choice.

Perhaps nothing so reveals the abstract character of Sartre's discussion of human relations as his admission in these pages that it is not the Other's *actions* and their effect on me that is his concern, but only his objectification of me.

> If there is an Other, whatever or whoever he may be, whatever may be his relations with me, and *without his acting upon me in any way* except by the pure upsurge of his being—then I have an outside. (*BN*, 263) [emphasis mine][5]

This outside is, of course, my alienation, degradation, and enslavement. It follows, then, that the way I overcome such degradation is

by turning the tables on the Other by asserting my subjectivity and objectifying him. Since my "slavery" is fundamentally psychological, that is, due to the Other's *awareness* of me and not to his actions on me, so is my liberation. In fact, according to Sartre it is entirely up to my free choice whether I see myself as the object of the other subject or assert my subjectivity and make him my object. In these pages he never considers the possibility that a person could be so physically, emotionally, and cognitively dominated by another that she would not be able to assert her subjectivity over the Other's. Furthermore, even if she could objectify the oppressive Other, and thus gain the upper hand in some psychological sense, that would hardly involve political or economic dominance over that person. Some slaves may have intimidated and scared their masters. They, nevertheless, remained slaves subject to the master's cruelty and control.

My point is not to deny the painful reality of psychological degradation. There is no doubt that being viewed as a thinglike object by others can be a humiliating and destructive experience, as victims of discrimination testify. I simply wish to stress that it is only this kind of degradation that Sartre considers in these pages devoted to human relationships. To repeat, his discussion of the impact of others on one's freedom examines human beings and their relations only insofar as they involve consciousness' objectification of one subject by another, and a subject's free conferral of meaning on that objectification, not insofar as they involve real physical, political, or economic actions or structures which enhance or deform human existence. In other words, it is basically relations between consciousnesses that Sartre discusses, not concrete relations between flesh and blood human beings immersed in history and in its sociopolitical systems.

In addition, throughout his analysis Sartre insists that no subject-to-subject relation between human beings, or consciousnesses, is possible.[6] Either I am the degraded object of another or the other is my object. To know another subject is inevitably to objectify it, and no nonalienating, nondegrading type of objectification is ever mentioned. In one of the few references to authenticity in these pages, Sartre states that only two authentic attitudes are possible: 1. that by which I recognize the Other as a subject who objectifies me, or 2. that by which I recognize myself as the free subject who

objectifies the Other. "No synthesis of these two forms is possible," he asserts (*BN*, 302). As we continue into his detailed discussion of concrete human relationships, we shall see that there, too, Sartre rejects any possibility of direct subject-to-subject relations.

Section 2. "Concrete Relations with Another"[7]

It is especially the section of *Being and Nothingness* with the above title that commentators cite to support their conclusion that human relations (at least for the early Sartre) are inevitably in conflict.[8] For it is here that he describes a host of relations, from love to hate, all of which involve overt hostility toward others. Love, desire, and hatred are the most fundamental relations, he claims, and all are attempts to dominate others. Love, for example, is portrayed as a subtle attempt to capture the free subjectivity of another by becoming one with her. Desire is an attempt to do the same thing through physical pleasure. By incarnating my free subjectivity in my body, I attempt to entice the other to incarnate her subjectivity in her body. Then by possessing her body, I would possess her freedom. Hatred deliberately attempts to destroy the other free subject. Sartre maintains that these three relations are present in all other relations, which are simply "enrichments" of them.[9] It follows that all of the concrete relationships he describes are hostile in nature and "must be envisaged within the perspective of *conflict*. Conflict is the original [i.e. fundamental] meaning of being-for-others" (*BN*, 364).

Sartre also repeats here his denial that people can enter into any relationships other than subject to object, and vice versa. He states that to apprehend the Other as both a free subject and an object is an "impossible ideal," and adds, "we shall never place ourselves concretely on a plane of equality; that is, on the plane where the recognition of the Other's freedom would involve the Other's recognition of our freedom" (*BN*, 408). He goes on, even if I should attempt to take the Other's freedom as my goal, I would thereby make an object of it and thus alienate and degrade it. No matter how benevolently I act toward the Other, I inevitably establish an external limit to his freedom and so "violate" it. Even if, for example, I create a tolerant society for another, I force him into that situation and thus "remove from him on principle those free possibilities of courageous resistance, of perseverance, of self-asser-

tion, which he would have the opportunity to develop in an intolerant world" (*BN*, 409). Finally, even when Sartre grants that there is a subject-to-subject type of relationship, as when people cooperate in seeking a common goal, he dismisses it as of little import. It is merely a "psychological" experience, not an ontological unity of subjects, he says. It involves only a "lateral" not a direct face-to-face awareness of other subjects, and such a lateral awareness presupposes a prior subject/object relation. Accordingly, he concludes his discussion of the we-subject relation by again insisting, "It is useless, therefore, for human reality to seek to get out of this dilemma: one must either transcend [and therefore objectify] the Other or allow oneself to be transcended [objectified] by him. The essence of the relations between consciousnesses is not the *Mitsein*; it is conflict" (*BN*, 429).

Not only are the implications of Sartre's position rather bleak as far as ethical relationships are concerned, one could certainly object, and many have, that his descriptions are hopelessly one-sided. No doubt there are hostile, conflictual human relations such as Sartre describes, but there are countless others which are not so. How could he be so unaware of positive intersubjective relations, especially since he himself was apparently involved in such relations with de Beauvoir, Nizan, Camus, his mother, and others at this time? The best response to this question is to point to the extremely significant footnote that Sartre adds at the end of the section in which he describes all human relations as embodying conflict. That footnote states, "These considerations do not exclude the possibility of an ethics of deliverance and salvation." He adds, "But this can be achieved only after a radical conversion which we can not discuss here" (*BN*, 412). A description of the nature of the radical conversion is left, apparently, for his work on ethics. However, if we turn to Sartre's three-page introduction to his discussion of concrete human relations, we can get a pretty good idea of what he has in mind.

In those pages Sartre makes it clear that in each of the human relationships to be described, the for-itselfs involved are fleeing from their status as merely contingent, factual beings and are attempting to achieve the state of a necessary being which is its own foundation.[10] That is, they are attempting to become God. In such a context, a for-itself's relations with Others will take, in general, one of two forms. Insofar as the other subject objectifies me, I am at the

mercy of his free evaluation. He confers on me a thinglike status of which I am not the foundation. Therefore, one way I can attempt to escape from this contingent facticity, which I am through the Other, is to "turn back upon the Other so as to make an object out of him in turn, since the Other's object-ness destroys my object-ness for him" (*BN*, 363). Hate is just such an attempt. The other possible reaction to the fact that I am the Other's object is for me to attempt to become the other subject, that is, become the subject which is the source and foundation of my thinglike status. If I could, I would become to some degree the foundation of myself. Love attempts this impossible union. And all of the other relations Sartre describes are simply variations on these alternative ways of reacting to the exasperating and threatening fact that I, who desire to become the foundation of my own being, receive a dimension of my being, my objectness, from a free subject beyond my control. I want to emphasize, however, that if one could cease the vain attempt to become the foundation of his or her being, the Other's free objectification of them, which they cannot control, would be somewhat less threatening. This brings us back to the radical conversion Sartre mentions in his footnote. As we will see when we get into the first ethics, the radical conversion is precisely the choice to cease to value the impossible goal of being God and so to cease in the attempt to use or destroy others in order to attain that end. That is to say, if I no longer strive to be the necessary foundation of my own being, then the fact that the Other objectifies me and confers on me a dimension of my being that I cannot be the foundation of will not necessarily lead me into the circle of conflicting relationships that Sartre describes. Exactly what the relationships would be between human beings who have undergone a radical conversion is, however, not discussed anywhere in *Being and Nothingness*. The topic is left for the "ethics of deliverance and salvation." Of course, even those who by their radical conversion have avoided the most overt forms of conflict that Sartre describes, even they can enter only into subject/object relations—where objectification inevitably entails a degrading reification of subjectivity. For as we have seen, Sartre dismisses the possibility of direct subject-to-subject relations as an "impossible ideal." That in itself would seem to present a serious obstacle to any so-called "ethics of deliverance and salvation," and when we present his first ethics we will have to see how he handles it.

Along the same line, it should be noted that throughout his analysis Sartre simply assumes, without argument, that objectification of one subject by another subject inevitably degrades the first subject. Yet surely I can be the object of a caring, generous look as well as a hostile, alienating stare. I suspect that Sartre ignores the former possibility because of his exaggerated emphasis on human freedom in his early ontology. Recall his repeated identification of man with free spontaneous consciousness, or simply with absolute and total freedom, and his corresponding minimization of facticity. From such a perspective another subject, no matter how benevolent, who gives me a dimension of being that I can neither know nor control, inevitably limits my freedom (albeit only externally). This is why Sartre asserts boldly that no matter what I do for another, even if I aid him, I necessarily "violate" his freedom! I violate it because I inevitably limit it. Yet this seems to imply, again, that the freedom Sartre wants for human beings is one without any limits, internal or external, a freedom, I submit, which the human condition does not allow.

I have said enough in the previous chapter about the early Sartre's abstract, unreal conception of human freedom. Let me conclude this section by again noting the equally abstract character of his treatment of human relations, even so-called concrete ones. The conflict, domination, and destruction involved in the latter do not primarily entail hostile physical actions by others nor oppressive political, economic, or social structures. They are rather the result of, and response to, the fact that conscious subjects are inevitably objectified by other subjects who are aware of them. Sartre's famous statement that conflict is "the essence of the relations between consciousnesses" says it all. His analysis concerns the relations between *consciousnesses*, not between concrete human beings! Likewise, deliverance from this conflict, to the extent that it is possible, comes not from concrete physical actions nor from reforming inhuman political and socioeconomic structures, but from changing one's consciousness. That is, the radical conversion Sartre briefly mentions consists of a fundamental change in an individual's *choices*. Of course, such a change will also result in an individual having less antagonistic behavior toward others. Nevertheless, Sartre's radical conversion seems to be an individualistic, and one might say mental, response to the real social problems of human conflict and opposition; it is a remedy which, though it may be ethical, is essentially apolitical and ahistorical.[11]

The next section will pursue Sartre's notion of radical conversion by looking at his discussion of it in the very last section of *Being and Nothingness*, the only section explicitly devoted to ethics. Before I consider it, however, I want to say a word about an earlier section entitled "Existential Psychoanalysis," for in it Sartre already begins to modify some of his positions about the nature of knowledge and the importance of others for one's self-awareness. Both items have important implications for his first ethics.

Section 3. Existential Psychoanalysis and Ethical Implications

Existential psychoanalysis for Sartre is basically the attempt to grasp the fundamental project of a particular individual situated in the world. "It is a method," he says "destined to bring to light, in a strictly objective form, the subjective choice by which each living person makes himself" (*BN*, 574). Note the phrase, "in a strictly objective form." Sartre explains that in order to reconstruct the life of a person, existential psychologists use "all the objective documentation which they can find: letters, witnesses, intimate diaries, 'social' information of every kind" (*BN*, 569). They seek to decipher and interpret all this empirical data in order to discern the irreducible and original choice the individual makes of herself in the world. Surprisingly, Sartre asserts that the person is not in a privileged position to study such data and decipher its deeper meaning but needs to be "aided and guided by a helping hand" (*BN*, 569) if she is to attain an awareness of her own fundamental choice. Such statements are extremely curious in the light of Sartre's earlier insistence that a lucid prereflective self-awareness is part of every consciousness. They also seem incompatible with his earlier assertions that the Other can only grasp me as an object, not as the being I am for myself, and that the Other's knowledge of my object side "does not serve as a regulative or constitutive concept for the pieces of knowledge which I may have for myself" (*BN*, 275). Indeed, as we have seen above, for the Other to know me as an object is precisely not to grasp me as a subject but to degrade me into a thinglike entity.

As far as a person's lucid prereflective self-consciousness is concerned, Sartre now offers the following clarification. While it is

true that each conscious act, including one's choice of his funda-
mental project, is self-conscious, "that certainly does not mean that
it must by the same token be *known* by him" (*BN*, 570). Even one's
reflection on his prereflective consciousness, though it grasps that
consciousness entirely, does not have the instruments or technique to
bring his fundamental project to the full light of day. Reflection, he
explains,

> is deprived of the means which would ordinarily permit *analysis* and
> *conceptualization*. It grasps everything, all at once, without shading,
> without relief, without connections of grandeur—not that these
> shades, these values, these reliefs exist somewhere and are hidden
> from it, but rather that they can exist only *by means of* and *for*
> knowledge. (*BN*, 571)

He adds, "reflection . . . will simply furnish us with the brute
materials toward which the psychoanalysts must take an objective
attitude" (*BN*, 571). (Earlier passages make it clear that the
reflection Sartre is talking about here must be *pure* reflection.)[12] In
other words, though each individual is prereflectively conscious of all
her conscious acts and can, in addition, become reflectively conscious
of them, such acts are present all together without distinction and
classification. The analysis and conceptualization of knowledge is
necessary to interpret the complex experiential aggregation of acts
and to determine which are peripheral, which more significant, and,
ultimately, which act of choice is absolutely fundamental.

However, this raises the other question. Even if one's lucid self-
awareness, both prereflective and reflective, is unable to analyze and
conceptualize its own conscious experience without using knowl-
edge, how can the psychoanalyst's *objective* knowledge of the subject
be of assistance? To objectify a subject, Sartre has insisted, is to
degrade and reify it. Furthermore, one's being-for-others is not one's
being-for-oneself and Sartre repeats that position here: "there is an
incompatibility between existence for-itself and objective existence.
. . . [W]hat always escapes these [objective] methods of investigation
is the project as it is for itself, the complex in its own being" (*BN*,
571). Yet he immediately adds that the subject's knowledge gained
by the objective methods of existential psychoanalysis "can help to
clarify reflection and that reflection can then become a possession
which will be a quasi-knowing" (*BN*, 571). I understand this obscure

statement to mean that the knowledge which existential analysis gains by its objective analysis of a subject can be used by that subject to clarify his own reflections on himself. Such knowledge can, in other words, enable the subject to attain a greater awareness, or quasi-knowledge, of himself, including his own fundamental project.

It is true that in the final analysis the criterion for deciding whether the psychologist's objective explanation has truly grasped a subject's fundamental project is whether the subject himself "recognizes the image of himself which is presented to him as if he were seeing himself in a mirror" (*BN*, 573). The subject's intuition accompanied by evidence is absolutely decisive, Sartre says, for he is always (prereflectively) conscious of his deepest self.[13] Nevertheless, if knowledge gained through objective analysis and conceptualization can assist a subject in achieving greater self-awareness or quasi-knowledge, this has to mean that such knowledge, and the objectification it involves, does not totally falsify the nature of the subject by reifying it. Even more, it must mean that knowledge of a subject as an object is not totally different from, or incongruent with, awareness of a subject as subject. In other words, contrary to Sartre's earlier statements, the other's knowledge of me as an object, as well as my own understanding of this knowledge, cannot be radically incompatible with, or inapplicable to, my awareness of myself as a subject.

Thus, Sartre is apparently admitting in these pages a knowledge, or quasi-knowledge, of subjectivity that does not involve a degrading objectification of it. No doubt it would have been clearer had he chosen an altogether different word to designate this nonalienating awareness of a subject. He does, occasionally, call such awareness *comprehension*, but the precise meaning of that term in not explained here.[14] We shall see that comprehension, as distinct from knowledge, becomes a central notion in his *Notebooks for an Ethics*. We shall also see Sartre continue to modify his early views about the role others play in promoting a person's self-awareness. Indeed, by the end of his life, he will consider others to be absolutely essential for a person to attain an accurate understanding of him- or herself.[15]

I turn finally to the important concluding section of *Being and Nothingness* entitled "*Perspectives Morales*," or "Ethical Implications." In three brief pages, Sartre indicates some of the major ethical implications of the ontology and existential psychoanalysis he has set forth. Though ontology itself cannot supply ethical norms, he says,

it can indicate what sort of ethics is most responsive to situated human reality. One thing that ontology and existential psychoanalysis have shown, Sartre states, is the nature of value and, in particular, that the human "is the being by whom values exist" (*BN*, 627). Values are not "transcendent givens independent of human subjectivity" but arise from our free projects. To understand Sartre's position here, we need to turn briefly to his earlier treatment of values.

Values are unconditional norms, Sartre states in an earlier section of *Being and Nothingness*.[16] As norms, they are not being but are "beyond being." They are not that which is (facts) but that which should be. As "imperatives," "exigencies," "appeals," "norms," values are experienced not as something real but as demands to be made real. Now since values are beyond what is, their reality can be due only to a being that is able to transcend what is and posit what is not. Such a being is, of course, human reality, and values are precisely that toward which every human being surpasses what is. In saying this, Sartre points out, he is rooting all values in human freedom, the freedom to transcend what is and grasp what is not (but should be). He goes on to indicate the devastating impact this position apparently has for ethics.

If only human freedom makes values exist, Sartre says, this "paralyzes" and "relativizes" ethics, for it means that no values are absolute or necessary or exist objectively in themselves. "My freedom is the sole foundation of values," he writes, and "*nothing*, absolutely nothing justifies me in adopting this or that particular value, this or that particular scale of values" (*BN*, 38). If all values are relative, if all are created by human freedom, then obviously any ethics which attempts to set forth objective norms of human conduct is doomed from the start. Even more disturbing, if all values are conferred by human freedom, then anything, no matter how horrendous, can be given value and thus be morally correct.[17]

Returning now to the concluding pages of *Being and Nothingness*, we find Sartre mentioning another position from his ontology and psychoanalysis that has serious ramifications for ethics. This is his view that the ultimate value and goal which human beings inevitably seek is to be God. We noted earlier that insofar as human reality is radically contingent it desires to achieve necessity. We want to exist "by right," Sartre says, not, as we do, by chance. At the same time we want to give to ourselves this right or necessity; we want to justify our existence ourselves in order to preserve our freedom. We do not

want our being to be necessitated by some external cause. However, to desire to be a being who would justify its own existence, a being who would cause itself to be necessary, is precisely to desire to be an *ens causa sui*, or God. Thus, God is our ultimate goal and value.[18] Of course, such a being is self-contradictory, Sartre notes, which means that our fundamental desire is in vain, a "useless passion" (*BN*, 615). In Hegelian terms, it means that "human reality is by nature an unhappy consciousness with no possibility of surpassing its unhappy state" (*BN*, 90). Once again, the ramifications for ethics appear disastrous. If all human actions, even moral ones, are vain attempts to achieve the impossible God, then what is the point of ethics? Sartre himself draws the grim conclusion in his closing remarks. All men "are condemned to despair; for all human activities are equivalent (for they all tend to sacrifice man in order that the self-cause may arise) and all are on principle doomed to failure. Thus it amounts to the same thing whether one gets drunk alone or is a leader of nations" (*BN*, 627). The most one could expect from ethics would be some assistance in coping with the despair and failure which cannot be overcome.

In fact, one of the purposes of Sartre's first, as well as his subsequent, ethics is to assist humans to live meaningfully in spite of their ultimate failure to attain the absolute. The last three paragraphs of *Being and Nothingness* offer some extremely important, though brief, suggestions in this regard. Existential psychoanalysis and ontology should prompt humans to "repudiate the spirit of seriousness," Sartre says, that is, to realize that there are no objective or intrinsic values in anything, *including being God*. If a human being realizes that his freedom is "the only source of value" and that, no matter how he tries to achieve the status of an *ens causa sui* (God), he is "doomed to failure," can he, Sartre asks, "turn his back upon this value? . . . Will freedom, by the very fact that it apprehends itself as a freedom in relation to itself, be able to put an end to the reign of this value?" (*BN*, 627). Or must freedom always seek that impossible goal/value even if it tries to detach itself from it? Sartre cryptically suggests that it would be possible for freedom to take itself, rather than God, as its primary value, and that doing so involves a pure rather than accessory (impure) reflection, but all explanation of these matters is deferred to his future work on ethics.

The problem with these brief concluding suggestions is that earlier in *Being and Nothingness* Sartre had insisted that human

beings *must* seek, and even "choose," God as their ultimate goal and value. As we have just seen, insofar as a human is a free, contingent being, he desires, Sartre says, to become a necessary being, which is its own foundation. This goal is the ultimate value of his fundamental project and *no other alternative* is possible given what a human being is. In other words, according to his own analysis humans have no free choice about whether or not to desire God as their ultimate value. Granted, there is a sense in which this value and goal has Sartrean freedom as its source, but it is only the questionable freedom that Sartre claims is present in our ability to transcend what is and grasp what is not. It is not a freedom to select a different value/goal.[19] What then to make of the questions with which he concludes *Being and Nothingness*, questions that imply that we can put "an end to the reign of this value?"

No definitive answer can be found in *Being and Nothingness*. I should, however, point to an extremely important distinction Sartre makes early in that work in his discussion of the notion of value, a distinction between prereflective and reflective values.[20] After demonstrating that human beings necessarily desire to be God, that God is our supreme value, he points out that this value, like so many others, is most often "lived" nonreflectively. That is, we simply take it, along with other "everyday" values, as given without questioning its source or justification. (We take these values as givens, Sartre suggests, in order to avoid the "ethical anguish" that would come from facing the fact that our freedom alone is their cause.) Such prereflective values are distinguished from those that reflection grasps. "In my reflective consciousness," Sartre says, "I remain free to direct my attention on these [prereflective] values, *or to neglect them*" (*BN*, 95) [my emphasis]. Unfortunately, he does not pursue the point any further. However, I believe his distinction between prereflective values and those on a reflective level can be applied to his final remarks about the value of God. Recall that the last lines of *Being and Nothingness* also spoke of reflection, specifically the need for a pure rather than accessory reflection, but postponed all discussion of it until the ethics. Now, if reflection can affirm or "neglect" my prereflective, lived values, this would mean that I could freely decide not to value that impossible goal, the *ens causa sui*, that I necessarily seek on the prereflective level. Of course, it will remain a goal/value that I deeply desire. Still, it need not be a goal/value that I deliberately choose or attempt to achieve through (vain)

activities. This is the reason, I think, that Sartre suggests in his concluding remarks that once I see that trying to be God is in vain and that its value is not absolute, intrinsic, or objective but comes from freedom, I can turn my back on this value and put an end to its reign. Admittedly, what I have just offered goes beyond anything Sartre explicitly says in *Being and Nothingness.*

Of course, even if one can choose some goal other than God as his primary value, what should it be? If absolutely nothing has intrinsic or objective value, then any choice to confer value on something seems totally arbitrary and purely a matter of subjective taste. Sartre himself does suggest that freedom be chosen in place of God, but he offers no reason why it should be preferred to pleasure or to power, for example. Moreover, what would it mean concretely to choose freedom as one's primary value, since he has so often claimed that human freedom is already absolute, infinite, total, and without limits? Sartre himself asks in his concluding lines, if one can "live" such a choice. He writes,

> In particular will freedom by taking itself for an end escape all *situation?* Or on the contrary, will it remain situated? Or will it situate itself so much the more precisely and the more individually as it projects itself further in anguish as a conditioned freedom and accepts more fully its responsibility as an existent by whom the world comes into being? (*BN*, 628)

All these questions are left for the future work on ethics to answer; still it is interesting to observe Sartre's recognition that legitimate queries can be raised about the situated and conditioned character of a freedom that would take itself for its end.[21] As we have repeatedly pointed out, Sartre's notion of human freedom and its relation to its situation tends to be extremely incomplete in this work of ontology, as does his understanding of the structure of human reality and human relationships. If ontology is to indicate the kind of ethics that is most appropriate to the nature of human reality, as Sartre claims, then one could expect that the abstract conception of the human being that pervades *Being and Nothingness* will have as its counterpart an equally abstract ethics.

4

The First Ethics—Ontological Foundations and Supreme Value

We turn now to Sartre's first ethics. Its major work, the *Notebooks for an Ethics,* was written in 1947–48 and consists primarily of two of approximately a dozen notebooks which Sartre devoted to the topic; unfortunately, the others have been lost. Published with these notebooks are two brief appendices, one written in 1945, the other undated. Since Sartre himself deliberately chose not to publish his notebooks during his lifetime, we owe their appearance in 1983, just a few years after his death, to his adopted daughter.

For reasons which I will discuss below, Sartre made it clear in late interviews that he considered the notebooks to be a "failed attempt" to develop a viable ethics and thus he ceased working on them, and, sometime in the 1950s, began a second ethics. Nevertheless, the almost six hundred pages of the unfinished *Notebooks for an Ethics* remain the most comprehensive source from which to discover the character of Sartre's first ethics. As the following analysis will show, a number of the basic positions which he adopts in *Notebooks* are also expressed by Sartre, albeit in much briefer form, in works which he did publish during this period.

Notebooks for an Ethics was written after Sartre's "Introduction to *Les Temps Modernes*" (1945), *Existentialism and Humanism* (1946), "Materialism and Revolution" (1946), "Cartesian Freedom" (1946), and *Anti-Semite and Jew* (1945–46), and at the same time as "What Is Literature?" and "Consciousness of Self and Knowledge of Self." It contains a wealth of material of uneven clarity and significance, ranging from passages which extensively treat one topic or a collection of related topics for over a hundred or more pages, to entries of only one paragraph, sentence, or phrase. Needless to say,

I will concentrate on those portions which have the most ethical import. Of course, since the notebooks were never finished by Sartre, one would not expect to find in them a total consistency in the ideas he discusses or the positions he adopts there—and, indeed, we do not. I will attempt to set forth the positions and points of view he most often presents. Because Sartre's ethics is grounded in his ontology, this first section will concentrate on the understanding of human reality and of human freedom that is present in the notebooks and in other works of this period.

Section 1. Ontological Foundations

There are places in these works where Sartre continues to equate man or human reality or myself with human consciousness and freedom, and with the for-itself as transcending project and freedom.[1] He even occasionally speaks of man, I, subjectivity, the for-itself as "pure negativity," "nonbeing," the lack or "negation of being," the "nothingness of being," as he did in *Being and Nothingness.*[2] However, such statements are not representative of the general tenor of *Notebooks* and related works which on balance present a much more concrete and realistic notion of human reality. Even the above equations usually occur within a wider context, which indicates that Sartre recognizes their incompleteness. *Notebooks* generally refers to man not simply as consciousness or freedom but also as facticity, body, and being.[3] Sartre states that the body is the being in itself which sustains the conscious for itself in being. As in *Being and Nothingness,* he says that by means of his body "man is a consciousness caught up in a certain particular and contingent point of view (*NE*, 420). As the contingency of the for-itself, the body is said to be man's limits and fragility. It is also the human being's passivity, because through it one is affected, even "contaminated," by the world, and can be rendered *totally* passive, that is, destroyed. Sartre even states that my body makes me "a thing that is part of the world with a fixed organism and life conditions" (*NE*, 94). Thus, for the most part, *Notebooks* presents the human being not as a pure consciousness but as one immersed, "invested," in facticity and concretely situated in the world. Overall, the published works of this period do the same.[4] To cite just one, in "Materialism and Revolution" Sartre writes,

It is not true that man is outside Nature and the world, as the idealist has it, or that he is only up to his ankles in it, baulking like a bather having a dip while her head is in the clouds. He is completely in Nature's clutches, and at any moment Nature can crush him and annihilate him, body and soul. He is in her clutches from the very beginning; for him being born really means 'coming into the world' in a situation not of his choice, with *this particular body, this* family, and *this* race, perhaps. (MR, 252)

Similarly, we also find in *Notebooks* Sartre stating that my body makes my freedom real and determinate:

contingency gives the dimension of necessity to what was indeterminate freedom. I assume these eyes, these senses, this head, this body, because through them I am free. . . . with this, my freedom also has a face. (*NE*, 492)

In another place he goes as far as to say that my body makes my freedom an "infinitely" concrete and qualified enterprise.[5] Yet we still find in these works passages in which he continues to insist on the total and unlimited character of human freedom. One such place in *Notebooks* occurs after he admits that the oppressed person can have his freedom severely restricted by his oppressor who denies him certain possibilities. The oppressor "attains freedom directly in its heart" (*NE*, 327), Sartre says, and "can reduce my freedom to being nothing more than a vain appearance, it can even reduce it to becoming an instrument for his own [the oppressor's] ends" (*NE*, 334). (*Anti-Semite and Jew* makes similar statements about the plight of the Jew in the anti-Semitic society.) Yet at the same time that *Notebooks* admits this, Sartre insists that the action of the oppressor "*does not touch* that freedom, or manhandle it, it remains entire" (*NE*, 333). (Using similar language, in *Anti-Semite and Jew* he states that the Jew who accepts his Jewishness "takes away all power and all virulence from anti-Semites . . . [who] can no longer touch him" (*ASJ*, 137). Likewise, in "Cartesian Freedom," he asserts that man has "total freedom," which is "infinite in each individual." "The situation of a man and his powers," he writes, "cannot increase or limit his freedom."[6]

Sartre affirms the total and unlimited character of human freedom in these works for the same basic reason he did in *Being and Nothingness*. I always transcend and negate my facticity and my situation no matter how restrictive they appear. For example, early in

Notebooks, while acknowledging that my economic status, my work, and my personal qualities prescribe limits to the choices I can make, he insists that I, nevertheless, "surpass" and am thus "outside" all of these limitations.[7] Typical is the following statement which comes after he admits that there are specific qualities which are a given part of the universal human condition:

> man *is* precisely the transcendence of everything given. Therefore, he finds himself always outside of every definition of the species. . . . Man through his negativity breaks every form that encloses him. (*NE,* 68–69)

Similarly, in "Cartesian Freedom" he states that man can "escape," "disengage himself," and "withdraw from everything within himself which is nature, from his memory, his imagination, his body."[8] "Materialism and Revolution" speaks of man, by his projection into the future, "disengaging himself," "rising above," and "escaping" from the society which crushes him. *Notebooks* even declares in one place that all "situations are equivalent as soon as they are surpassed by freedom. . . . it would be absurd to classify situations as more or less *easy* for freedom [to surpass]" (*NE,* 90–91).

However, insistence on freedom's transcendence of facticity is far from the whole story. For in his notebooks, Sartre also calls it *mysticism* to think that freedom is indifferent to its situation, and he clearly recognizes that to take freedom simply as the negation and surpassing of the given is to substitute abstract freedom for true concrete freedom.[9] In fact, *Notebooks* most often emphasizes the immersion of human freedom in facticity and in the concrete situations which condition and limit it and even, at times, render it totally powerless. Generally, it maintains that although man surpasses facticity, he does not do so entirely; he surpasses while preserving it. He cannot totally detach himself, for example, from his body or his fragility or his political society. All transcending, Sartre usually admits, is "colored" by the given which it retains in itself.[10] This means, he says in a few places, that the concrete relation between human freedom and its situation is dialectical, for each is affected by and affects the other.

> The dialectic goes as follows: the original project illuminates the surroundings of the situation. But already the surroundings lay siege to and color the original project. What is more, the situation defines

itself insofar as it is surpassed by the project and the project has no signification except as the project of changing *this* disposition of the world. . . . therefore, it gets defined by the situation. Situation and project are inseparable, each is abstract without the other, and it is the totality, "project and situation," that defines the person. (*NE*, 463)[11]

To illustrate the dialectical relationship, Sartre discusses a person whose freedom is affected, "contaminated," by his contraction of tuberculosis.[12] This malady infects him, weakens him, changes him, such that it removes from him certain possibilities and certain horizons; for example, he cannot run in a marathon or engage in mountain climbing. Nevertheless, Sartre insists, although his freedom is limited, the tubercular still surpasses his situation for he is free to decide how to react to it and thus what meaning to give it.

It is true to say that these possibilities have been taken away from me, but it is also true to say that I renounce them or that I try to hold on to them or that I do not want to see that they are taken from me or that I undertake some systematic regimen to get them back again. (*NE*, 432)

In other words, the possibilities of marathon running and of mountain climbing are "replaced by a choice of possible attitudes toward the disappearance of these possibilities." The invalid will inevitably surpass, transcend, his condition toward some goal or other, and the goal he chooses will confer meaning on his illness. If he refuses to admit he is ill and tries to run or mountain climb, his tubercular condition will be an annoying, debilitating obstacle to such activities. If he seeks to become a tyrannical center of attention, his illness will be an asset. If he seriously attempts to recover, his condition will be a challenge provoking a rigorous course of conduct. The dialectical relation, then, means that, on the one hand, his illness removes possibilities from him and compels him to respond to it, but, on the other, that his freely chosen projects in their turn give significance and meaning to his condition. It is for this reason that Sartre repeats here what he said in *Being and Nothingness:* limits to my freedom appear only in relation to my free projects.[13]

Sartre concludes his example of the invalid with the general statement that I am

always transformed, undermined, flattened out, overthrown from the outside, yet always free, always obliged to take up things again, to take responsibility for what I am not responsible for. Totally determined and totally free. (*NE,* 433)

The last sentence is, no doubt, an exaggeration, but it has the merit of clearly admitting, contrary to some statements in *Being and Nothingness,* that I am *both* determined (i.e., limited in ways beyond my control) and free (for I always have many possibilities and can confer various meanings on my limitations). Speaking of the latter, Sartre even asserts that "an ill person possesses neither fewer nor more possibilities than a well one" (*NE,* 432), a statement which calls to mind the infamous declaration in *Being and Nothingness,* that "the slave in chains is as free as his master." Of course, such assertions vividly highlight the fact that many possibilities for choice are present even in extremely restrictive situations. But the above remark is also another illustration that in his *Notebooks* Sartre, at times, still tends to overstate the extent of human freedom. Nonetheless, to repeat myself, on the whole the *Notebooks for an Ethics* and the other works of the late forties offer a more complete and balanced position about the nature of human reality and the relation of consciousness to the body and of freedom to facticity than was set forth in the earlier ontology, which, as we saw, tended to ignore or severely minimize both the body and the force of circumstances.

Further evidence that Sartre is moving away from his earlier abstract conception of human reality and freedom toward a more concrete one is the fact that *Notebooks* contains a number of reflections on the human being's relation to history. In some of them he addresses what he takes to be the Marxist view and criticizes it for oversimplifying history and for being too deterministic.[14] For a plurality of histories made by many people and societies, Marxism substitutes the "myth" of one inevitably progressing history; for free individual human beings and their many projects, it substitutes the economic substructure of society and makes all other features of the social order determined by it and thus inessential. One of his early aphorisms summarizes his position: "Existentialism against History through the affirmation of the irreducible individuality of the person" (*NE,* 25). Still, in his discussions Sartre demonstrates his awareness that economic, political, scientific, and technological factors form the concrete milieu of situated human freedom. Though he repeatedly rejects a simple determinism, he admits that the

technological and economic components of society do prescribe limits outside of which free historical action, including technological and social change, is impossible. Certain political, economic, and technological structures must be present for certain actions and inventions to be at all possible. (He refers to the invention of the cannon, the steam engine, and the atom bomb but undertakes no detailed discussion of any of them.)

In *Notebooks* Sartre even undertakes a fairly concrete study of the nature of feudalism in the Middle Ages in order to illustrate how economic factors set limits to but do not determine human freedom.[15] He also devotes a few pages to discussing the nature of work in ancient times (slavery) and in the modern period (the industrial bourgeois), and states that the individual makes himself, and is made, through his work on the world. Different conditions of work, he says, promote but never determine different social and personal relationships among human beings.[16] He stresses the point that, if human beings are to relate to each other and to themselves as free individuals, the present socioeconomic structures in which they work, structures that steal the workers' products from them and reduce them to anonymous forces of production whose destiny is beyond their control, must be radically changed. Most other works of this period also stress the need to fundamentally change the structures of present society in order to advance human freedom.[17] Sartre's treatment of these topics is often part of a larger discussion of various kinds of oppression, a discussion which clearly demonstrates his appreciation of the power of concrete circumstances to condition, limit, and sometimes thoroughly restrict human freedom. I will reserve my analysis of his views of oppression for the next chapter.

As I draw this section to a close, I would like to suggest that a major reason for Sartre's greater recognition of the concrete is his increasing awareness that the freedom he has categorized as total and unlimited, the freedom which transcends and escapes from every situation, the freedom which confers meaning on all situations, is only an abstract freedom of consciousness or thought. Thus, "Cartesian Freedom" speaks of "autonomous thinking" which is independent of all external forces and is total and infinite no matter how limited one's power over circumstances may be.[18] Along the same line, "Consciousness of Self and Knowledge of Self" reiterates a major theme of Sartre's earlier works that consciousness is pure act lacking all passivity.[19]

The breakthrough comes when Sartre realizes that a free con-
sciousness is not the same as a concrete human being, and, in fact,
that a totally free spontaneous consciousness is not even present in
human beings. As far as I can tell, except for the essay "Conscious-
ness of Self and Knowledge of Self," none of the works of this
period, including the *Notebooks,* apply the term *spontaneity* to human
consciousness or freedom. Thus, Sartre is not forced to go through
the incredible machinations that he did in *Being and Nothingness* and
in his earlier psychological works to preserve human consciousness
and freedom from all passivity and from all causal influence. On the
contrary, as we have seen, *Notebooks* and other works often speak of
human choices and projects as limited and conditioned (colored) by
one's facticity and situation. "A worker is not *free* to think and feel
like a bourgeois," he writes.[20] He even, in a few places, allows for the
possibility of "mystification," namely, that oppressed people can be
so psychologically duped by their oppressors that they are hardly
aware of their freedom.[21]

Perhaps the text which most clearly demonstrates Sartre's recog-
nition that a free consciousness is not a free human being is found in
"Materialism and Revolution." There he explicitly rejects "a certain
inner freedom that man could retain in any situation."

> This inner freedom is a pure idealist hoax; care is taken never to
> present it as the necessary condition of the *act.* . . . If Epictetus, in
> chains, does not rebel, it is because he feels free, because he enjoys
> his freedom. On that basis, one state is as good as another, the
> slave's situation is as good as the master's; why should anyone want
> to change it? This freedom is fundamentally reducible to a more or
> less clear affirmation of the autonomy of thought. But in conferring
> independence upon thought, this affirmation separates it from the
> situation. . . . What remains for the slave are abstract thoughts and
> empty intentions, under the name of metaphysical freedom. (MR,
> 237)

A page later, he adds that to tell workers on the assembly line, who
perform meaningless tasks hundreds of times a day, "that they retain
within the action in which they are engaged, an inner freedom of
thought, would be childish or hateful."

Note the reference in the above passage to the slave in chains. It
is hard to believe it is purely accidental. I suspect it is chosen precisely
because it is so obviously at odds with the position stated in *Being
and Nothingness.* Indeed, a similar comment occurs in Sartre's

introduction to *Les Temps Modernes*: "freedom ought not to be envisaged as a metaphysical endowment of 'human nature.' Neither is it . . . some unspecified internal refuge that would remain to us even in chains."[22] "What Is Literature?" uses exactly the same language in criticizing oppressors who deceive themselves and the oppressed "by asserting that one can remain free in chains if one has a taste for the inner life" (WIL, 76–77). I submit that such passages give further evidence that, just a few years after the publication of *Being and Nothingness,* Sartre was well on his way to rejecting the abstract concept of freedom, the spontaneous transcendent consciousness which is totally free in every situation, that dominated his early ontology.

In the same vein, Sartre, in *Notebooks,* rejects what he calls abstract morality in favor of concrete.[23] Abstract morality correctly recognizes that human beings are free in every situation. This is true inasmuch as no human being is limited just to his or her facticity. The problem with abstract morality is that it considers humans to be freedom, and nothing else. It is purely formal and contentless, Sartre complains, precisely because it leaves out the individual's concrete facticity and circumstances. For abstract morality the slave is as free as his master, since both are free human beings, not things. But such equality means only that both are self-conscious consciousnesses which, as *Being and Nothingness* showed, are not self-identical beings-in-themselves but beings at a distance from themselves, beings which always transcend their facticity toward nonexistent goals. However, to focus on the fact that humans are not self-identical things, and on human transcendence of facticity, is to focus only on the negative side of freedom, Sartre now says. It totally ignores the radically different concrete conditions of the slave and the master and, therefore, the need to strive for positive goals which involve real social and political liberation and equality. Thus, abstract morality results in inertia and resignation, since it does not challenge the status quo nor seek to change it, no matter how repressive or subhuman it may be. Why should it if everyone is by nature free? What difference do concrete circumstances make?

A morality which is abstract, Sartre goes on, presupposes that moral salvation is possible in some absolute transcendental realm. Concrete morality, on the contrary, addresses human beings in their historical situation and proposes particular goals to them in order, ultimately, to establish the realm of concrete human freedom. In our

day, he says, a morality which is concrete must be a finite revolutionary politics which seeks to prepare the city of ends, which he identifies with true socialism and the classless society.[24] (These goals will be discussed in the next chapter.)

Sartre's rejection of abstract morality in *Notebooks,* which corresponds to his more concrete understanding of human reality and freedom, is certainly welcome, especially since, as I noted above, the abstract positions adopted in his early ontology could indeed lead to a morality of inertia and noninvolvement. However, it remains to be seen just how concrete his first morality really is.

Section 2. Freedom: The Primary Moral Value

This section will concentrate on the reasons Sartre gives for making freedom the supreme moral value of his first ethics. Intimately connected to the selection of freedom are the notions of pure reflection and authenticity, and I will begin with an analysis of them.

a. Pure Reflection and Authenticity

As we noted in Chapter 3, one of the problems that Sartre's early ontology posed for ethics was that it (the ontology) demonstrated that the fundamental project of all humans was to be God, *ens causa sui.* Yet, if we seek to attain this impossible goal/value, all our actions "are doomed to failure," and our existence is "a useless passion." On the other hand, we also pointed out that in his closing remarks to *Being and Nothingness,* Sartre briefly suggested that it might be possible for human beings to put an end to the reign of that value by choosing a different primary goal. Discussion of this possibility, which was said to involve a pure rather than accomplice reflection, was reserved for the ethics.

When we turn to the *Notebooks for an Ethics,* we do indeed find Sartre discussing pure (or nonaccomplice) reflection at some length, beginning in the earliest pages.[25] Reflection is not contemplation, he states; it is not a passive observation of the unreflected. Rather, all reflection is a project with a goal. The goal of pure or nonaccomplice reflection is best seen in contrast with that of impure or accomplice—which is far more common, even "natural," Sartre says. (Recall that in *The Transcendence of the Ego,* he likened impure reflection to the "natural attitude" discussed by Husserl.[26]) Accom-

plice reflection is so designated because it takes its origin in, and goes along with—in other words, is an accomplice of—the natural tendency and nonthematic project of prereflective consciousness which seeks to be God. Because reflection is inevitably posterior to, and so "is born in the unreflected," it naturally, Sartre says, tends to arise at first as an effort to achieve that impossible goal. Of course, accomplice reflection is doomed to the same failure as the nonthetic project from which it arises, and for this reason, as we know, "it amounts to the same thing whether one gets drunk alone or is a leader of nations." Yet this very failure, Sartre says clearly in *Notebooks,* coupled with a human being's prereflective consciousness of her freedom can motivate a person to undertake a nonaccomplice or pure reflection. This reflection, which, for the first time, he explicitly identifies with the conversion briefly mentioned in *Being and Nothingness,* "refuses to 'go along with' the God project." (*NE,* 559). Pure reflection "renounces being as *en-soi-pour-soi,* that is, as cause of itself," (*NE,* 479), and so is not an accomplice of our nonthetic project. The following passage, published in an appendix in *Notebooks,* clearly distinguishes the two reflections in terms of their projects:

> it is clear that accomplice reflection is just the prolongation of the bad faith found at the heart of the primitive nonthetic project [to be God], whereas pure reflection is a rupture with this projection and the constitution of a freedom that takes itself as its end. (*NE,* 559-60)

Earlier Sartre had explained that accomplice reflection was in bad faith because it refuses to face up to the failure, the impossibility, of becoming an *ens causa sui,* or God. Pure reflection, conversion, recognizes and accepts that failure, breaks with the God project, and replaces that vain goal with freedom. Note that this explanation is perfectly in accord with Sartre's brief suggestion at the close of *Being and Nothingness* and with his earlier distinction between values that are prereflectively sought and those reflectively chosen. Being God is a value humans naturally, prereflectively seek.[27] Accomplice or impure reflection chooses to accept this value and seeks to attain that impossible goal. Pure, nonaccomplice reflection chooses to reject it and seeks freedom instead.[28] (Though why freedom should be valued in place of God remains to be seen.)

As we saw in Chapter 1, the distinction between pure and impure reflection was introduced early by Sartre, in *The Transcendence of the*

Ego, and he indicated there that pure reflection was necessary for a realistic, positive ethics.[29] *Being and Nothingness* made little mention of this distinction, and, when it did, it stated that it was going to leave the discussion of pure reflection or conversion for ethics. In fact, Sartre stated explicitly in *Being and Nothingness* that he was dealing there only with descriptions on the level of impure, or accessory, reflection.[30] I might add that recognition of this is crucial for a proper interpretation of much of that ontology, for it means that it generally describes human reality, its relation to others and to the world, from the perspective of impure reflection (or sometimes simply on the prereflective level) but not from the perspective of pure reflection or conversion. Sartre affirms this when he asserts, on the fourth page of his *Notebooks,* "*Being and Nothingness* is an ontology before conversion"! For their part, the notebooks, from their first pages to the appendices, emphasize pure reflection.

So far we have presented the negative side of pure reflection, its rejection of the God project. What about its positive side, its choice of freedom? With pure reflection, Sartre says, I accept my diasporic mode of being. That is, I accept the fact that I am not a substantial, necessary thing, which has a right to be, but a contingent, gratuitous freedom, which continually questions itself about the purpose of its existence. I accept the fact that there are no transcendent a priori values and no inherent rights to confirm or justify my life.[31] Thus, in pure reflection

> the For-itself appears in its absolute unjustifiability and its relationship to the universe is altered. It has no right, even mystical, . . . it is superfluous in relation to the social world and to the world in general, the universe can get along without it. (*NE,* 481)

This choice of oneself as free, contingent, and unjustified is a radically different way of relating to oneself than the "natural" way of accomplice reflection, which pretends, in bad faith, that one can become a necessary self-justifying being. This "new way of being oneself and for oneself," Sartre says, is an "*authentic*" way, "which transcends the dialectic of sincerity and bad faith" (*NE,* 474). For him to refer to *authenticity* in these terms recalls his use of the word in *Being and Nothingness* in a footnote he added to his discussion of bad faith. There he stated that authenticity could "radically escape

bad faith" (*BN*, 70), without falling into the lie that he called sincerity.

Actually, the notion of authenticity was discussed at some length by Sartre in *Anti-Semite and Jew* a year or two before he wrote *Notebooks for an Ethics*. In that earlier work he defined it as "having a true and lucid consciousness of the situation, in assuming the responsibilities and risks which it involves." (*ASJ*, 90). Though later in that work he suggests a link between authenticity and a classless society, his definition there remains so formal that it is almost vacuous. It would seem to allow an individual to do or accept absolutely anything so long as she were clearly conscious of it and accepted personal responsibility for it.[32] Thus, if a mass murderer like Jeffrey Dahmer, for example, had a true and lucid consciousness of the situation, namely, that he has lured to his apartment, killed, and dismembered over a score of gay males, and has accepted personal responsibility for it, as he finally did by confessing to these crimes, he would fit *Anti-Semite and Jew*'s definition of authenticity! This point deserves emphasis, since Sartre's first ethics has sometimes been called an ethics of authenticity, as if authenticity were its goal and an end in itself. If that were true, the first ethics would be even more idealistic, that is, contentless, than it actually is. In *Anti-Semite and Jew* Sartre himself says that the choice of authenticity does not of itself involve sociopolitical changes and, in fact, is compatible with various political decisions.[33]

Fortunately, *Notebooks* is clearer than *Anti-Semite and Jew* about the basic nature of authenticity. It describes the authentic individual as one who by pure reflection has a true and lucid awareness of herself as she is: unsubstantial, unnecessary, unjustified, and free. Not only does the authentic person know this, she accepts and wills it, and takes responsibility for her existence.[34]

One might still ask, however, just what it means concretely for the authentic individual to choose herself or her unjustified freedom as her primary value and accept responsibility for this choice. One response Sartre gives repeatedly in the notebooks is that the authentic person grasps creation, sometimes referred to as generosity, as the fundamental ontological structure and destiny of her freedom.

The following text explicitly links authenticity, the choice of freedom, and creation:

Therefore, authentic man never loses sight of the absolute goals of the human condition. He is the pure choice of his absolute goals. These goals are: to save the world (in making there be being), to make freedom the foundation of the world, to take responsibility for creation and to make the origin of the world absolute through freedom taking hold of itself. (*NE*, 448)

As we know, for Sartre human freedom creates all the meaning and value in the universe. Thus, if the world is to have meaning (be "saved"), it will have it only through freedom. Yet it is not just that human freedom creates meaning in an already existing world; rather, as we saw in *Being and Nothingness,* and *Notebooks* repeats, human consciousness, as a free being which is nonbeing, carves up the self-identical undifferentiated density of being-in-itself into the ordered diversity of objects that we call the world.[35] It is not that human beings choose to be creators of the world, as if we could also choose not to be. Rather, we are creators in our "original ontological structure" as free consciousnesses that cause the phenomenal world to appear out of the full positivity of being.[36] Insofar as we are condemned to be free, we are condemned to create, Sartre states:

Thus authenticity will unveil to us that we are condemned to create and that at the same time . . . the very structure of freedom imposes this on us. (*NE*, 515).

The authentic individual, then, in pure reflection accepts and wills her creativity. She consents to the fact that her "task" and "destiny" (Sartre's terms) is to freely reveal "Being" by giving it structure and meaning as a world.

However, to speak of creation as the human being's *task* and *destiny* is strange. For who or what other than a human being can give her a task? Sartre's explanation is interesting, for he partly resorts to what he himself calls a "myth." (In *Being and Nothingness* it was called *metaphysics.*) Being-in-itself is radically contingent, that is, it simply is in-itself, for no reason or purpose, for nothing and no one. Since it does not proceed from a conscious intention, it has no foundation and no explanation or justification for its being. At this point Sartre introduces the myth. Borrowing from Hegel and foreshadowing the later Heidegger, he observes that it is as if the in-itself produces being-for-itself in order to found and justify itself by giving itself a *sens* and *raison d'être*. It is as if Being-in-itself "calls" human consciousness to save it by revealing it, structuring it into a

world, and conferring value and meaning on it. Now in order to be authentic, Sartre says, man should respond to this call by "accepting losing himself in order to save Being." The authentic individual, he explains, delights in losing himself as being (i.e., in ceasing his attempts to be a substantial self-identical thing) in order to find himself as the free consciousness by which Being is saved from meaninglessness. For him, "there is no other reason for being than this giving," and he takes joy in willing his creative generosity.[37]

These remarks of Sartre's sound so similar to what he says about artistic creation in "What Is Literature?" that it might be helpful to briefly look at that work, written at the same time as *Notebooks*. In "What Is Literature?" Sartre states that the final goal of artistic creation is to "recover this world by giving it to be seen as it is, but as if it had its source in human freedom" (WIL, 63). Of course, the work of art does arise from the artist's freedom, as well as from that of the spectator who chooses to be conscious of it. Furthermore, unlike the things of nature which have no finality nor any reason for being, all the elements of the work created by the artist are put there for a reason. They have a purpose. This finality makes the work of art appear as a value and task, Sartre says, that is, it appeals to the spectator as something to be brought into being, to be created. Now, inasmuch as I am the creator of a world shot through with purpose and value, I am and feel essential to it. This feeling is the cause of the emotion of aesthetic joy, an emotion which also includes feelings of security and sovereign calm, because I see my existence, not as an unjustified contingency, but as the necessary foundation and essential cause of a meaningful (imaginary) universe.[38] Apparently the contrast between the meaningful, but imaginary, world of artistic creation and the meaningless real world leads me to also take the latter as my "task." For through the experience of aesthetic joy, Sartre says, the factual givenness of the world is transformed into an imperative and value, so that I feel that "the essential and freely accepted function of my freedom is to make that unique and absolute object which is the universe come into being" (WIL, 65). If I could create the real universe and infuse it with purpose and value, I would, of course, be essential to it and so would experience the same security and joy in my relation to it that one does in the creation of the imaginary realm.

The similarities between Sartre's view of artistic creation and the creation of the world in *Notebooks,* even in the very language used,

are, I trust, evident. Just as the artist and spectator freely create an imaginary realm with meaning and purpose, so every human freely creates the phenomenal universe with its structure and values. Just as the goal of artistic creation in "What Is Literature?" is the recovery of the universe by seeing it as issuing from freedom, so the authentic individual in *Notebooks* wills her freedom to be the foundation of the world. Just as the artist feels essential to the world she creates, so the authentic person, by willing her creation of a meaningful world, ceases to be a totally unjustified contingent existent living in a pointless universe. With joy she sees her existence as having a task or purpose, for it is the foundation of, and thus essential to, that meaning-filled world.

Of course, even the authentic human being remains at bottom contingent, unnecessary, and nonessential, as does, therefore, the phenomenal world she creates. Furthermore, while her freedom is the generous source of that world and its meaning, it is not the creator of its very being, which is irreducibly in-itself and contingent. All this is simply to say that the kind of meaning one can confer on her world, by willing her freedom as its foundation, is human, not divine. No human can cause herself or her world to be necessary. No human can create a meaning and justification for the world that would make it exist by right rather than by chance. In a word no human can be God. However, this should pose no insurmountable problem, for after all human beings are the only source of meaning in Sartre's universe, and a thoroughly human meaning can be given to one's creations. The authentic person recognizes and wills to do precisely this.

One result of doing so, as we've said, is that her existence now has a purpose, a *raison d'être*. It is not a "useless passion" or "doomed to failure." In fact, Sartre says, strictly speaking human life is in itself neither meaningful nor meaningless, neither justified nor unjustified.[39] It simply is with no a priori sense or value. But this means, "it is yours to give sense (*sens*) to and the value of it is nothing else but the sense you choose" (*EH*, 54). The authentic person gives her life meaning (*sens*) and value by accepting and affirming herself as the free creator of a meaningful world.

While it makes eminent practical sense to reject the unattainable God as one's goal and to value instead attainable ends such as freedom and creation, one could still ask why, morally speaking, these particular ends should be valued instead of others. Why not, for

example, choose pleasure or power as one's primary values, for they too are attainable goals? Surely, lives centered on the acquisition of pleasure or the accumulation of power are also meaningful, purposeful ones. Sartre himself may prefer human freedom and creativity, but since neither they nor anything else possess objective or intrinsic value in his ontology, since their value comes solely from an individual person's free choice, anyone else can freely choose differently. By denying all objective values, critics argue, Sartre has no basis for claiming that his moral goals should be preferred to any others.[40]

b. Reasons for Making Freedom the Primary Moral Value

Actually, Sartre refers to the primary goal of his ethics in various ways in the *Notebooks*, although all are intimately connected to freedom and many seem practically equivalent to it. Thus, while he refers to the final goal of humanity as the freedom of all and of men's ultimate end as "founding a reign of concrete freedom," "the human realm,"[41] he also calls this realm and goal a city of ends, where each treats the other as an end and all live in intersubjective unity.[42] This city is identified with a socialist, classless society which in turn is designated as the place where "freedom is valued as such and willed as such" (*NE*, 418).[43] One passage puts all this in perspective. There Sartre says that the goal of human reality is not love or respect or happiness, nor is it a classless society or city of ends, as if these would be achieved once and for all and bring history to a close. Rather, "the person *is* his goal in the form of an ecstasis [i.e., freedom] and a gift" (*NE*, 169).

To speak of a person as a gift refers, of course, to her as the creator of the world, and, as we have seen, *Notebooks* does refer to creation as the absolute end of human existence. Now while it is precisely because a human being is free that she is creator of the world, nevertheless, to make one's goal the structuring of Being into a meaningful world is not identically the same as making human freedom one's goal. The latter takes *human* reality as its goal; the former takes *Being's* appearance and justification as primary. (Recall that Sartre advanced the myth that Being-in-itself produced being-for-itself and gave it the task and destiny to justify and save it.)

Fortunately, both *Notebooks* and other works of this period generally make it clear enough that freedom is the primary goal of Sartre's first morality. In a couple of places in *Notebooks*, for example,

he offers a hierarchy of values and places generosity at the top. Yet he states that the basis of his ranking is the degree of freedom that appears in each value, and he asserts that all the values listed have "to lead to" (*NE*, 9) or "converge on" (*NE*, 470) freedom. Also, we cited above (page 53) a passage where he explicitly states that pure reflection rejects God and takes freedom itself for its end. *Existentialism and Humanism* states that morally speaking men should have as their ultimate goal "the quest of freedom itself as such (*EH*, 51). "What Is Literature?" identifies the city of ends with "the reign of human freedom" (WIL, 108) and states that the end of socialism "is to put the human person in possession of his freedom" (WIL, 192). "Materialism and Revolution" says the same.[44] There are also a number of places in *Notebooks* where Sartre indicates that the reason human beings create a world and thereby confer meaning and justification on Being is, ultimately, to attain meaning and justification for their own existence.[45] Since human reality is fundamentally a being in the world ontologically grounded in Being, in the final analysis it can have meaning only if the world and Being have meaning. In accord with this, the most straightforward ontological interpretation of Sartre's myth is that it is human reality itself that wants its world and Being to have a foundation and justification. For if they have none, neither will it. In other words, it is not Being but human being that gives itself the task and destiny to create the world and thereby save Being, for doing so is essential to its own self-justification. Thus, in *Notebooks* the creation of the world and the justification of Being seem to be a means to the end which is human reality and its justification.

Still, the question remains. Since there are many features of human life that one might value in order to give meaning and justification to human existence, why select freedom in place of God as the primary moral value? Why not make pleasure or power primary? The most straightforward and easy answer is that at this stage of his development, as we have seen, Sartre often identifies human reality with freedom. In the grand tradition of humanism, then, it makes perfect sense to propose freedom as man's highest moral value and goal, for this is simply to propose human existence itself as man's highest moral value and goal. *Notebooks*, however, offers a rather more sophisticated argument, a cryptic version of which appears in *Existentialism and Humanism*. To understand it, we need to investigate more thoroughly Sartre's notion of justifica-

tion which we introduced in the discussion of the authentic person and creativity.

Strictly speaking, to justify something, he explains, is to give it a conscious intentional foundation so that its reality is not a gratuitous, meaningless fact but possesses an *absolute* meaning and purpose (*sens*).[46] Of course, in Sartre's world it is human being alone, or more precisely human freedoms, which are the ultimate foundation and source of all the value and *sens* that any beings, including their own, possess. Now for the meaning of anything to be absolute, Sartre says, its source and foundation must itself possess absolute value. How significant would a meaning be which came from, and thus rested on, a worthless, totally gratuitous foundation? But, Sartre insists, human beings in their freedom are, in a sense, absolute, not as gods, but insofar as their freedom is the *irreducible* (i.e., not relative to anything else) and only source of meaning and value.[47] If I reflectively affirm my freedom, then I confer on it an absolute meaning and value and thereby justify it; "it is me, which nothing justifies, who justifies myself inwardly" (*NE*, 482). Insofar as my justified freedom is in turn the absolute source of the meaning and value of both my own and others' beings, our reality is also justified. Thus, Sartre writes, "since the human world is a world of absolute consciousnesses assuming themselves in their absoluteness [that is, freely willing their freedom], man's creations are absolute" (*NE*, 528). "So the rock or the sea is *from this point of view* for an Absolute; its being is justified by the single fact that I justify my own" (*NE*, 485).[48] Even stronger, by choosing my freedom and justifying my own existence I become, Sartre says (in a weak sense), God as *causa sui*, for I will myself to be the absolute cause and foundation of the meaning of my being as well as the cause of the world's meaning.[49] (I call this a "weak" sense, since we cannot cause our own or the world's being, nor cause them to be necessary beings existing by right rather than contingently.)

To put it succinctly, Sartre argues that, since human freedom alone can supply an absolute foundation and thus a full-fledged justification for its own and everything else's being, the logical thing for humans to do is to choose to accept their freedom and to confer value and meaning on it. As he states in *Existentialism and Humanism*, since human freedom is in fact the only (thus the absolute) source of all meaning and value, "strict consistency" requires that it be chosen as the primary value.[50] Freedom should be

valued above everything else, for only then will it, and its creations—both of one's own life and of one's world—possess an absolute meaning and purpose, and thus be justified.

There has been a great deal of recent debate about the validity of this argument, most of it centering around the fact that it is persuasive only if one first values logical consistency and/or consistency with reality.[51] Since freedom is the source of all values for Sartre, it would not be rational or consistent with the nature of things to value some goal and not first and foremost value the freedom through which that goal becomes a value. Likewise, inasmuch as the early Sartre often simply identifies man with freedom, it is certainly consistent for him to propose freedom as a human being's highest moral value. But, of course, in Sartre's ontology, one may freely choose to value irrationality and inconsistency, for neither they nor their opposites possess any intrinsic or objective value. Is Sartre, in spite of himself, presupposing that logical consistency and consistency with reality have objective value? Some critics have made this charge. I believe, rather, that Sartre fully recognizes that consistency has value ultimately only because one freely gives it value. He states in *Being and Nothingness,* for example, that the choice to be rational is itself "beyond all reasons" (*BN,* 479) and "prior to all logic" (*BN,* 570), because it is precisely by that choice that one confers value on logic and rational argumentation. Indeed, it is impossible to accept reasons in support of valuing logical consistency or rationality without, in effect, begging the question! Reasons will have value, and so be persuasive, only to one who has already freely chosen to value rationality.

In opposition to my view, Linda Bell has claimed that Sartre's argument for freedom rests on the fact that in order to freely value anything one must value freedom: "the choice of anything whatsoever as a value logically entails the choice of freedom as a value." This is true, she asserts, because "one who wills the end wills the means" and because in Sartre's world freedom "stands in a unique position of means to every other value."[52]

However, what exactly does it mean to say "one who wills the end wills the means"? It is not clear if Bell is claiming that one cannot *in fact* will an end without also willing the means to it; in other words that willing the end must *actually* "entail" willing the means. Surely I can will a goal, e.g., a healthy body, and yet not will the means to it, e.g., daily exercise or a low cholesterol diet. People do this all the

time. It may be illogical or stupid to will ends without willing the means to them, but we can in fact do so. To say, then, "one who wills the end wills the means" must mean that it is irrational, logically inconsistent, to will an end and not also will the means. As Bell says, correctly, one "logically [though not factually] entails" the other. He who wills the end (a justified existence) should, to be reasonable, will the means to it (freedom). I agree; however, I must repeat that for Sartre human beings have no absolute obligation to be reasonable or logically consistent, for being or doing so has no objective value. To claim, as Bell does, that "willing the means is at least part of what is meant by willing the ends. Whatever is going on, one who allegedly wills the end without at the same time willing the means is not truly willing the end,"[53] seems to me to be false. As I said above, one can "truly" will an end (health) and inconsistently not will the means (exercise). Besides, "truth" can have no more objective value for Sartre than does consistency.[54]

A somewhat similar argument is proposed by Thomas Flynn.[55] He admits that Sartre's own defense of the need for rational consistency is "weak," and suggests that Sartre should have referred to "existential" rather than "logical" consistency. Thus, Flynn says, for a person to freely choose "unfreedom" is not logically inconsistent but "a futile and empty gesture; in fact a nonact." To freely choose unfreedom is "impossible in practice;" it is like choosing not to choose. I believe Flynn is on to something. I would agree that it is existentially, or practically, inconsistent to freely choose unfreedom (though it is too strong to claim it is "impossible in practice," for it seems clear that some people do freely choose unfreedom, for example, freely choose to enslave themselves to drugs). However, the notion of existential inconsistency does not address the main conclusion Sartre wishes to defend, namely, that freedom should be the *primary* value one chooses in place of God. To be sure, it is existentially inconsistent to freely choose unfreedom; but it is not existentially inconsistent to freely choose power or pleasure or God (rather than freedom) as one's *supreme* value, so long as one still awards some lesser value to freedom. In other words, I do not think that Sartre can appeal to existential consistency in order to demonstrate that freedom should be one's primary value. Instead, he seems (correctly, in my opinion) to suggest that it would be logically inconsistent, and inconsistent with reality, especially human reality, to desire a meaningful existence and not first and foremost value the

human freedom that alone is the source of all meaning and value. I do think that Sartre's argument is sound but, to repeat, only if human beings first value rationality and consistency with the way things are. And Sartre concedes that to do so is ultimately a free nonrational choice.

A more serious objection, one Sartre himself raised later, is that it is not altogether clear just what it means *concretely* to choose freedom as one's primary moral value. Some critics have objected that since Sartre holds that all humans are free by nature (i.e., structurally) as well as in their choices, it makes no sense to advise them to make freedom their moral goal. Others allege that so long as an individual accepts and values his or her freedom, he or she can do anything and still be authentic. They claim that Sartre is in effect advocating total capriciousness and license.[56] Sartre's remarks about the authentic person choosing creativity as his or her goal are also not of much help. Although he does say that the authentic individual wills to create the maximum amount of Being, and that this will occur more through concrete action than through contemplation or escape into the imaginary, Sartre admits that *all* human actions and attitudes are creative since they all cause the appearance of some kind of meaningful world.[57] One may create a world of brutality and ugliness, another a world of justice and beauty, but both creations are equally infused with meaning. Thus, for the *Notebooks* to speak of authenticity as involving the choice of creativity, that is, as choosing to will freedom as the foundation of the world, offers little or no guidance about the kind of world that should be created. Only by investigating the social character of Sartre's first morality can we supply some content to its goal of freedom. For the *Notebooks for an Ethics* is clear that the authentic individual values not just her own freedom but that of other human beings as well.

5

The Social Dimension of Sartre's First Ethics

Section 1. Authentic Human Relations

In Chapter 3 I argued that the conflictual human relations Sartre described so vividly in *Being and Nothingness* were relations among individuals who were attempting to be God, *ens causa sui*, and who, therefore, reacted negatively to other free consciousnesses because the other consciousnesses inevitably conferred on them an object status they could not control. I also pointed to the footnote Sartre added at the end of one of his discussions which suggested that the negative character of the human relationships described there could be significantly altered if people underwent a radical conversion and ceased their vain attempts to be God. When we turn to the *Notebooks for an Ethics*, we find Sartre clearly stating that in *Being and Nothingness* he was not attempting to set forth the essential nature or necessary structure of all human relations but only of those among unconverted individuals, inauthentic persons, who have not undertaken a pure reflection. Very early in his notebooks Sartre writes, "the struggle of consciousness only makes sense before conversion." After conversion "there is no ontological reason to stay on the level of struggle"(*NE*, 20). Likewise, he asserts that conversion means "ethics without oppression," and, explicitly referring to *Being and Nothingness*, he states that conversion can transform the "hell" of human passions described there.[1]

Conversion removes attempts at domination and conflict, because the converted individual renounces attempts to be in total control of her own being like a *causa sui*. The fact that others objectify her and thus give her a dimension of being, her being-object, that she cannot control does not "trouble" her, Sartre says. By conversion, pure reflection, I not only accept my freedom, "I accept my being-an-

object" as an inevitable part of my human condition.[2] As a result, my objectivity need not be a cause of alienation and conflict. "It only becomes so," Sartre writes, "if the Other refuses to see a freedom in me too. But if, on the contrary, he makes me exist as an existing freedom, as well as a *Being/object* . . . he enriches the world and me" (*NE*, 500). In other words, if both the Other and I undergo conversion, reject the God-project, and choose our mutual freedoms as our goal, our objectification of each other is not oppressive nor a source of conflict but a positive enhancement of our existence. We can cooperatively work together, adopting each other's free projects, in intersubjective relationships which constitute the city of ends or reign of freedom, which, as we mentioned in the previous chapter, is one way Sartre refers to the ultimate goal of his morality. Ideally this city involves the total elimination of conflict by a "conversion of everyone," "an absolute conversion to intersubjectivity." Although he does not describe this goal in any detail, and in fact says we cannot do so from our present alienated and oppressed situation, he labels it *socialism* and says that it includes "suppression of classes and of the State," "emancipation of the proletariat," and "radical economic transformation," so as to give control to the workers. This "era of freedom" will only be achieved by removing present oppressive structures, especially the capitalist class system where an elite few dominate the entire socioeconomic realm.[3] Clearly, then, for Sartre the converted individual, the authentic person, is a humanistic socialist who promotes the coming of the democratic classless society.

Sartre also speaks of the generosity involved in authentically willing the freedom of others. Just as the authentic individual is generous toward Being, inasmuch as he creates a world of meaning in it, so the authentic person is generous toward other human beings. Once again Sartre advocates that we reconcile ourselves with our destiny, for all of our actions and all of the objects we create, including the object we ourselves are for others, are inevitably given to others to freely respond to. Of course this means that I ultimately cannot control how others use, ignore, or abuse my creations, nor do I have mastery over the meaning they give them or me. But since the authentic person has undertaken a pure reflection and undergone conversion and so no longer attempts to become an impossible self-cause, he is able to accept the fact that others "steal" his actions, objects, and his very objectivity from him. He can accept being at risk

before the freedom of others as an inevitable part of being in a social world. Even more, the authentic individual considers his creations and his very self to be gifts offered to the other, Sartre says. They are created precisely so that the other can take and use them as he chooses. In this way generosity is also a positive decision to create and be for the other. Moreover, generosity does not attempt to force the other to use my creations in prescribed ways, it offers them as gifts and appeals to his very freedom.[4]

There is still more. The authentic individual's generosity also involves the decision to assist others in accomplishing their freely chosen projects. Since the other's goals are necessarily linked to his facticity and situation, this means that the authentic individual values not just the future goals of the other but also his present facticity located in a particular situation.

> Precisely to the extent that I have, in attaining myself through conversion, refused the abstract in order to will the concrete . . . I value it [the facticity of the other, his body] in that it makes [his] project a concrete and particular existence, much richer than a simple abstract dogma. This project that the authentic man of action pursues is never "the goal of humanity" but rather in such and such particular circumstances with such and such means, at such and such historical conjuncture, the liberation or the development of such and such concrete group. (*NE*, 507)

Politically speaking, the concrete project of the "authentic man of action" is to promote the city of ends, the coming of true socialism in the classless society. To will the other in this way, as freedom concretely immersed in facticity, is designated as "authentic love" by Sartre.

> Here is an original structure of authentic love . . . to unveil the Other's being-within-the-world, to assume this unveiling and to set this Being within the absolute; to *rejoice* in it without appropriating it; to shelter it in my freedom and to surpass it only in the direction of the Other's ends. (*NE*, 508)

Needless to say, relationships of authentic love are radically different from those subject/object relations described in *Being and Nothingness*, and that should raise a number of questions. An obvious one is, why should I will the concrete freedom of anyone other than myself? Why should I authentically love and value any freedom other than my own, since the other's has no more intrinsic or objective value than

does mine? Since all values are creations of human freedom according to Sartre, if I freely choose to will only my own freedom, it will thereby possess a value that no one else's has. No doubt Sartre would label my choice inauthentic, but, then, authenticity itself has value for me only if I choose it to. The question remains, even if rephrased, why should I choose to be authentic and generously love others and seek the city of ends? Furthermore, even if I wanted to engage in them, how are authentic love or generosity possible given the basic epistemological positions of Sartre's early ontology, particularly his view that nonalienating direct subject to subject relations are impossible?

Section 2. Reasons for Willing the Freedom of Others

Neither the *Notebooks for an Ethics* nor any other work of the period offers full-fledged arguments to prove that one should value others' freedoms along with his or her own. One suggestion Sartre does make in his notebooks and in *Anti-Semite and Jew* rests on the inherent equality of all human beings, as he sees it.[5] Since no freedom possesses any intrinsic value which would make it ontologically superior over another, Sartre implies that consistency demands that all freedoms be valued equally. If I were to prefer my own freedom to that of others, he says, that would indicate that I consider mine to be unconditionally superior to theirs. While there is some plausibility to this reasoning, I believe that ultimately it is incorrect. By preferring my freedom to that of others, I need not imply that it possesses some objective value that theirs lacks. I may simply recognize that my freedom is the ultimate source of all my values and also that, if I freely select it over others, the result will be that my very choice will give it a value that others will not have. Furthermore, to choose to value one thing that possesses no intrinsic value over other things that also lack intrinsic value does not involve any inconsistency, as far as I can see.

A much stronger argument can be made for Sartre by combining statements he makes in the *Notebooks for an Ethics* with some in *Existentialism and Humanism*. In this latter work Sartre asserts that "I am obliged to will the freedom of others at the same time as mine" (*EH*, 52) and offers in support something like an appeal to

universalization. He states first that when a person chooses the self he strives to become, "he chooses all men." This is because "In effect there is not one of our acts that in creating the man whom we wish to be, does not create at the same time an image of man such as we judge he ought to be" (*EH*, 29). Although these suggestions have some resemblance to a Kantian notion of universalizability, note that Sartre's key word is *image*, not *rule* or *principle*. He does not say that when I choose, I implicitly propose a rule which all persons in morally similar situations are to follow. Rather he says that when I choose an ideal for myself, "I am creating a certain image of man" (*EH*, 30), an ideal of what *man* ought to *be*. I would argue that Sartre's assertion here is too broad, for I do not believe that it is true that every time I choose something as good or valuable for *me* (or what I ought to be), I in effect choose it as good or valuable for *everyone* (or that it is what *man* ought to be).[6] In my moral experience the most morally relevant features of my concrete situation are sometimes my *unique* individuality or my situation's *unique* characteristics. In such experiences the moral value or obligation pertains to me not insofar as I am similar to other human beings, but only insomuch as I am a unique individual—and it would be question-begging in the extreme to claim that such experiences are not *moral* in character. I submit that it is only if the good or value I choose for myself is rooted in what I believe to be good or valuable for me insofar as I am a human being that it can be claimed that when I choose, I (at least implicitly) create an image (ideal) of what *man* should be.

Be that as it may, I will concede that Sartre is correct when he claims in *Existentialism and Humanism* that when I choose my freedom as my primary value I, in effect, propose that each person's freedom should be his or her primary value. For, as we saw in Chapter 4, the reason Sartre says I should choose my freedom is because it is the source of all my values. And this reason, this fact, is indeed part of the universal human condition according to Sartre; each and every person's freedom is the source of all of his or her values. Freedom is a good for me, then, precisely in that respect in which I am the same as all other human beings, and so in choosing my freedom I do in effect propose an image of what other human beings should be—namely, they should be individuals who choose their respective freedoms as their primary value. Still, how does it follow from this that I, or anyone else, am obliged to choose as

valuable anyone's freedom other than my own; that "I am obliged to will the freedom of others at the same time as mine"? This conclusion can result only if there is a necessary connection between my proposing that each person's freedom should be *his* or *her* supreme value, and my choosing his or her freedom as a value for *me*.

The best argument that I have found in support of such a connection is given by Linda Bell. Invoking Sartre's inextricable linking of choosing and acting, she reasons that if I will that others choose their freedom as a value, this must mean I will that they act in accordance with their choice. But "if I will that others act in accordance with their choice of freedom as a value, I must at least will that they have the freedom thus to act. Must I not then will that they not be oppressed?" Moreover, she adds, since "to value is to act," this means that I myself must act against oppression of them.[7]

This is a strong argument and may well be what Sartre has in mind but does not explicitly say. It surely does seem that if I will that others value their freedom (that is, if I propose as a value that others value their freedom), it would be inconsistent for me to oppress or otherwise interfere to prevent them from acting according to their choice. It would also seem to be inconsistent for me to will that others value their freedom and yet not act against third parties who seek to interfere with others' exercises of their choice of their freedom.

However, to say that I should not myself interfere, or allow third parties to interfere, with others is one thing. It is much stronger to claim, as Sartre appears to do, that I must positively act to increase or enhance my own and others' freedoms and achieve the city of ends. Part of the difficulty is that it is not altogether clear just what it means to say that one should act "in accordance with" the choice to value freedom or even what precisely it means to choose to value freedom. Let me explain.

To choose to value something and to act accordingly can mean, on the one hand, to strive to realize in one's life and in society the ideals in question. In this sense to value something like justice or peace would involve acting to make them real. On the other hand, to choose to value something or someone may simply mean to acknowledge or appraise that object or person as having worth. Obviously, when an object or person already exists, to value it and act accordingly cannot mean to strive to make it real. (To value Mother Theresa, or my present state of pleasure, or the status quo, cannot

mean to act to make them real, for they already are.) Furthermore, I can choose to value things that can in no way be made real, such as a dog I owned when I was seven years old. My point is this: to choose to value something does not necessarily entail choosing or acting to increase or promote its reality; it may simply mean to affirm or acknowledge the worth or importance of its reality (present or past).

Thus, to follow Sartre and to will or choose to value freedom (one's own or others') can simply mean to willingly acknowledge and accept as worthwhile the fact that oneself and others are structurally free and able to make free choices; this would be to admit that oneself and others are beings-for-themselves, not things totally determined by processes and forces. Action in accord with this choice would be, I suppose, to admit to oneself and others one's responsibility for one's choices and actions and not to evade this by offering excuses. Note that the freedoms in question here are our ontological freedom and freedom of choice, both of which are part and parcel of our fundamental human structure. Obviously, to value our structural freedom as a being-for-itself cannot entail acting to make it real, for it already is. Likewise, to value our freedom of choice in this sense would not mean to strive to increase it but to declare it to have worth and importance for us (and not to deny or flee it in bad faith). On the other hand, to will or choose to value freedom (mine or others') may mean to will, and hence to act, to make freedom real or more real, where the freedom in question could be political or psychological freedom. Again, the point is that even if one grants, as I do, Sartre's claim that in willing or choosing to value my freedom I, in effect, will that others choose to value theirs, this does not in itself oblige me to do any more than to affirm as worthwhile the fact that both I and others are ontologically free and can make free choices. (And, of course, in every situation human beings are ontologically free and possess some freedom of choice.) Only if we arbitrarily identify choosing to value something with choosing to make that something real (or more real), can we claim that "willing freedom" entails acting in the situation to *increase* or *expand* that freedom. (In fact, I think Sartre does tend to make such an identification and I will discuss this later.)

If my analysis here is correct, it means that this first suggested argument of Sartre's (as expounded by Bell) adequately demonstrates that one who wills her freedom, and thus that of others,

should not interfere with or oppress the freedom of others or allow third parties to do so. It does not prove, however, that such a one must positively strive to increase or enhance these freedoms. But we need not stop here, for Sartre has more to offer in support of his position.

The second reason offered by the early Sartre as to why one should will the freedom of others seems to have been overlooked by many. As the following passage states, it has to do with the interdependency of human freedoms.

> In willing freedom, we discover that it depends entirely upon the freedom of others and that the freedom of others depends on our own. Obviously, freedom as the definition of man does not depend upon others, but as soon as there is engagement I am obliged to will the freedom of others at the same time as mine. (*EH*, 51–52)

The interdependency of human freedoms that Sartre has in mind here is both sociopolitical and psychological, for in an earlier passage in that same work he writes, "The other is indispensable to my existence, and equally so to any knowledge I can have of myself" (*EH*, 45). Accordingly, I will investigate both kinds of dependency in order to determine how they enable him to conclude, "I am obliged to will the freedom of others at the same time as mine."

As we have seen, for the most part the works of this period show Sartre's recognition that in the practical social order my freedom is dependent on that of others and theirs on mine. Both the range of options available to our free choice and our freedom to attain the goals we choose are heavily dependent on the will and actions of others. However, the fact of such dependence does not in and of itself oblige any of us to cooperate with or to will the Other's freedom. For in some situations—for example, if one is powerful enough—it could well be that he or she can most effectively increase his or her freedom by restricting the freedom of others and forcing them into his or her service. To do so would not in any way deny interdependency; quite the contrary, it readily acknowledges it. It is only if we join Sartre's earlier argument to this notion of dependency that we can obtain the conclusion he draws. We saw above that, for Sartre, when I choose my freedom as my primary value, I, in effect, also choose that others choose their freedom as primary, and it would be inconsistent with this choice for me to oppress or restrict the acts of the other that are in accord with the other's choice of freedom,

or to allow third parties to do so. If this is so, then a "discovery" of my dependency on others, that is, of my need for them to will my freedom, can only lead me to will rather than restrict theirs. However, as we have just discussed at length, "willing" another's freedom does not necessarily mean that I must actually act to increase and expand that freedom. All it need mean is that I must acknowledge it in the sense that I affirm it to be of value and so do not interfere with it or allow anyone else to.

On the other hand, if the reason for my willing the other's freedom is that I need him or her to will mine, we could ask, what kind of willing of my freedom am I myself dependent upon in the practical order? Without a doubt, I need and want others to acknowledge that my freedom is of value and so not to interfere, or let third parties interfere, with it. Yet this is hardly enough, for I am radically dependent on others if I am to achieve most of the goals that I freely choose, that is, I need their positive assistance, not their benign neglect. How many of the goods of life can I alone supply for myself? Now if it is the positive assistance of others that my dependency calls for, then for me to will their freedom minimally by merely affirming it to be of value, while neglecting to assist it, will hardly prompt them to actively promote mine. It is far more likely that I will gain their aid if I on my part actively engage myself in aiding them. Thus, I believe that the dependency Sartre cites does lead to his conclusion that I should will, in the sense of actively promote, the freedom of others so that they will do the same for me. An investigation of psychological dependency also supports this conclusion.

In *Existentialism and Humanism* Sartre asserts, "I cannot attain any truth whatsoever about myself except through the mediation of another" (*EH*, 45), a statement which is perplexing since it is so sharply at odds with the position Sartre usually adopted in his earlier works. There, as we have seen, he claimed that I am always lucidly aware, prereflectively, of myself and my freedom, and it is bad faith to pretend otherwise. He also stated that others could neither aid nor diminish that self-awareness, although toward the end of *Being and Nothingness*, he modified this by admitting that the existential psychoanalyst, at least, can assist one in attaining greater self-awareness and self-knowledge. *Notebooks for an Ethics* often repeats the standard position of the early ontology.[8] Yet there are some passages in it, and in other works of this period, where Sartre admits

that individuals can be "mystified" by those who oppress and lie to them so that they are either not aware that they are free or think they are free when they are not. Such individuals need to "wake up," Sartre says, although that may be extremely difficult if they are in situations which render them powerless.[9] He also speaks of children normally not recognizing that they are free sources of value but instead considering themselves dependent on others (adults) for their values and tasks.[10] Now if others can severely limit or even deprive me of the awareness of my freedom, could it not also be the case that others can assist me in attaining that self-awareness? As far as I can see, Sartre never explicitly says so in the *Notebooks* or in any other work of that time. To be sure, his work on Genet does illustrate someone who did not recognize his freedom to be other than a thief precisely because his society branded him a thief at an early age and treated him accordingly. It describes the developmental process through which an individual only gradually comes to a self-awareness of his or her freedom and it implies that in a more loving, affirming society a person (like Genet) would become conscious of his or her personal freedom even as a child. However, *Saint Genet* is published four or five years after *Notebooks*, and it would be forcing things, I think, to read its insights back into the earlier ethics. The most one can say about *Notebooks* is that in spite of frequently repeating the position of the early ontology, that each consciousness or human being is always prereflectively aware of its freedom, there are indications in it and even more in *Existentialism and Humanism* that Sartre is increasingly coming to recognize that a person's awareness of his or her freedom is to some degree dependent on others.

I suspect that Sartre's reference to one's psychological dependency on others in *Existentialism and Humanism* is of a piece with his claim in "Materialism and Revolution" that one's "freedom can be asserted only by the recognition bestowed upon it by other freedoms" (MR, 255). Unfortunately, he does little to clarify the precise meaning of the term *recognition*. Just as "willing" or "valuing" freedom can have various meanings, so "recognizing" someone as free admits of a variety of meanings. To recognize someone as a free subject can minimally mean to (1) understand, or be aware, that they are not a thing but a nondetermined human being who continually projects itself beyond what is toward not yet existing possibilities and goals, and (2) understand, or be aware, that their acts are freely chosen, that is, not the necessary result of

psychological and environmental forces. Now it seems to me that even a slave can recognize me, the master, as a free subject in both of the above senses. The slave can be aware that the master is a free human being who transcends what is toward not yet existing possibilities, and the slave can also understand that the master's very acts of enslaving (not to mention his other acts) are the result of his free choice and not merely the products of social, economic, and other conditions over which he, the master, has no control. Indeed, it is precisely the slave's recognition that the master *freely* chooses to enslave him that makes slavery the especially heinous oppression that it is. Obviously the term *recognition* is used here in a sense roughly equivalent to "to understand, to be aware of, to acknowledge or identify." The slave can understand, be aware of, acknowledge, identify the master as a free subject rather than a determined thing. I take it that such recognition, which even a slave can offer, is not what some authors have in mind when they claim that my own recognition of my freedom requires *free* recognition by other free subjects.[11]

There is yet a stronger sense of recognition which includes a positive evaluative dimension. I suspect it is this notion that Sartre and his commentators have in mind, for to recognize others in this third sense means to consider them to be of value. Thus, when oppressed peoples demand recognition, they are not just stating that they want others to understand or be aware that they are free human beings and not things; they are also demanding that they be treated as having a certain value and dignity. To need this kind of recognition of one's freedom, then, is to need it to be valued, approved, by others. The claim that I am psychologically dependent on others is the claim that I myself would not recognize the value or worth of my freedom if others did not do so. In Sartre's universe this evaluative kind of recognition is especially important because the only sources of meaning and value that exist are free human beings. Since Sartre also believes that one of the, if not the *most*, basic needs of a human being is for a valuable and meaningful life, it is essential that a person receive positive evaluation from others. Of course, each individual can freely choose to confer value on his or her own life and it will thereby have value. However, if other freedoms also recognize my value, he says, this will "enrich" the solitary worth I give myself.[12] It follows, then, that I should recognize (value) the freedom of others because it is the source of their valuation of me. Failure on my

part to do so will mean that any value or recognition they offer me, even if positive in character, will be worthless in my eyes. Moreover, it is far more likely that they will recognize me to be of value if I so recognize, rather than ignore or repress, them.

Even more important in this regard are Sartre's suggestions, and they are only that, that the recognition value I especially want is from those who choose to offer it freely, rather than those who offer it because their situation almost forces it from them. The recognition value I receive from my vassal or slave is worth something, for even they are not mere things but free subjects, albeit in a very restricted sense. Yet the value to me of their recognition is minimal compared to that which I place on the recognition by an equal. This is because the extreme psychological and physical dependency of the former on me almost compels them to value me. Someone who is not in such a relation of dependency is much more free to value me or not, and, therefore, if she does so, her recognition value of me will be significantly more meaningful to me (just as freely given love is far more valuable to its recipient than love obtained under duress). For the same reason the recognition value I receive from a child, or from an adult who is emotionally a child, is worth less in my eyes than that from a mature adult. The recognition value I receive from those whose existence is consumed by poverty, ignorance, disease, and oppression is not as valuable to me as that which I receive from those whose freedom is not so impoverished. For, again, it is unlikely that those who suffer such deprivations will recognize me as anything more than their possible benefactor if even that. They have little freedom or ability to recognize or value me as the free individual I am. If this reasoning is correct, if I especially desire recognition value from those who offer it freely and not because of dire need or extreme dependency, it follows that I should strive to aid others in achieving their freedom. In other words, I should work to promote Sartre's city of ends, that society in which individuals are equals, freely able to recognize and value each other as ends. Let me repeat that such a full-fledged argument is not found in Sartre's first ethics, although the ingredients for it are. It is, however, presented in some detail by Simone de Beauvoir in her *Pyrrhus et Cinéas*.[13]

This is a very strong argument, in my opinion, but one could question how far it extends. Although Sartre occasionally speaks as if one should will the freedom of all other human beings, that seems to be an exaggeration. His argument from interdependency obvi-

ously implies that I have no obligation to will the freedom of those whose lives and subjectivity I can never touch, nor they mine. A more serious question is whether, and to what extent, I am obliged to promote, or even acknowledge, the freedom of those whose lives are only minimally linked to mine. At first glance Sartre's argument appears to be so based on self-interest (for it seems to advise me to value and promote others' freedoms so that they will value and promote mine) that it would hardly require me to promote the freedom of those from whom I could expect little or nothing in return. We should, however, take seriously his phrase, "the city of *ends*," for it indicates that Sartre is not advocating that we turn others into mere means for our personal justification. As I noted earlier, if others become simply my servants or slaves, they are not able to offer me the meaning and value I desire, the affirmation of my being by free and independent subjects. In other words, only individuals whose freedoms I respect as *ends in themselves* can give to my existence the kind of value affirmation I crave. Still, the question persists. Just who am I obliged to treat as ends, according to Sartre's dependency arguments? In particular, to what extent am I required to acknowledge and promote the freedom of those whose existence is hardly linked to mine at all? Inasmuch as my psychological dependency on many others is slight (for example, I experience little need to receive recognition value from most of the humans on this planet), my obligation to will their freedom is correspondingly slight. Likewise, if my sociopolitical dependency on others is small (and I suspect there is little that many human beings can do to enhance or restrict my freedom), my obligation to will their freedom is also minimal. Thus, while Sartre's appeal to interdependency does establish an obligation for me to promote others' freedoms as ends, it appears that this obligation does not extend nearly as far as he wants it to, namely, to the most wretched of the earth and to the promotion of a *worldwide* classless society and city of ends.

Section 3. The Possibility of Authentic Human Relations

We need to respond now to the second of the two questions posed above, namely, how is it possible to choose the freedom of others and

achieve a city of ends given the epistemological positions of Sartre's early ontology?

Except for the section devoted to existential psychoanalysis, in *Being and Nothingness* Sartre spoke as if knowledge of others inevitably involved a kind of objectification of them which entailed an alienation of their free subjectivity. (See above, Chapter 3, Section 3.) To objectify a subject was to reify it, to "degrade" it to the status of a thinglike object; "objectification is a radical metamorphosis" (*BN*, 273). Accordingly, Sartre stated that even if I want to take the other's freedom as my end, if I do so I turn it into an object and thus violate it. *Being and Nothingness* went even further and denied the possibility "of the simultaneous apprehension of [the other's] freedom and of his objectivity." It limited human relations to those of subject to object or object to subject. "We shall never place ourselves concretely on a plane of equality," Sartre wrote, "that is, on the plane where the recognition of the Other's freedom would involve the Other's recognition of our freedom" (*BN*, 408).

Although *Notebooks* does stress the possibility of overcoming conflict and oppression, it also repeats many of these themes. It too speaks of objectification by others as the "negation of my subjectivity" (*NE, 11*), and thus as a "sin against freedom" (*NE*, 384) because objectification involves freedom's alienation, an alienation "from which man cannot exit" (*NE*, 413). In the same vein, *Notebooks* states that to take freedom as an end is to "substantialize" it (*NE*, 169), and asserts that "reification [is] an initial ontological phenomenon" among human beings (*NE*, 468). The last remark refers to childhood. Although objectification befalls me throughout life, because it occurs in childhood, Sartre says, it has as its normal result that I take the others' (my parents', adults') views of me as ontologically primary. This is humanity's "original fault" (*NE*, 11) and its "primitive alienation" (*NE*, 413). It is alienation because the child (and the adult who remains psychologically a child) does not explicitly recognize himself as the free source of his own life and values but sees himself as a dependent, even inessential, object of the essential others who supply the values and tasks that must be accepted if life is to have significance. In one place, he calls this alienation *oppression*,

> oppression [is] when my free subjectivity is given as inessential, my
> freedom as an epiphenomenon, my initiative as subordinated and

secondary, when my activity is directed by the Other and takes the Other as its end. (*NE*, 366)

Of course, oppression and alienation can take many more overt forms—master/slave, capitalist/worker, colonizer/colonized, male/female—all of which Sartre discusses. Nevertheless, objectification is common to all of them, he says; it is the ontological condition that renders oppression possible, and even "normal," since it occurs so early in a person's life.

However, in a radical departure from the view that dominates *Being and Nothingness*,[14] Sartre now insists that objectification, although it makes oppression possible, is not in itself oppression. For the *Notebooks*, to be the object of others does not necessarily mean to be degraded, reified, or enslaved by them, as it did in the earlier work. Nor does the simple fact that I am another's object mean that I must give the other's freedom and values priority over mine.

For one thing, as we have seen, the authentic individual, by her pure reflection, accepts her being an object as part of the human condition. Human reality, Sartre states, "can and must in authenticity assume the objective transformation of itself and its metamorphosis into destiny" (*NE*, 418). Indeed, as we saw above, the authentic person generously offers the objective transformation of herself, her acts and products, as gifts to others. Even more important, the fact that people are each other's objects need in itself pose "no problem," Sartre says. "My act has a troubling objectivity only because it is taken up by consciousnesses which make of it [only] an object and that make themselves objects in relation to it" (*NE*, 10). Being an object "is in no way a fall or a threat *in itself*," he writes.

> It only becomes so if the Other refuses to see a freedom in me *too*. But if, on the contrary, he makes me exist as an existing freedom as well as a *Being/object* . . . he enriches the world and me, he *gives a meaning* to my existence *in addition* to the subjective meaning that I myself give to it. (*NE*, 500)

Clearly, such mutual enrichment is precisely what takes place in the city of ends where authentic individuals choose to recognize and confer value and meaning on each other.

This means that, unlike *Being and Nothingness* where only subject/object relations were possible, *Notebooks* asserts that we can

apprehend each other as both freedom and object at the same time. The narrow alternatives of his earlier work "may be transformed through conversion" (*NE*, 499), Sartre affirms. Because it described human relations before conversion, *Being and Nothingness* lacked an understanding of the possibility of the "reciprocal recognition" or "reciprocal comprehension" of freedoms (*NE*, 414).

The notion of comprehension, only briefly mentioned in *Being and Nothingness*, is very important in this connection and so is discussed at some length in *Notebooks*.[15] Unlike knowledge, or the infamous Sartrean look, which simply objectify the other subject, comprehension grasps the other as freedom by sympathetically engaging itself in his pursuit of his goals. Thus, comprehension is not simply a passive contemplation at a distance of the other's freedom and its project; rather, when I comprehend, I anticipate in myself the action of the other toward his goals. I "outline," Sartre says, "my adopting [the other's] end" (*NE*, 277). I freely participate in the other's free projection toward his ends and in so doing grasp his freedom without transcending it. Yet sympathetic comprehension of another's freely chosen ends is not itself adoption of them, Sartre insists. The authentic individual in his generosity not only comprehends, but also adopts the other's free project as his own by willing its realization. Though one thereby becomes in a sense an instrument of the other's freedom, "I am not transcended [objectified] by this freedom since I freely adopt his end" (*NE*, 280), Sartre says. Likewise, the other that I help is not objectified by me. For he "unveils the other's [i.e., my] freedom through his passion and comprehension, but he does not unveil it as a transcendence-object opposed to his freedom, nor as a transcendence-subject that paralyzes him. He unveils it at the heart of his own freedom as a free movement accompanying him toward his ends" *(NE, 287)*

For Sartre, this sympathetic engagement in the freedom of the other involves a unity between persons that was totally missing in *Being and Nothingness*. Although he maintains that such unity is not an ontological fusion of individuals into some superindividual reality, he does describe it as a "certain kind of interpenetration of freedoms" (*NE*, 290) where "each freedom is wholly in the other one" (*NE*, 288). Relations of this kind occur in authentic love and friendship, he says. They involve a "unity of diversity" or a "sameness" that both respects the other free individual and overcomes radical separation and otherness; in them, "otherness is

replaced by unity, even though, ontically, otherness always remains" (*NE*, 49). This is a unity on the plane of will and action, he explains, that is not possible on the plane of being. Because of this unity, I am able to apprehend and will the other's freedom as such without degrading or reifying it. Whatever objectification of the other still occurs is, then, not a debasement, oppression, or source of conflict, since it is objectification not by an alien other but by one who is the same, one who comprehends the other person primarily as a free subject.[16]

Thus the *Notebooks'* account of human relations constitutes a substantial advance beyond the narrow subject/object form that predominates in *Being and Nothingness*. (I might add that it also significantly supplements other early published works, such as "What Is Literature?" and "Materialism and Revolution," which, although they assert the possibility of intersubjective relations, contain no discussion of conversion or comprehension which make such relations possible.) At the same time, *Notebooks* also significantly goes beyond the exclusively psychological notions of oppression and conflict present in *Being and Nothingness*. Since, for the latter, conflict and oppression inevitably resulted when free subjects were objectified by other free subjects, deliverance was equally psychological, a radical change of one's fundamental project. (See above, Chapter 3, pages 33–35.) For its part, the *Notebooks'* lengthy discussion of oppression insists that it involves more than just being the object of others.[17] Oppression requires a free decision on the part of some to oppress others.[18] Some freely choose to deny certain possibilities and projects (for example, to vote, to live, and to work where they please) to others whom they (the oppressors) recognize are free. An entire class may be oppressed by having to live in material conditions, such as poverty, segregation, and slavery, which it is powerless to change. Again, this is due to the free choices and actions of others—not just to their objectification. In such conditions, the freedom of the oppressed may even be so limited, deformed, and inessential that they almost become things, totally subject to the will of their oppressors. (I say "almost," because Sartre maintains that, even in extremely degrading situations, the oppressed retain the freedom to accept or reject the domination of the master. Revolt and suicide are always alternatives to resignation.)[19] As an illustration of the very real notion of oppression Sartre has in mind, he mentions, both in *Notebooks* and in "Materialism and Revolution," the degra-

dation involved in modern work or forced labor.[20] The worker in a modern industrialized society is often in a situation where his or her options are extremely limited. If he or she wants to survive, he or she simply must accept a menial, mind-deadening, low-paying job whose standards and goals are totally determined beforehand by someone else. Oppression may also result from some being subject to the violence of the lies and cunning of others. It may involve the oppressor controlling the oppressed's thoughts and acts by, for example, maintaining his or her ignorance, provoking fear or hope or guilt.[21] Again, the point to stress in all of this is that Sartre distinguishes between the ontological condition which makes oppression possible, namely the fact that one is, inevitably, the object of the Other's knowledge, and actual oppression which requires, in addition, the other's free refusal to *treat* a person as the free being he or she also is. The oppressor chooses to *act* on my free subjectivity by severely restricting my possibilities and my power to attain my goals in order to turn me into a mere object/thing subordinate to his will.

Just as oppression involves free decisions and actions, not simply objectification, so its removal, Sartre stresses, requires free decisions to respect and promote freedom and concrete actions to change those social structures which force others to live subhumanly. In fact, although objectivity can never be totally overcome, oppression can in principle be abolished, Sartre claims, in a classless society, the city of ends where each wills the freedom of the other with authentic love and generosity.[22]

Section 4. Conclusion

I have tried to show that Sartre's first ethics is a coherent, reasoned theory basically grounded in the ontology of *Being and Nothingness* as modified by *Notebooks for an Ethics*. Contrary to his critics, Sartre's early ethics is not totally relativistic, for it proposes a common value for all human beings—freedom, the city of ends. It is not anarchistic nor radically individualistic, for it requires each person to promote the freedom of all. Nor is it nihilistic, for it does not claim that human existence is forever unjustified; it asserts that life will be as meaningful as humans themselves make it. I have also shown that Sartre's position that all values are human creations, far from

rendering ethics impossible, allows for a radical conversion which rejects the prereflective value of the God project and supplies the very basis of the argument that freedom should be man's primary value. Finally, I have argued that Sartre gives solid reasons for asserting that people should enter into authentic relations of love and generosity by willing each others' freedoms.

Yet this is not to say that Sartre's first ethics is without problems, and he himself said so. Earlier I indicated some difficulties I have with the arguments he advances to prove that freedom, and the freedom of others, should be a human being's primary goal. Whether Sartre himself perceived these particular difficulties, I cannot say, but it is clear that he did come to see that a number of the important values of his first ethics, creativity, generosity, as well as freedom itself, were terribly vague or, to use his term, idealistic. In Chapter 4, I pointed out that since all human acts create some kind of phenomenal world, it is not clear what Sartre is advocating when he recommends that human beings will their creativity. Likewise, to encourage authentic love and generosity and to say that we should value the concrete freedom of others is to offer rather thin advice. Occasionally, it almost sounds as if we are to accept and support every concrete freedom and whatever goal it chooses. Of course, in *Notebooks for an Ethics* and related works, Sartre clearly manifests his support for the oppressed and alienated, rather than for their powerful oppressors. As we noted in the previous section, he advocates a thorough change of those structures which restrict the freedom of so many. (In fact, I suspect that a major reason he identifies the city of ends with the classless society is simply that he considers the latter to be free from all oppression and domination.) Nevertheless, as far as I can see, Sartre offers no guidelines or specific recommendations as to how one might distinguish between those whose concrete freedoms are to be supported and those whose are not, nor does he justify his preferential option for the oppressed. Also, few particulars are offered about how a classless city of ends could be brought into being in our concrete historical situation, nor how it might function politically and economically. Let me repeat that to offer this criticism is to say no more than Sartre himself did later when he criticized his first ethics for being an abstract irreal idealism.[23]

Another notion of Sartre's, central to his early ethics, that I find very problematic is his concept of value. Although, unlike *Being and*

Nothingness, the *Notebooks* contains no extensive treatment of the topic, it is clear that Sartre's understanding of the nature of values remains much the same there as in his early ontology. Thus, like *Being and Nothingness*, *Notebooks* describes values as goals, ideals, exigencies, norms, which are nonbeings, for they are not what is but what should be, ought to be, or have to be.[24] Their nature as something which ought to be, Sartre explains, makes them unable to be definitely realized, for if they were, they would simply be what is. Like *Being and Nothingness*, *Notebooks* also emphatically rejects the spirit of seriousness, that is, the view that values are objective, transcendent givens "written in nature" independent of human choices, desires, and projects. Sartre continues to insist that human beings alone, either individually or in groups, are the source of all values by arguing as he did in the earlier work that since values are nonbeing, since they are what is not but what ought to be, they must have their origin in a being which can transcend what is and grasp what is not.[25] One important addition which works after *Being and Nothingness* do make to Sartre's conception of value is the claim that values have a certain universal character; because of this they appear as "transcendent" and "objective", and thus as "demands" on others.[26] In *Existentialism and Humanism*, as we have seen, he maintains that when I choose values I in some sense choose them for all men. In an appendix to *Notebooks*, he similarly asserts that the value (here called the *good*) which issues from me appears as something that should be done, not just by me, but by others as well. "Not only is it [a good] my ideal, it is also my ideal that it become the ideal of others" (*NE*, 557), he writes. Though he offers no explanation of this statement, I believe that Sartre is referring to the fact that when I experience justice or love, for example, to be values or goods, I experience them to be more than just my personal or private values; I experience them to be valuable or good for others too. This is the reason I want others also to choose them as valuable or good, as their ideals. (It is interesting that Sartre makes the same claim about aesthetic values in "What is Literature?")

I have a number of difficulties with this early notion of value. For one thing, Sartre so identifies values with nonbeing (justice, for example, is what ought to be) that it is unintelligible how any actual action or person can be valuable (e.g., be a just act or person) and so legitimately have value ascribed to it. Yet he does concede that actions, but not beings, can have values "realized" in them.[27] The

problem is that Sartre overly restricts the notion of value by taking just one of its perfectly legitimate meanings, namely as a prescription, something that should be done, and ignoring all others.[28] Equally problematic is his statement about the universality of values. Now I do agree that a reflection on moral experience shows the presence of a certain universality in most of the values experienced. I do think that most, though not all, moral values are experienced by an individual as claims or demands not just on him or her but on others as well. When I experience racial justice to be a value, for instance, I do not experience it simply to be a value for me alone; I experience it as something that is, or should be, a value for others too. I would also agree with Sartre that it is the experience of their universal character that causes values to appear to be transcendent and objective. However, there can be no legitimacy to any such appearance or to any such universality of values in his early ontology. Since all values are human creations which ultimately have their source in individual freedom, no human being in good faith could believe that the values he or she chooses are transcendent or objective, universal in that sense. Of course, an entire class or social group may have the same values, but that is only because each individual in them has chosen the same ones that the others have. Individuals may also be mystified into experiencing and believing that the values of others are objective and universal and so must be chosen. But this is precisely the spirit of seriousness which Sartre decries. For the early Sartre there is simply no ontological justification for the experience of the universality and objectivity of any values nor, therefore, for the experience that other human beings should choose the same values as I do.

On the other hand, it is important to remember that Sartre's claim that all values have human freedom as their source is true in two quite different senses. As we pointed out earlier (Chapter 3, Section 3), there are values which issue from free choice, and there are others which come from human reality's structural freedom, that is, its ability to transcend what is and grasp what is not. I have argued above that the latter freedom is a dubious one at best, since it does not involve the ability to freely select among genuine alternatives; accordingly, I have criticized the early Sartre for claiming that all human emotions and desires are free. Yet in *Notebooks* he continues to speak of values issuing from choice as well as from human desires (he mentions hunger and sexual desire), as if both kinds have their

source in freedom.[29] Even if, in some sense, they do, there remains a fundamental difference between those which are freely caused by our choices and values which arise from our emotions and desires. The latter values, such as the value of the food to a starving person or the value of a sexually attractive person to someone sexually aroused, are often not ones we can freely turn off or on (though we may be able to control our behavioral response to them), for they are not the result of our free choice but of our "natural" desires (for nourishment, for sex). This distinction becomes extremely important when it comes to the question of the objectivity or subjectivity of values, but I will defer further discussion of it until we have seen Sartre's second ethics. In it he will significantly modify this early conception of the nature of values.

6

Critique of Dialectical Reason

This chapter will discuss the work which Sartre stated was the sequel to *Being and Nothingness*, the *Critique of Dialectical Reason*. The *Critique* is situated in a crucial position between the early ontology and the second ethics and provides the ontological basis for the latter. Sartre himself said that his (second) "morality could come only after it" (*SBH*, 77).

Overall, as we have seen, *Notebooks for an Ethics* moved beyond the abstract analysis of the early ontology to a more concrete understanding of human reality and its engagement in the world. Yet, at times, it also repeated *Being and Nothingness*'s identification of man with consciousness and freedom and minimized the power of circumstances by speaking of human freedom as total, absolute, and unlimited. Similarly, while most of his essays of the late forties gave circumstances their due and displayed a richer notion of human reality and freedom, there were some that continued to repeat the abstractions of the early ontology. In other words, in spite of their general orientation, the works of this period manifested some ambiguity in Sartre's understanding of human existence, freedom, and circumstances.

By 1952, however, the date of the publication of his lengthy study of Jean Genet, Sartre had made up his mind. He unequivocally acknowledged, even emphasized, the power of circumstances, especially those of the social order, to limit and condition human existence. In that work, he categorically rejected "social atomism", the view that human reality is what it is in itself, in isolation. Rather, he said, "human reality is in-society as it is in-the-world." It "is made" by its social relationships: "everything comes to us from others."[1] *Saint Genet, Actor and Martyr* described in great detail how Jean Genet was conditioned in his childhood by his adoptive family, conditioned internally to take adults' views of him as primary, even

to the point of being unaware of his own agency and freedom. Gone is the total lucid self-awareness of Sartre's early conception of consciousness, for Genet, like all humans, comes to recognize his freedom and achieve some degree of liberation only gradually through a long and painful personal development in which interaction with others is central.

The *Critique of Dialectical Reason* continues this stress on the social conditioning of human reality, emphasizing how the economic, political, and social structures that humans create "make" human beings. A major new tool that it employs is Marxism, which Sartre came to understand and accept (on his own terms) in the decade or so after *Notebooks*. A number of authors have described this period, and I do not propose to retrace their steps.[2] Let me just observe that, although *Notebooks* identified the goal of the first ethics, freedom for all, with Marx's classless society, in many other respects it was quite critical of Marxism, as was "Materialism and Revolution." As we noted earlier, Sartre criticized Marxism for its reductive materialism, its determinism, its oversimplification of human history, and its ignoring of the individual. When we come, just ten years later, to *Search for a Method* (originally published in 1957 and later revised and included in the *Critique*), we find Sartre clearly affiliating himself with Marxism and, in fact, claiming that Marx's philosophy is the only creative philosophy of our day and, therefore, that we cannot go beyond it.[3] Though he continues to criticize contemporary Marxists (not Marx himself) for ignoring the concrete human being and oversimplifying the richness of human history, he basically accepts Marx's materialistic understanding of human reality and history. Accordingly, from its first pages, the *Critique* incarnates the human being in a physical organism and immerses it in a material world which radically conditions and limits it. For Sartre, Marx has also provided the "guiding principles" for understanding the historical relation of humans to their world and to each other. Sartre agrees that human beings make their history within a given environment that conditions them, and that, in the final analysis, the economic conditions of that environment are primary. He quotes with approval Marx's statement, "the mode of production of material life in general dominates the development of social, political, and intellectual life" (*SM*, 33–34). Marx is correct, too, in emphasizing the primacy of the class struggle in history and in his analysis of the evils of capitalism where an elite few dominate and exploit the masses through their

control of the basic forces of production and their power over the social, political, and intellectual life of the society. Thus, the *Critique*'s detailed study of the mutual interactions between human beings and their total environment seems light years away from the earlier abstract phenomenological investigations of consciousness and its objects. In fact, while the *Notebooks for an Ethics* introduced few new ontological categories beyond those of *Being and Nothingness*, the *Critique* does, as we shall see.

In what follows, I will first present the conception of human reality that Sartre offers in the *Critique* and then discuss more fully some of his descriptions of the relations between human beings, their freedom, and the natural and social environments which contain them. Since there have been a number of detailed discussions of the contents of the *Critique*,[4] my treatment will highlight only areas that have import for the second ethics. In subsequent chapters, I shall set forth the ethics which is based on this ontology and contrast it with the first ethics.

Section 1. Human Reality

The human being of the *Critique* seems to be almost a different species from the human being of *Being and Nothingness* and earlier works, which so frequently equated *man* with being-for-itself, pure spontaneous consciousness, freedom, and even with nonbeing and nothingness. From the beginning the *Critique* defines man not as free consciousness, not even as consciousness existing or invested in its body, but as a completely material organism.[5] A human being, Sartre says, is composed of the same physical elements and molecules as all other material things. Like any organism, it differs from nonorganic matter inasmuch as the elements which compose it are not separate entities externally related to each other but are intrinsically interrelated and unified in a "bond of interiority" so as to form the single synthetic whole that is the living organism. The organism is not, therefore, just a collection or sum of its parts, for the latter are not independent entities going their separate ways. It is a synthetic unity which governs and unites its parts for its preservation and development.

Yet the human organism is a synthesis of parts that are never integrated so completely that their distinctness is totally eliminated,

and so it is threatened by all those things that can dissolve or otherwise cause its decomposition into the inorganic. As material beings, humans are subject to the same physical forces (gravity, pressure, heat, and so forth) that every other material thing is subject to. My body can be burned, crushed, and mutilated, and all of this may occur whether I know and will it or not. This is, therefore, the passive, "inorganic" side of our existence, Sartre says; it is a dimension of our being that operates to a great extent independently of our conscious direction.[6] For example, my digestive, respiratory, and excretory functions normally take place according to their own biochemical laws, which I am neither aware of nor able to control completely by my free choice. In a healthy organism these functions are governed and unified by the whole, and this, too, occurs automatically and nonconsciously for the most part. Furthermore, the organism's maintenance and growth is ultimately dependent upon satisfying its material needs whose very presence and impulse are not matters of our free decisions. Yet it is the conatus of these needs, Sartre says, that initiates all of the organism's actions on its environment.[7] (As we shall see, the notion of needs is absolutely central to the second ethics.)

What distinguishes the human organism from all others, Sartre says, is its consciousness, which he does not now define as a purely spontaneous, nonsubstantial being (or nonbeing) radically different from inert matter (or being). Rather, although the *Critique* maintains that thought is not a mere passive effect or epiphenomenon of matter, it insists that man is "wholly matter" (*CDR*, I, 180) and characterizes its position as a "monism of materiality" (*CDR*, I, 181). In general, Sartre labels the stance he adopts in the *Critique* "realistic materialism" (*CDR*, I, 29). Yet the consciousness of the material human organism is still characterized above all by its ability to go beyond, or transcend, a situation, that is, to negate, deny, wrench itself away from that situation toward future goals. This, of course, is the notion of project which Sartre retains from his earliest works, though, perhaps in order to emphasize its roots in organic materiality and in need, he usually calls it *praxis* in the *Critique*. Human praxis, issuing from need, is described as a free, purposeful (conscious) activity which organizes (*totalizes* is his preferred term) all of the various objects of its environment into an ongoing unity as it goes beyond them towards the goal that it seeks.[8] As in earlier works, Sartre continues to refer to human praxis/project as free

simply because it transcends its environment toward nonexistent goals—a view of freedom that I have already expressed serious reservations about. Be that as it may, consciousness is clearly not viewed as pure spontaneity totally independent of matter but as an integral part of the concrete praxis of the human organism.

Since consciousness is present in human praxis, this means its totalizing activity is always aware of itself to some degree. Thus, Sartre writes, "human praxis [is] transparent to itself as the unity in act either of a rejection [of the given situation] or of a project, [and] defines its own practical understanding as the totalizing grasp of a unified diversity" (*CDR*, I, 60). To speak of praxis as "transparent to itself" (elsewhere he calls this self-awareness *comprehension* and refers to it as *translucid*) sounds very like the lucid self-awareness of the prereflective cogito in the early works. However, despite the similarity in language, the self-awareness of praxis and the self-awareness of the prereflective cogito are not identical since in the *Critique* Sartre also speaks of "degrees" of translucidity and of comprehension, and even of "implicit or obscure" comprehension (*CDR*, I, 76). More on this later. In any case the *Critique* is clear that, insofar as human beings are self-conscious beings, they are not just externally affected by objects outside of themselves, they also "internalize" many facets of their environment. They live their situation experientially, Sartre says; that is, it structures and shapes them *from within*, and thus affects their awareness of themselves and of the world as well as their actions on both.[10]

All of this needs to be fleshed out with specific examples and some concrete detail, which the following sections will do.

Section 2. The Human in the World

"Concrete man," Sartre says, "is defined simultaneously by his needs, by the material conditions of his existence, and by the nature of his work—that is, by his struggle against things and against men" (*SM*, 14). As is well known, Sartre agrees with Marx that the struggle between human organisms and their world is dialectical. In fact, a stated goal of the *Critique* is to demonstrate that all the complex relationships between humans, the natural world, and their social world, in other words all of history itself, are intelligible only if understood dialectically.[11] Now to stress the dialectic is to insist on

the mutual interaction and causation between human beings and their world. As Sartre puts it, "the individual is conditioned by the social environment and . . . he turns back upon it to condition it in turn; it is this—and nothing else—which makes his reality" (*SM*, 71). Since the ultimate sources of the dialectic, and hence of all history, are numerous human praxes acting on matter and on each other, the dialectic is not itself some overarching superhuman cause but is simply the effect of all of these interactions. This is in principle evident to any concrete individual who reflects on his or her experience, Sartre says, for the dialectic "is the very experience of living, since to live is to act and be acted on, and since the dialectic is the rationality of praxis," acting on the world (*CDR*, I, 39).

The more than eight hundred pages of the *Critique* contain a wealth of explanations and illustrations of dialectical relations. The amount of research into history, economics, and sociology that Sartre did for this work is staggering. It will be sufficient for my purposes to explicate some of the major features of the relationships between humans and their physical and social worlds that he describes. I might add that it seems to me that the purpose of the *Critique* is not just to enable human beings to understand the factors and forces operative in their history but also to enable human beings to control them—to allow them to become, in Marx's language, their own product rather than the product of their product as they are at present. In any case that is certainly the goal of Sartre's second ethics.

a. Worked Matter, the Practico-Inert[12]

As we know, at the basis of all history for Sartre is the human organism working on nature to satisfy its needs. In modifying nature to fulfill their needs, human beings inevitably produce something that escapes their control, the practico-inert, which reverberates back on them to condition their freedom. For example, in order to operate the machines they produce, humans have to adapt themselves to serve them, even to the point of performing extremely mechanical, noncreative tasks. In general, to fulfill their needs in a highly complex industrialized society, humans must adjust to the mechanical rhythms and structures of that system. In this way our own creations, the results of our free praxes, condition our future praxes by limiting our possibilities and demanding the performance of specific actions. The obligation to serve our products can be harsh indeed; those who,

through lack of skills or opportunity, cannot do so are severely marginalized.

b. Culture/The Past

Human culture has its ultimate origin in past and present human praxes but, at the same time, it has a reality of its own, Sartre says, not totally subject to human control. Thus, it too is a form of the practico-inert. From a dialectical perspective we must not view our relation to our culture as external, as if it is simply our product. Rather, "instead of me being a particular social atom which itself defines the cultural possibilities, this participation [in a culture] defines me (in a specific way)." I am linked to my culture, the result of millennia of human history, by bonds of interiority, meaning that

> I find myself dialectically conditioned by the totalized and totalizing part of the process of human development: as a "cultured" man (an expression which applies to every man whatsoever . . .) I totalize myself on the basis of centuries of history and, in accordance with my culture, I totalize this experience. This means that my life itself is centuries old, since the schemata which permit me to understand, to modify and to totalize my practical undertakings . . . have *entered the present* (present in their effect and past in their completed history). (*CDR*, I, 54)

For example, it is through the language, ideologies, and techniques inherited from the past that every human being understands and acts upon nature, society, and history, and on him or herself. "Language and culture are not inside the individual like stamps registered by his nervous system. It is the individual who is inside culture and inside language" (*SM*, 113). Of course this means, as we said earlier, that a person's self-awareness is conditioned and limited by his or her culture; no perfectly lucid prereflective cogito here.

c. Class Being[13]

In contemporary society, everyone is a member of a class. At the origin of this membership according to Sartre are products of human praxes, including ideologies, systems of social relations, and material objects. These products condition the members of the class; Sartre refers to them as "inertia which infiltrates freedom" (*CDR*, I, 237). He explains,

> They are simply the *crystallized practice* of previous generations: individuals find an existence already sketched out for them at birth; they "have their position in life and their personal development assigned to them by their class." What is "assigned" to them is a type of work, and a material condition and a standard of living tied to this activity; it is a fundamental attitude, as well as a determinate provision of material and intellectual tools; it is a strictly limited field of possibilities. (*CDR*, I, 232)

Clearly, then, no one begins as a *tabula rasa* for Sartre; each of us is born into a class with only certain possibilities known and available to him or her. For many their life and destiny is so "prefabricated" that their options are only various means to the same miserable end. He gives as an illustration a woman working in a Dop shampoo factory who is "wholly reduced to her work, her fatigue, her wages, and the material impossibilities that these wages assign to her: the impossibility of eating properly, of buying shoes, of sending her child to the country, of satisfying her most modest wishes" (*CDR*, I, 232). This woman may be able to choose one brand of toothpaste or one breakfast cereal from others, or to do her job more or less quickly, but she has no freedom to leave or change her class and its oppressed state. She is *forced*, Sartre says, "to live a prefabricated destiny as *her reality*" (*CDR*, I, 232). Explicitly rejecting positions adopted in *Being and Nothingness*, he asserts,

> it would be quite wrong to interpret me as saying that man is free in all situations as the Stoics claimed. I mean the exact opposite: all men are slaves insofar as their life unfolds in the practico-inert field. . . . The practico-inert field is the field of our servitude, which means *not* ideal servitude, but real subservience to "natural" forces, to "mechanical" forces and to "anti-social apparatuses". (*CDR*, I, 331–32)

We see again the severe restrictions on freedom the Sartre of the *Critique* is willing to admit.

Even while highlighting such restrictions, however, he insists that human freedom remains in the form of praxis which internalizes, organizes, and transcends the practico-inert toward particular goals. Thus, while he concedes that "freedom in this context does not mean the possibility of choice, but the necessity [NB] of living these constraints in the form of demands [*exigencies*] which must be fulfilled by a praxis" (*CDR*, I, 326), he continues to maintain that this praxis is free because it is "the perpetual transcendence of our

ends," and that to be conscious of it is to grasp ourselves "as a permanent possibility of transcending any actual circumstances" (*CDR*, I, 328–29). Yet, since he also admits that this alleged freedom without choices is only an "appearance" for the exploited person who has merely a few trivial options within "his general destiny as exploited" (*CDR*, I, 330), it seems once again that this freedom to "transcend" circumstances is only a freedom of thought, not a real concrete freedom from oppressive forces.[14]

d. The Family[15]

It is in a person's particular family that one "discovers the point of insertion for man and his class . . . a mediation between the universal class and the individual." The examination of the individual in his or her family, called *psychoanalysis*, "alone enables us to study the process by which a child, groping in the dark, is going to attempt to play, without understanding it, the social role which adults impose upon him" (*SM*, 60). Only through psychoanalysis can we come to understand "the action upon our adult life of the childhood we never wholly surpass" (*SM*, 64). (Note, again, that neither the child nor the adult is blessed with lucid prereflective self-awareness.) Except for some brief illustrations of how Baudelaire and Flaubert were conditioned by their class in and through their family, Sartre does no psychoanalysis in the *Critique* itself. Of course, the earlier work on Genet was just such a study. In it Sartre described how the illegitimate orphan Jean Genet accepted society's view, present in his adoptive family, that in order to truly be, one must possess things. Owning nothing, the child Genet stole and was branded a thief. He believed this judgment of adults and his life became a matter of internalizing their sentence. Sartre's own autobiography, *The Words*, as well as his final work on Flaubert are also psychoanalytic studies. We will turn our attention to the latter after we have presented the second ethics.

There are many other social ensembles (neighborhoods, clubs, unions, political parties, and so on) which mediate between the individual and his or her class, or, more generally, between an individual and the relations of production and productive forces of a certain historical period, and all of them must be studied, Sartre says, in order to understand concrete human beings in their historical reality. (Contemporary Marxists are too "lazy" to do so, he complains.) The *Critique*, however, focuses only on those social relation-

ships (outside of the family) which he considers to be the most fundamental. Since Sartre's basic categories are well known, I will concentrate on that particular social relationship which the *Critique* proposes as both the most effective *means* for human beings to use to attain their goals and as their ultimate *end*.

Section 3. Social Relations

We noted in Chapter 5 that *Notebooks for an Ethics* constitutes a significant advance over *Being and Nothingness* in Sartre's view of social relations, in particular in allowing for, and encouraging, subject-to-subject (or, more accurately, subject/object to subject/object) relations as well as in presenting a more concrete analysis of oppression. The *Critique* continues in this direction. In it human relations are not described as relations between free consciousnesses who consider all objectification by others a degradation to be avoided or controlled. They are, instead, associations between conscious material organisms living together in a natural world limited by scarcity, who through their praxes act on the world and on each other to fulfill their needs. Their praxes confer on the practico-inert, worked matter, the power to react upon the human organisms and condition them and their social relationships. The most common relation among human beings according to Sartre is the series. We will begin with it although it is in many ways the very opposite of Sartre's ideal social relationship, for the latter grows out of, and in reaction to, it.

a. The Series[16]

A collection of individuals loosely united around the same object, but having no common bond other than the fact that they are part of this collection, is a series. Since they have no internal relation or union with each other, Sartre says, each of the members of a series is effectively alone, an other among others, an atomic individual. Compared to an organized group, the series possesses an inorganic character, for it is passive, impotent, and inert. It is, therefore, particularly vulnerable to the power of its common object and to those who are able to control that object.

Sartre gives many examples of series: people waiting for a bus, listeners of a radio station, customers, workers in a factory, inhabit-

ants of the same suburb. Perhaps his best illustration is merchants and customers in the common marketplace. In setting prices each merchant must, among other things, take into account his or her competitors and customers. Since neither buyers nor sellers are organized, however, the price finally imposes itself on each of them because it imposes itself on the other buyers and sellers. Merchants have to set their prices according to what others set and what customers will spend, that is, according to "what the market will bear." Although everyone, in fact, produces the market in the first place and sustains it in existence, it operates, Sartre says, as a monstrous force which subjects individuals to itself and thus transforms the producer into its product. The market may drive a merchant out of business if he or she cannot price competitively; it may even kill some people, by making certain services (e.g., medical care) unaffordable by them. Of course, the market may also be manipulated by a small number of people who dominate and control its natural and financial resources, its factories and offices, and its media. The masses of consumers may, in fact, be so conditioned by the propaganda of advertising and public opinion that, while remaining an impotent series, they believe that they are part of an effective organization simply because they buy the same, vote the same, and think the same as the others.

b. The Group[17]

For Sartre the most effective response to serial powerlessness is for individuals to join together in common action in a group. Because the group enriches the power of the individuals within it, it increases their freedom by enabling them to effectively control the practico-inert forces which condition them and, thus, more readily fulfill their needs. On the other hand, insofar as I am a member of a group, I must conform my action to that of my fellow members; I cannot do whatever I please whenever I please. This limitation of freedom, however, is not as restrictive as it might seem, at least not in the early stage of the group's existence. Crucial here is Sartre's notion of "the same," mentioned briefly in *Notebooks*. Though the members of a group remain distinct individuals, they are not alone and separate as are members of the series. They are united by performing common actions toward common goals and so each person sees himself not as other than the Others, but as the *same* as the Others: "Through the mediation of the group, he [my fellow member] is neither the Other

nor identical (identical with *me*): but he comes to the group as I do; he is *the same* as me" (*CDR*, I, 377). Because we are united in the group, I find in the other's action not his other-being, Sartre says, but *my own* freedom, and he finds his freedom in my action. "It is not that I am myself in the Other: It is that in *praxis* there is no *Other*, there are only several *myselves*" (*CDR*, I, 394–95).[18]

Accordingly, Sartre speaks of each member of the group as "liquidating" seriality and negating separate otherness and plurality. Each member interiorizes the multiple actions of the other group members by seeing them as the same as his, with the result that his personal freedom is "synthetically enriched" and "swelled."[19] In the group, plurality "does not appear as an *other-being* . . . but as the interiorized reality which multiplies individual effectiveness a hundredfold" (*CDR*, I, 394). Furthermore, when I freely allow my actions to be regulated and limited by those who are the same as me, I am in effect regulating them myself. Thus their acts and directives involve no more limitation of my freedom than do my own, Sartre claims.[20] Likewise, their objectification of me is not an alienation or degradation of my subjectivity since it is objectification by one who acts and sees him- or herself as the same as me and who, therefore, also recognizes me as free praxis.[21]

For Sartre the group can take either of two forms: the group in fusion, one spontaneously arising in the face of some threat, or the group consciously and deliberately chosen by its members pledging to maintain its existence. In both of its forms, it is an achievement of freedom, Sartre states. But, although some have not noticed, it is actually the pledged group rather than the group in fusion that he describes in the most glowing terms as "the origin of humanity," where men are related as "brothers," and as "the victory of man as common freedom over seriality."[22]

c. The Pledged Group[23]

In the group in fusion, no commitment is made by anyone to continue common action for common goals. By the pledge, however, individuals reflectively and deliberately consent to the group relationship and agree to maintain their common praxis. One result is that there is more permanence and unity in the group than existed at its initial spontaneous stage, and for this reason Sartre considers the group after the pledge to have more reality. The pledge, he

maintains, "is a real modification of the group" and creates a "new entity," our "common being," "man as a common individual"— which he designates as "the origin of humanity."[24] This does not mean that those in a pledged group merge into the same substance or superorganism. We remain ontologically distinct individuals, Sartre insists.[25] Our being is common, he says, because we recognize each other as "accomplices" in the common act that removes us from seriality. We are "brothers" not because of an identity of nature but because, "following the creative act of the pledge, we *are our own sons*, our common creation" (*CDR*, I, 437). He goes on to say that relations such as friendship, comradeship, and even love are simply further specifications of that basic fraternity which unites those who take the same pledge.

There is no doubt that Sartre considers the pledged group to represent a victory, because it is the most effective means of promoting human freedom over the series and the practico-inert in the long run. Yet there is some ambivalence in his estimation of the pledged group, for, precisely because it has more reality or being (i.e., permanence), it involves greater limitations of freedom than does the spontaneous group. There is no longer as much freedom to leave the group or to deviate from its common action. The spontaneous group is transformed into a "group of constraint," Sartre writes (*CDR*, I, 438). This occurs because members of the pledged group explicitly reflect on the group and thereby more clearly make each other objects and see each other as other-beings. As a result, Sartre says, there is more "distance" between them. Still, at the same time, they do remain the same and see themselves as such, and so they "do not relapse into seriality, since, for each . . . this *Other-Being* is *the same* Other-Being as for his neighbor" (*CDR*, I, 434). Nevertheless, there is more otherness or distance in the pledged group than in the spontaneous one, and so a greater force than just their pledge is necessary to keep the group members together and produce their common being. Terror performs this function for Sartre. Through my pledge to the other group members, I give them the right to discipline and even kill me if I deviate substantially from the common praxis or seek to leave the group. Since fear of this terror keeps individuals in the group, even when external threats have vanished, terror is primarily a cohesive not a destructive force, Sartre claims. And it is a source of unity and

sameness precisely because every member of the group is, by his free pledge, subject to the same terror. Even if he threatens or kills me for deviating from the group, the other group member remains my "brother, whose existence *is not other than mine*" (*CDR*, I, 437).[26]

Of course, the whole purpose of terror and other restrictions is to ensure the unity and permanence (being) of the most effective means for human liberation and the fulfillment of needs. Whatever restraints are present in the group are freely chosen by its members and so are imposed on them by persons who, to a great degree, are the same as each other. On balance, then, the pledged group is for Sartre the most powerful instrument for the enhancement of human freedom. Moreover, it is not just an instrument for men's use; it is also their *absolute end* as the free milieu of free human relations. It is only near the end of the *Critique* that Sartre makes that assertion, and I will conclude this section by quoting his words at length, for they express so clearly his esteem for the group.

> To go back to the deepest origin of the group, there can be no doubt that . . . it produces itself through the project of taking the inhuman power of mediation between men away from worked matter in order to give it, in the community, to each and to all and to constitute itself, as structured, as a resumption of control over the materiality of the practical field (things and collectives) by free *communized praxis* (the pledge, etc.). From its first appearance as the erosion of the collective, it is possible to see in it . . . the project of removing man from the status of alterity which makes him a product of his product, in order to transform him *hot (a chaud)*, by appropriate practices, into a *product of the group*, that is to say—as long as the group is freedom—*into his own product*. . . . The group defines and produces itself not only as an instrument, but also as a *mode of existence*; it posits itself for itself . . . as the free milieu of free human relations; and on the basis of the pledge, it produces man as free common individual and confers a new birth on the Other: thus the group is both the most effective *means* of controlling the surrounding materiality in the context of scarcity and the *absolute end* as pure freedom liberating men from alterity [seriality]. (*CDR*, I, 672–73)

I presume, though the *Critique* does not explicitly say so here, that the pledged group, the free milieu of free human relations, is also the place where human needs are best satisfied. After all, it is needs, and

their desire for satisfaction, that are the deepest origin of all praxes, including that which creates groups.

d. Dissolution of the Group

Once human beings turn their efforts toward preserving the group, there is great danger that the inertia conferred on the group will become even stronger and that the pledged group will evolve into collectives in which inert structure predominates over freedom. In the *Critique* Sartre describes that process in detail—the spontaneous upsurge of a group from seriality, its permanence established by the pledge, and then its progressive deterioration into an institution and bureaucracy, finally its return to the series. To review this devolution would take me too far afield; I will simply point out that what happens is that as the being or permanence of the group, organization, or other collective becomes more important, individual freedom becomes more restricted. Since one can never be totally integrated into the collective as into a superindividual organism, increasingly stronger efforts are made to insure the permanence of the function that the individual performs in the collective. As a result the individual as such becomes expendable and his or her freedom is severely constrained.

Is the devolution of the group inevitable, as many commentators have claimed? Sartre does indeed sometimes speak of the process as necessary, but in other places he states he is only describing the logical relationships between these formal social structures, not historical ones.[27] Actually, I have little doubt that the Sartre of the *Critique* believes that human beings have a natural tendency, rooted no doubt in their desire to be God, to seek to make the group into a permanent being and thus achieve for themselves as its members a permanence and necessity in being. However, unless he has totally changed his mind about conversion, Sartre would still have to grant that human beings can reject that impossible goal if they recognize that neither socially nor individually can they become necessary beings. They can then cease the vain attempt to turn the group into a single organism and instead take the group itself "as the free milieu of free human relations" as their absolute end.

In the final one hundred fifty pages of the first volume of the *Critique*, Sartre endeavors to show, progressively more concretely, the dialectical interaction among series, groups, institutions, and

other kinds of social collectives as they actually exist together in history. He uses these categories to examine the history of French labor unions, to discuss the class struggle as it is present in the superexploitation of French colonialism in Algiers, and to present a fairly detailed account of the class struggle and the development of industrialization in France in the nineteenth and into the twentieth centuries. He concludes by promising to make intelligible the real dialectical development of "History" in the next volume, by using the formal structures he has set forth in this volume.

Section 4. Conclusion of Volume One

Clearly, in the first *Critique* Sartre has made significant advances in understanding the concrete reality of human existence in the world. Even from the perspective of the first ethics and its goal, freedom for all, the *Critique*, more than any other work up to its time, embodies the most thorough account of the multiple factors that limit and condition human freedom, factors which must be controlled and modified by concrete sociopolitical actions if freedom for all, the city of ends, is to be achieved in human history. Totally gone is any suggestion that salvation is an individual matter of a pure reflection or a radical conversion to authenticity. In fact, the term *authenticity* is never used in the *Critique*. (Although, to be fair, the notion of authenticity itself had gained a significant social and political dimension in some works after *Being and Nothingness*, as we saw in the previous chapter.) Of course, the insistence on the need for people to work cooperatively with others in pledged groups in order to obtain more freedom for all is an extension of the notion of interdependency that was central to the social dimension of the first ethics.

Yet it is important to note that in the area of human relationships the *Critique* remains in some important respects within the parameters of *Being and Nothingness*. True, the relations of human beings in groups is not one of conflict but of unity, fraternity, and subject/object to subject/object, not unlike the relation of authentic love in the *Notebooks*. The unity of people in a group, however, is primarily a practical one of individuals acting together for a common goal. Two or more friends simply enjoying each other's company, having no goal other than the mutual sharing of themselves, do not appear

to be a group in Sartre's sense. Furthermore, relationships of love and friendship in the *Critique* (though interestingly enough, not in *Notebooks!*) are themselves rooted in common action and so are said to be simply further specifications of the relations of individuals who are unified by terror and fear into a pledged group.[28] But it seems incredible to think that a community united in love and friendship must be held together by violence or a threat of violence!

Why does Sartre consider the unity of the group to be so fragile that only terror can force it to stay together? Why could people not join and remain together out of love, especially since they see each other as the same? I believe that the answer is that in the *Critique* Sartre still views human beings as so individualistic, so ontologically separate, so fearful of the loss of their personal freedom, and hence so distrustful of others, that they can or will not cooperate and unite with each other over an extended period of time. His insistence on individuality and freedom is also the reason that he hesitates to grant the group a distinct ontological status over and above that of the individuals who comprise it, and it explains why he believes that the group tends to dissolve back into atomic units (seriality), no matter what steps are taken to preserve it. I think it also explains why Sartre remains undecided in the *Critique* whether the abolition of scarcity would really remove all alienation among human beings. Let me pursue this point.

Although he frequently suggests that human conflict arises because of scarcity and that abolishing scarcity will eliminate conflict, at the same time Sartre admits to being undecided whether all alienation can be abolished even in a situation of abundance. For even there, he says, human beings will remain ontologically separate, and might not this very separateness give rise to alienation?[29] Now in the *Critique* alienation refers primarily to the impotence of human beings because of their domination by forces (both human and practico-inert) external to them. Thus, when Sartre wonders whether alienation will be abolished since ontological separateness remains, he is asking whether some individuals, even in a classless society of material abundance, might not still freely choose to dominate and prey on others. Of course they might, or so it seems to me, though, presumably, they would have less reason to do so than in a situation of scarcity. Moreover, if I am correct about Sartre's propensity, even in the *Critique*, to view humans as free individuals who fundamentally desire to remain independent and in total control of their own

being, then I suspect that conflict remains not just a possibility but a *likely* possibility, even after the abolition of scarcity. Indeed, it is not clear to me why scarcity itself should result in conflict rather than increased collaboration among human beings—except that, to repeat, Sartre's individualistic conception of humans, as desiring complete control of their lives, renders conflict practically inevitable. Of course, this desire for total self-control is the old desire to be God, *ens causa sui.* In other words, it seems that it is basically because he believes that every human wants to be a self-cause, that Sartre considers each person always to be deeply suspicious of, and antagonistic to, other human beings and their freedoms. That is the reason why conflict results in our present world of scarcity and may well result even with its abolition. It also explains why only force, or mutual fear of the loss of their freedom, can keep humans together, even when cooperation is absolutely necessary for their long term mutual well-being.

Another respect in which the *Critique* retains a fundamental similarity to *Being and Nothingness* is in its tendency to emphasize antagonistic dualities.[30] From its first pages, free praxis is sharply opposed to inert, inorganic matter. Sartre also continually speaks as if objectification, the embodiment of praxis in matter which forms the practico-inert, is inevitably alienating and antifreedom. It is as if he is certain, or almost certain, that one's products will not turn out to be of overall benefit to him or her. Similarly, the processes of the practico-inert are labeled *counter* finalities, not the more neutral term *other* finalities. The praxis of others is most often called antipraxis, not just other praxis. Similarly, alienation is defined as an other having control over my practico-inert product, which seems to assume that such control is bound to be for my detriment, not benefit. The obvious exception to all this negativity is the group, yet even here Sartre speaks of freedom's limitation by the pledge as an "accepted mutilation" (*CDR*, I, 441), and we have already noted his portrayal of its degeneration into the institution and its return to the series as, in some sense, necessary.

This propensity to consider both worked matter and other human beings as antagonistic and threatening to the individual's free praxis and goals indicates to me, once again, that Sartre still has a very individualistic ideal. His model is an individual who would be totally free by being in complete control of her products so that she could use them to fulfill her needs (and in that sense be her own product,

i.e., *ens causa sui*), or totally free by being completely independent of matter and of others—like the absolutely free for-itself present in much of *Being and Nothingness* and in earlier works. In any case, while the *Critique* makes positive advances in understanding real concrete human beings and their world, Sartre's predominately negative portrayal of that relationship renders its ontological perspective somewhat deficient. We will see what ramifications this has on the second ethics.

Section 5. Volume II of the *Critique of Dialectical Reason*

A study of the *Critique* would not be complete without a few words about its posthumously published second volume. Although, like any manuscript Sartre himself did not finish or publish, it should not be given precedence over those he did, the fact is that *Critique* II is almost entirely a well-written, coherent work, one which possesses more structural unity than *Notebooks for an Ethics.* Furthermore, Volume II descends directly and logically from Volume I. It offers no new positions or categories of thought but continues the analysis of the first volume by applying the notions and structures which were set forth in it to a concrete study of our history, in particular to the history of the Soviet Union in the twentieth century. From the perspective of morality, the *Critique*'s second volume is important because it is closer in time to the major work of Sartre's second ethics, his 1964 Rome lecture, than is the first. This no doubt is the reason that some of the suggestions Sartre advances in *CDR* II's closing pages, suggestions which enlarge some basic notions of *CDR* I beyond anything found in that volume, are retrieved and amplified in his 1964 lecture, as we shall see.

The stated purpose of Volume II is to fulfill the project announced in Volume I, namely, to demonstrate that by adopting the dialectic we can show that our history, a history of scarcity, class struggle, and alienation, is a totalization with one overall meaning and direction, even though there is no single totalizer guiding it all. Volume II breaks off, however, without achieving this aim and, perhaps, with the realization that it is not achievable. Given Sartre's insistence that the ultimate source of history is the praxis of each individual organism, his categorical rejection of any superorganism in

which individuals would be submerged, and his repeated reluctance to attribute an ontological status to social realities, it is difficult to see how that project could succeed.[31]

A large portion of Volume II is a detailed and provocative study of the Soviet Union, from its revolution through Stalin. While Sartre's dialectical analyses are often insightful, his explanation of historical events by means of the economic, sociological, and other similar factors behind them is often so complete that the reader is left wondering to what extent individual freedom is present in this history. Intimately connected to this issue is the question whether moral evaluations can be made of the human beings and the historical actions involved, and, in fact, throughout his lengthy discussions Sartre does refrain from morally criticizing even those, like Stalin, whose policies he labels as atrocious and brutal. I will briefly review just one of his analyses to illustrate.[32]

After the revolution, the Soviet Union needed to rapidly industrialize in order to liberate the masses from poverty and preserve the revolution from external enemies. This demanded a huge supply of workers, but the civil war had killed many urban workers, and massive immigration of foreigners could weaken the revolution. Thus millions of Soviet peasants were conscripted for the work force. Since they were rural, illiterate, uncultured, and ethnically diverse people, ill-attracted or -suited to the discipline of urban industrialization, it was necessary to forcibly uproot them, educate, acculturate, and unify them into the industrial complex. This was done by an elite class of managers who, in effect, became the ruling class directing the historical process. (For reasons I will not discuss, power shortly came to be centralized in one person, Stalin.) In this way Sartre explains how the original goal of revolutionary praxis, the liberation of the masses, was, due to the primitive conditions of the Soviet Union in the early twentieth century, deviated into a rigid hierarchy and bureaucratic society. Was any other alternative possible? Apparently not, for he says that given the circumstances and the praxis "urbanization *had to be accomplished* in that way and no other" (*CDR*, II, 139). Yet he continues to insist, as he has throughout the *Critique*, that free human praxis is the ultimate source of Soviet history, including its deviations, even while suggesting that both the masses and their leaders had few, if any, alternatives.

The problem, once again, is that Sartre wants to claim a freedom, the freedom of praxis which transcends the present toward goals,

whether or not the individual has any alternatives from which to choose. I have repeatedly stated that I consider a notion of freedom without alternatives to be highly suspect. Be that as it may, I believe that it is because he believes that they had no real alternatives that Sartre is unwilling to criticize morally Soviet leaders who, he admits, did "atrocious" things to their countrymen. Perhaps they could have been a little less brutal and oppressive, but he seems to believe they basically did what had to be done to preserve the revolution, given the human material and time available to them.[33] Occasionally, Sartre suggests (this is in 1958) that since industrialization has occurred, because millions of peasants have become educated, productive workers (or perished), the Soviets could recognize that there is no need for continued authoritarian rule and finally become a decentralized, egalitarian democracy.[34] Nevertheless, I do suspect that if a truly socialist classless society were attained, Sartre would consider all the means taken by the leadership, including "destroy[ing] these workers as free practical organisms and as common individuals, in order to be able to create man from their destruction" (*CDR*, II, 150), to be morally justified because they were necessary to achieve that end.

I said earlier that Volume II of the *Critique* applies the categories set out in Volume I. I should add that it also makes some attempt to relate these categories, especially the most basic ones, praxis and matter, to the regions of Being discussed in *Being and Nothingness*. This comes roughly two-thirds of the way into *Critique* II when Sartre turns from a study of history to ontological considerations and reintroduces the terminology of being-for-itself and being-in-itself.[35] (In fact, he discusses the latter notion much more than the former.) Of course, the original abstract notion of being-for-itself is replaced by a concrete human organism whose relation to being-in-itself is not just negation and nihilation but dialectical interaction. The human organism must act on being-in-itself in order to satisfy its needs, and the fact that the being acted upon is *in itself* guarantees, Sartre says, that the whole dialectical process is not just an epiphenomenon of human praxis but an absolute reality which is in principle partially outside of human knowledge and control.[36] One result of this insight is that Sartre makes it clearer here than he did in Volume I that the ontological character of every concrete historical reality comes both from human praxis and from a world whose reality is not reducible to the dialectical structures human

history imposes on it. In other words, humans are dialectically conditioned not only by the structures they have imposed on nature but also by the structures inherent in nature itself, even though we cannot grasp the character of these natural structures apart from our perspectives on them and the meaning they have for us. It follows that any moral/political ideal or goal that presumes that human beings can someday fully control the practico-inert, and thereby completely become their own product, is fundamentally misguided.

From this perspective, the last few pages of *Critique* II are most interesting.[37] In them Sartre adopts a less antagonistic perspective on the relation between free praxis and the practico-inert. For the most part Volume II follows Volume I in portraying that relationship negatively and speaks of praxis as deviated and stolen by its practico-inert product, so that something unintended and unwanted is produced in nature, in society, and in the human source itself. Now he gathers up a few hints dropped earlier and suggests that the reverberations of the practico-inert on the human organism might be controlled and directed to achieve the aims of that organism. Although complete control of their products is impossible, human beings could so dominate them that, on the whole, they would be able to be used for the fulfillment of human needs. Sartre even seems to offer some hope that this might happen, for, he repeats, at the basis of all practico-inert structures are the needs of the human organism. Even when such structures are most oppressive and thwart their fulfillment, they originate from, *and are sustained by*, human needs: "neither the practico-inert, nor oppression, nor exploitation, nor *this* particular alienation would be possible if the huge, ponderous socio-economic machine were not sustained, conditioned and set in motion *by needs*" (*CDR*, II, 388). Furthermore, all praxis always has "an identical and unsurpassable goal" (*CDR*, II, 389), the satisfaction of these needs. This end is unsurpassable in two senses. First, it is ultimate; there is no further goal for which it is a means. Second, this end, human fulfillment, is directly or indirectly the ineradicable aim of all human praxis. To be sure, as Sartre shows time and again, worked matter (be it a machine or a social system) has its own demands which a person experiences as requiring his or her obedient service. Yet, Sartre insists, these demands "have meaning only in relation to the unsurpassable end. Why satisfy the passive demands of matter unless by neglecting them you risked death in the shorter or longer run?" (*CDR*, II, 387) In other words, the

requirements of the practico-inert "take on a meaning [as an imperative demand] because, *fundamentally*, the ensemble made up of the economic process and the organization of labor *relates to the preservation of the organism*" (*CDR*, II, 388). The human organism's needs demanding satisfaction supply the urgency of all ends, even those that appear most abstract and autonomous, Sartre says.

This point is extremely important and will be developed in the second ethics. While practico-inert structures, such as those present in capitalism and bureaucratic state socialism, may frustrate human needs, they are fundamentally rooted in, as well as contradicted by, these same needs. Sartre's final words in *Critique* II are that human praxis never lets itself be limited by any of its results, especially those that alienate the organism. Action struggles against its alienation insofar as it continually transcends every objectification of itself and its products. It "never lets itself be defined by the result—whatever it may be—that it has just obtained" (*CDR*, II, 392). So long as human needs are not satisfied, the struggle will go on.

This perspective gives a much more hopeful reading of human history than most of the *Critique* offers. If human praxis rooted in needs, whose unquenchable, unsurpassable goal is the fulfilled human organism, is the motor of all history, then oppression, degradation, and domination by the practico-inert will never be completely accepted or submitted to. Nor is it unreasonable to hope that their common needs will impel humans to work together, in pledged groups, to direct the effect on them of the structures they create so that scarcity can be abolished and the needs of all addressed. As Ronald Aronson points out, if the *Critique* had been written from this perspective from the beginning, it would have taken on a more positive tone by presenting the practico-inert, not as a danger to freedom, but as a positive instrument for human well-being.[38]

We shall see that Sartre's second ethics contains some of this positive perspective and that is one way that it is the legitimate offspring of the *Critiques*. More important, that ethics is grounded in the *Critiques'* fundamental ontological concepts: praxis, the practico-inert, the historical dialectic, and, especially, the free human organism whose needs posit human fulfillment as its unsurpassable goal.

7

The Second Ethics

In interviews he gave during the last decade of his life, Sartre stated that after he gave up his first morality (around 1950) as too abstract and idealistic and became more politically involved, he initially adopted an amoral political realism like that of many communists. This was a purely pragmatic position that evaluated policies and actions solely in terms of their political efficacy, in particular in terms of their promoting or retarding the coming of democratic socialism and the classless society.[1]

This often meant, as we found in *Critique* II, an unwillingness to morally critique the evolution of socialism in the Soviet Union and to criticize the horrendous actions of Joseph Stalin and/or the Communist Party from an ethical perspective. As I noted earlier, Sartre's tendency was to explain, and in that sense justify, them as either necessary for the advancement of socialism or, if not strictly necessary, as privileged, because performed by the only existing country or party that proclaimed socialist ideals and had any realistic hope of achieving them. Though he was uneasy with this position and never wholeheartedly subscribed to it, he says that he held it until the 1960s.[2] At that time he returned to considerations of ethics and worked to develop what he called a realistic, materialistic morality, based on the ontological foundations of the *Critique*. This is the second ethics, which we will expound in this chapter.

Although Sartre indicated that he wrote many notes for this morality for over a decade (from the early sixties to the mid seventies), at one time saying it "was entirely composed in his mind" and at another that it would appear shortly, no single work devoted to this ethics has ever been published.[3] It did, nevertheless, find its way into some published speeches, essays, and interviews of the period. Only recently available are the handwritten notes of a lecture Sartre gave at the Instituto Gramsci in Rome on May 23, 1964, at

a conference entitled "Ethics and Society," sponsored by the Italian Communist Party. Because this is the only work which offers a systematic and detailed presentation of the second ethics, I will discuss it at some length.[4]

The Rome manuscript has a significantly different status than the other unpublished and unfinished manuscripts of Sartre's that I have referred to in this book. Unlike *Notebooks for an Ethics* and the second volume of the *Critique of Dialectical Reason,* the Rome lecture was publicly presented by its author. Furthermore, a greater portion of it was published in Sartre's lifetime than of either of the other two manuscripts.[5] This indicates, I believe, that in his eyes most of the Rome manuscript was very close to, if not in, final form. (My own reading leads me to conclude that that is the case for more than 80 percent of it.) Add to this the fact that no less an authority than Simone de Beauvoir referred to the Rome lecture as "the culmination" of Sartre's ethics.[6] Thus, there is ample justification for considering it the defining document of Sartre's second ethics. (With all due respect to de Beauvoir, however, we must remember that since Sartre began a third ethics late in life, he must have believed that something was lacking in his second.)

Section 1. The Problem

The lecture's brief first section with the above title sets the tone and poses the issues Sartre intends to discuss. It also provides a good transition between *Critique* II and the lecture itself as well as a brief recapitulation of the development of socialism vis-à-vis ethics.

Sartre's opening sentence is, "The historical moment has come for socialism to rediscover its ethical structure, or rather, to unveil it."[7] Pre-Marxian socialism of the mid nineteenth century did present itself as an ethics, he says. However, it lacked a rigorous scientific knowledge of the material basis and social structures of society, and, as a result, its conception of humanity became an abstract, contentless ideal which turned into idealism. After the failure of the uprisings of 1848, he goes on, revolutionary organizations renounced speculation on the nature of man and sought to establish a concrete scientific knowledge of society, an effort which culminated in Marx's recognition that the class struggle is the mover of history. From this perspective, the important questions concerned not the morality but

the efficacy of particular plans for achieving socialism. With the coming of the Soviet revolution, world revolutionary organizations were called upon to defend, at whatever cost, that particular incarnation of socialism. During the Stalinist period, then, no revolutionary could be critical of the Soviet Union's policies for fear of weakening the historical movement toward socialism. The Soviet Union's own internal obligation was to consolidate the revolution by rapid industrialization and increased productivity. It was thought that the establishment of new productive relations would produce a new kind of human being. However, this way of looking at things, Sartre says, amounts to "sending ethics on vacation." Not only does it disallow the legitimacy of any moral evaluation of the actions of the Soviet Union, it considers the new human being and human society, including its morality, to be simply the necessary product of that society's economic substructure. Morality, then, is reduced to a mere epiphenomenon of human behavior, which is itself entirely conditioned by the infrastructures of society. Nevertheless, at the twentieth congress, after the death of Stalin and the end of rapid Soviet industrialization, morality was resurrected. Various practices and policies of the Soviet Union were condemned, not simply as strategic or tactical errors, but as morally wrong. Sartre provocatively suggests that one of the reasons for the revival of the ethical was to prevent a return of a Stalinist-like dictatorship.

The first section of the Rome lecture concludes by introducing the *Critiques'* dialectical conception of history and stresses the difficulties involved in reinstating the efficacy of the ethical within a social world that is constituted according to dialectical laws. The problem is, Sartre explains, that socialist ethics can be, and is, imposed on societies whose economic systems are not socialist. Revolutionaries do this, for instance, when they morally criticize Stalinist or capitalist societies in the name of socialist norms. Yet, at the same time, every morality, socialist included (and indeed, all social constructions), is dialectically conditioned by the more basic structures, especially the productive relations, of the society in which it exists. How then can the moral code of a given society, which is a result of its particular substructures, legitimately be used to judge a different society with different substructures and a different morality? This dilemma must be resolved, Sartre says, without making morality so general and contentless that it offers only an abstract universal sketch of an ideal human being, one which would

be irrelevant to real humans existing in concrete historical circumstances. A solution must also avoid making morality so particular or idiosyncratic (my word, not Sartre's) that it totally lacks general moral principles and so applies only to the individual society in which it is found. In that case, Sartre points out, we lose the unique and specific character of morality, for it is reduced simply to particular historical facts that express the behavior of the people in a given society. Sartre will amplify this criticism in the second section of his lecture.

Before we turn there, however, note that Sartre has so far very briefly reviewed some of the history of the Soviet Union from the revolution up through Stalin that he discussed at length in *Critique* II, but now from a moral perspective. His description of the development of socialist ethics, from idealism to an amoral pragmatic relation, parallels his own evolution from an idealistic morality to an amoral political realism. It is also abundantly clear that he is no longer in that amoral phase, for, unlike *Critique* II where *he* sent ethics on vacation, he now aligns himself with those who have reinstated ethics and have morally criticized the Stalinist dictatorship. Sartre's opening sentence is no less than a call for just such a recovery of the ethical dimension of socialism which, he says, has been too long veiled.

Section 2. The Experience of Morality

Sartre begins his second section by undertaking a phenomenological analysis of moral experience in order to set out its specific character. He centers on the "common ontological structure" (DF, 242) present in all such experience (whether it be of customs, duties, imperatives, or institutions), which he says is its normative character, meaning both its prescriptive feature and its possibility feature. Sartre explains that every norm, imperative, or value (the terms are not interchangeable; norm is the generic one),[8] presents itself in experience as demanding obedience no matter what the circumstances or conditions. The experience of a norm as a moral requirement that must be met *no matter what* means that a person has the *possibility* of obeying it, no matter what his or her situation. This in turn means that a person has the "inner power" to determine his or her future behavior, and thus his or her future being, free from

the total domination of external factors. In other words, Sartre argues that the experience of moral norms as unconditional, that is, as demanding obedience no matter what the circumstances, is an experience of human freedom.[9]

Furthermore, insofar as the norm calls me to freely create my future self independent of my past and present external circumstances, it calls me to a "pure future," Sartre says, one neither totally predictable in terms of the past nor determined by it. (He speaks initially of this future as "in no way" determined by the past, but catches himself just a few pages later and admits that the past conditions the future.)[10] Just what this pure future is remains to be seen.

In addition to the normative, prescriptive structure of moral norms, there is always, of course, a specific content or factual character to them. Norms always prescribe the doing or not doing of something or other; they say, for example, "don't lie" or "marry within your tribe." Such prescriptions are "particularizations and limitations of the normative structure in its generality" (RL, 14), Sartre states, and the particular content expressed in a norm or code of norms is conditioned by the structures of its society. However, he rejects any positivistic attempt to completely reduce norms to facts of behavior, that is, to the moral conduct and customs described by the social scientist. Even when the morals of a given society do no more than oblige one to repeat the conduct of the past, they still possess an unconditional normative character, for they proscribe performing that past action in the future and assert that it must and, therefore, can be done, no matter what that future may be.[11] To make his point, Sartre undertakes an analysis of the controversy that had recently taken place when some mothers in Liège, who had taken the thalidomide pill, killed their severely deformed babies.

I will not repeat his detailed account but only point out that he argues that those (whom he calls *neoPositivists*) who claim that different moral norms are nothing more than the product of the different structures of different societies fail to account for the lived moral experience of these mothers. For they, who in anguish debated whether or not to kill their babies, experienced a serious conflict of moral obligations. On the one hand, there was the norm (in an agrarian society) which states that all life is of value; on the other, there was the norm (in a bourgeois industrial society) which states that only life *of a certain quality* is of value. Now if norms are totally

reducible to facts which describe customs or conduct, then their character as norms, that is, as moral *demands* or *requirements* to be obeyed, is lost, Sartre insists. Facts oblige nothing; it is the unconditional *obligatory* character of different and opposed norms that is lived in moral conflict. To disregard this dimension of moral experience is to disregard the precise ontological structure of the norm.[12]

Those who reduce norms to facts also reduce all history to the evolution of practico-inert systems, Sartre complains. In doing so, they eliminate human agents and their praxes. These neoPositivists, structuralists, and even some Marxists thereby ignore the dialectical character of history. As in the *Critiques,* Sartre insists it is human beings who make history, human beings who are in turn conditioned by their physical and social products.

At this point in his lecture, Sartre somewhat abruptly links the twofold character of moral norms (pure unconditional obligations on the one hand and content conditioned by particular social systems on the other) with the class structure of capitalist society.[13] The bourgeois, who benefit from it, support the capitalist system with its particular moral imperatives, values, and customs. In doing so they imprison (and alienate) the unconditional character of ethical norms in the practico-inert structures of capitalism. The oppressed proletariat also support that system in order to survive in it, but at the same time, and more deeply, they contest it. In doing so they seek, Sartre claims, a "pure future beyond the system" (DF, 251), one based on the ruins of capitalism. Indeed, he goes even further and states that the pure future the oppressed seek is an unconditioned future, "to be created—not by building a system (not even a *socialist system*), but by destroying every system" (DF, 251). This is because, whether they explicitly know it or not, the oppressed basically respond to norms insofar as they are unconditional and pure, that is, not limited by the content of any system. Accordingly, they seek a future not only beyond capitalism but beyond every system which conditions and limits.

Sartre offers a similar argument based on the very nature of praxis, an argument he alluded to at the end of the second *Critique.*[14] History, he reiterates, is a combat of practico-inert and praxis with each winning in its turn. Although praxis is rooted in and conditioned by past and present systems, it always transcends its past and

present toward a not yet existing future. Therefore, praxis in principle involves the destruction and negation of all practico-inert systems and, as such, has as its ultimate goal an unconditioned future. Sartre adds that since history is rooted in human praxis, and especially in the oppressed class, it too has this future, a future without systems. But, he now asks, what exactly is this unconditioned future that is the direction and meaning (*sens*) of history?

To answer he returns to the thalidomide example and attempts to show that the mothers who killed their babies did so in protest against the inhuman conditions of our world and in the name of the possibility of living a totally human life. "Human plenitude," "the fully alive human organism," human life as the possibility "of realizing in itself and for-and-through-others integral man" (RL, 55): these are the ways Sartre characterizes the goal of the Liège mothers, and of all members of the exploited class. The unconditioned possibility to become *man* is the ultimate unconditioned moral norm which guides their praxes and through them all of history. This, then, is the "true ethics," Sartre states, which is the *sens* and overall unity of human history.[15]

Sartre readily concedes that the exploited often do not know that integral humanity is the goal they seek. They are frequently mystified and duped by their oppressors and by the alienated moralities which the latter instill in them. In concrete historical circumstances, the oppressed may seek to replace another's repressive system with their own, instead of pursuing human plenitude for all. Nevertheless, he continues to maintain that integral humanity is the true goal of the oppressed, of history and of all human praxes, even of those that produce alienated moralities and submen. Sartre's defense of this last claim is particularly interesting. He argues that insofar as the ontological structure of every moral norm embodies an unconditional obligation, it calls us to create an unconditioned future, one which transcends all systems. Inasmuch as all specific norms of particular moralities in given societies contain, in addition to their specific content, an unconditional character, these norms all contain a solicitation towards such a pure future, no matter how warped and alienated their particular content may be. In this way, Sartre says, the true ethics, which has our unconditional future as its goal, is incarnated in all alienated forms of morality. Moreover, since it is their specifically normative (prescriptive) character that makes par-

ticular societal imperatives and values into norms in the first place, rather than just facts, the pure norm, Sartre argues, is the *basis* of all particular norms. It is this basis at the same time that it contests its particular limitations in a given moral code. Similarly, insofar as all praxis acts for norms which, in addition to their content, possess an unconditional character, all praxis seeks an unconditioned end. This end, Sartre says, is present in even the most trivial daily action and in the least gesture, whether one realizes it or not. This end is *man*. Thus, all praxis "fundamentally or indirectly tends to produce man—even if it in fact realizes his destruction" (RL, 72).[15]

This concludes my summary of the second section of the Rome lecture. Although I will save most of my evaluation until later, I do want to call attention to the way Sartre has argued so far for the identification of the pure norm, the unconditioned future goal of all praxis and hence of all history, with man or integral humanity. He has attempted to establish the linkage primarily by means of an analysis of one historical case, and by appealing to (but not actually arguing for) the Marxist position that the oppressed class is the ultimate motor of history and that, whether it knows it or not, this class seeks as its ultimate goal a future of human plenitude for all. Now, needless to say, even if the Liège mothers who killed their babies were, unknown to themselves, acting for integral humanity, that would hardly establish a more general claim that *all* human praxis which acts for the sake of norms has this goal. Similarly, since it is certainly not historically the case that all oppressed classes have in fact (even unknown to themselves) always acted for the sake of the human fulfillment of all, nor even that the oppressed have always been the primary movers of history—and Sartre concedes both of these points[17]—he needs to do much more than appeal to traditional Marxist doctrines to support his position. In order to claim that all human actions, and hence human history, in some deep sense have human fulfillment as their ultimate goal, he needs to show that there is something deep within the structure of human beings that makes it so. In fact, on the last page of his second section, Sartre appears to recognize this point for he writes, "it is necessary to find at the most profound depth of human reality, that is, in its very animality, in its biological character, the roots of its ethico-historical condition" (RL, 73). If we just stopped here, he adds, what we have presented so far would be an overly idealistic account of the human condition.

Section 3. The Roots of the Ethical

Section three is the longest part of the Rome lecture. Most of it consists of a discussion of French colonialism in Algiers,[18] a topic Sartre had already considered in his first *Critique*. While his analysis is interesting, since it involves moral appraisal of a concrete historical situation, it would take me too far afield to present it in detail. For our purposes let us note that Sartre argues that the system of colonialism, including its morality, involves an alienation of true morality. Because the colonist sees himself and his system as both a fact and a norm, he considers his moral obligation to be the maintenance of both. Like all bourgeois humanism, colonization limits the unconditioned end of true morality, integral humanity, to the man of the system of colonization. The colonist defines *man* not according to his membership in a species but as a colonist. Algerian natives, for their part, are kept in a state of subhumanity by the system, a state they are never allowed to leave since even to admit that they could become human, that is, become colonists, would destroy the system and those now privileged by it. Yet in a larger sense, the colonists too are oppressed. They are dialectically "forced" by the motherland which exploits them, and by each other, to maintain the oppression of the natives even if individually they might not want to. Racism, Sartre says, is an imperative forced on the colonist by the praxis which is crystallized into the system of colonialism. He concludes these initial remarks by repeating that the source of these inhuman moralities is our true end, integral humanity: "the only source of these inhuman moralities which refuse man all becoming is integral man as our unconditioned possibility." It is this relation of man to himself, across history and its deviations, he says, that we posit by every action and limit by every alienated morality. The end even of colonial morality, "*it is man*; without the relation of man-agent to man-end, no inhuman end would be possible" (RL, 95). Once again he states that since all praxis continually transcends the practico-inert structures it creates, it thereby dissolves those limitations which are the mutilations of man by things.

So far Sartre's analysis mostly repeats that of the previous section of his lecture. Now he moves to directly address the issue he raised at the close of section two, namely, the necessity of discovering the roots of the ethical (and of history) in the very depth of human

reality. In doing so he returns to some points he made at the end of the second *Critique*. We must discard the alienated moralities, he writes, and attempt to grasp moral reality in itself, that is, to grasp praxis as constituted by its unconditional (not limited or alienated) end. Does this moral reality exist somewhere in its purity, he asks, and in response he returns to the colonized, the inhuman products of colonization. As he did in section two, he claims that such oppressed people are both the product and the challenge of the system. There is in them "an incomprehensible force" which leads them to refuse the inhuman status imposed on them by the system and to deny it in the name of man. This force demands the end of the subhumanity of man and "is the very root of ethics, its gushing forth at the deepest level of materiality" (RL, 97)."[19] This root, he states, is need, a concept which, as we have seen, has been central to his thought since the *Critique*. Needs, Sartre goes on, are not just inert lacks of some object. They are felt exigencies, felt (at least obscurely) demands for satisfaction. Through its needs the organism negates and surpasses its situation and affirms its integrity as an organism as its own absolute end and as its "duty-to-be [*devoir-être*]." Accordingly, from need, Sartre says, arises "the first normative structure," for "by need, which demands to be satisfied, human life is *given to be reproduced* by man" (RL, 98).[20]

Recall in this connection that at the close of *Critique* II Sartre asserted that the demands of every practico-inert system appear to us as requirements precisely because they arise from human needs which insist on being satisfied. He now makes the same point about morality and moral norms, arguing that it is our own needs that cause us to experience moral norms to be obligatory or prescriptive. (Remember that his phenomenological analysis of section two showed that the basic ontological structure of every moral norm, whatever its content, was its prescriptive character.) Needs *demanding* to be satisfied cause their goal, the fulfilled human organism, to be experienced as our *normative* future, the end that *has to be obtained*. Note, by the way, that this norm or end is not something we human beings freely select; it is "given," Sartre states, as our goal by our needs.

Needs also posit the organism as independent of its environment to some degree since they require the organism to work on its surroundings and change them so that they can be satisfied. Needs demand that praxis subordinate the world to the organism but, in

order to act on the inert, the organism must itself become inert, Sartre says, and that is the very moment of alienation. Yet, he adds, this alienation is quickly dissolved by the integration of the thing into the organism, for example, by eating. I mention this because it is one of the few places in the lecture where Sartre gives some indication that he recognizes that the practico-inert product is not always opposed to, or alienating of, human praxis but can be controlled and used for the enhancement of human life. Sartre concludes this first treatment of needs with the following succinct summary: "The root of morality is in need, that is, in the animality of man. Need posits man as his own end" (RL, 100).[21]

Lest one think that by rooting needs in the "animality" of man, Sartre is postulating no difference between animal and human needs, he immediately adds that animal needs become human when they are present in a human environment, and that my needs reveal to me my dependency on other human beings and their praxes.[22] Later he will make the same point by asserting that we become human only through human culture in human societies.[23] Clearly, then, although in one sense there may be little apparent difference between a human's and an animal's basic biological needs, humans have needs that impel them to seek their fulfillment beyond the animal realm in human society and culture. I take it that this is what Sartre has in mind when he states that even their minimum *human* needs are sufficient to uproot the oppressed, degraded colonized people from the animal realm.[24]

By rooting morality and moral norms in human needs, Sartre has provided himself with a solid ontological basis for many of the claims he made earlier in this and the previous section. I am referring to his assertions that true morality and its pure norm, human plenitude, are at the basis of all alienated moralities; that all praxis, even that which produces systems which thoroughly alienate human beings, has integral humanity as unconditional future and goal—and that human history also has this goal. Let me explain.

In the first place, as we have seen, needs, which demand to be satisfied no matter what the situation, are the source of the *unconditional* character of moral norms for Sartre. No matter how variable its particular content, every human moral system possesses an unconditional normative character, not because it is rooted in some superhuman eternal absolute, but because it is concretely rooted in the needs of human beings who are present in all kinds of

conditions in different cultures and societies. Inasmuch as human organisms share the "universal human condition" (*EH*, 46) as members of the same species, they apparently have the same *basic* needs. Although he is famous for denying a universal human nature, Sartre himself distinguishes between man defined as a member of the human species (sometimes called *nude* man by him) and man defined by a particular socioeconomic system, and he clearly indicates that the former should be primary.[25] The needs of human beings in diverse cultural systems and in various historical periods do obviously differ, but all humans as members of the same species have in common the same ultimate norm or goal, the fulfillment of their basic *human* needs to become more fully human.

Now, since all praxis, including the production of morality, issues from human needs that demand fulfillment in every situation, Sartre can legitimately argue that even the alienated moralities and norms of oppressive systems are rooted in, and obtain their unconditional normative character from, such needs and their unconditional norm, integral humanity. In other words, it is only because they too arise from human needs unconditionally requiring satisfaction that the values and imperatives of particular, even inhuman, moralities are experienced as norms, that is, as demands and obligations which have to be realized. (In the second *Critique*, as we saw, Sartre made exactly the same argument about alienating practico-inert structures.) It is reasonable, then, for him to claim that alienated inhuman moralities are, at bottom, limited, truncated versions of true morality and its ultimate norm and goal.

I should add that Sartre proposes another, more questionable, reason for holding that alienated moralities are limitations of true morality.[26] It rests on his assertion that needs are not blind, unconscious forces but are "felt" exigencies. He apparently means by this that human beings are never totally unaware of their basic needs but in a prereflective, nonthematic way are always conscious of them and of their true goal. He claims, for example, that we as well as the oppressed know that we are subhuman because we have an obscure awareness of the human which we are not. Also, he speaks of those who create alienated moralities, and thereby erect barriers to the true human future, as having "an obscure intuition" of that future which they deliberately deny to others. Similarly, he accuses colonists of racism when they deny humanity to the colonized because, he says, the colonists are really aware that man is the true future of man. In

these ways Sartre suggests that both the oppressed and their oppressors are, at least nonthematically and nonreflectively, conscious of the true goal of morality and thus are aware that alienated moralities are its limitation.

Rooting morality in needs also allows Sartre now to claim what he briefly hinted at in *Critique* II, namely that every human action and all history has human fulfillment as its goal. Since the source of every praxis, even those that produce oppressive systems, is human needs seeking satisfaction, it makes sense to say that all praxis has, in some deep sense, integral humanity as its true goal. (It seems analogous to Aristotle's claim that all human beings ultimately seek happiness, even when they create misery and suffering for themselves.) Since human praxes and their products are the source of human history, it follows, then, that integral humanity is also history's ultimate goal. Actually, in this lecture Sartre's position on history is somewhat ambiguous. Occasionally he speaks, as he did in the *Critique,* as if all of history is *in fact* moving toward this single goal; other times he sounds as if he means only that history *should* move toward this end.[27] The second view certainly is noncontroversial—if all humans seek integral humanity, the fulfillment of their needs, it surely makes sense to advocate that history be directed toward that goal. I suspect, however, that Sartre's position is somewhat stronger without, of course, his ever claiming that the human ideal will inevitably be achieved. The fact that each and every human being seeks the fulfillment of his or her needs, the fact that all praxis aims at this goal, provides grounds for hoping, and perhaps even *expecting,* that human history in general is moving in that direction. In an interview given a few years after the Rome lecture, Sartre did say that a reason for his optimism about the direction of history is that he feels in himself needs which are the same as those of every man.[28]

Yet even after he has rooted morality, praxis, and history in human needs, Sartre still continues to single out oppressed people and to claim that it is specifically through them that history aims at the goal of true morality, integral humanity. However, since he once again readily admits that the oppressed Algerian natives (his example) are duped into believing that human fulfillment lies in being a colonist, and since he even outlines in some detail the steps the oppressed need to go through to come eventually to recognize that their true end is a future man beyond all systems, it is difficult to understand how he can justify giving such primacy to the oppressed.

If they can be so unaware of their true end that they must go through a laborious developmental process to attain that awareness, it seems gratuitous to claim that they do in fact seek that ideal goal. As far as I can see, the strongest reason Sartre offers for his faith in the oppressed is that they are, or are more likely to become, more conscious of their true human needs and goals than are their oppressors who have a stake in preserving their privileged status in the present system. If their oppression increases to the point that the masses can barely satisfy their needs at all, then those needs will even more forcefully and clearly demand fulfillment, and it will become evident that that requires destruction of the present system and of those who enforce it.[29] Once again, I must protest that, in the face of numerous historical revolutions of the oppressed that have ended up simply substituting a new set of oppressors for the old, Sartre is too sanguine about the underlying motives and goals of subjugated people. Be that as it may, I have no quarrel with his desire to give moral priority to the liberation of the oppressed, since they are, after all, the vast majority of the human race.

The third section of the lecture concludes with Sartre offering an interesting expanded interpretation of Kant's dictum—if you must, you can. In his previous section Sartre argued, like Kant, that the experience of unconditional moral norms meant that human beings were always free, no matter what the circumstances, to obey these demands. He now pushes this point further and claims that to experience man as one's unconditional moral norm means that one can, no matter what the circumstances, become human to some degree. It is always possible, he states, to surpass the subman in yourself and in your oppressor and to make man exist. It may be that the most that the oppressed colonized natives can do is negative, that is, risk their lives by refusing any support to the colonial system. Nevertheless, by being willing to die or to kill in fighting the system, the natives show themselves to be free men over and against that practico-inert structure. In this way, they become not only the producers but the advent of future man, Sartre says, for "every producer of man is man" (RL, 125).[30]

Of course, it would be better if both colonized and colonizer joined together to destroy the system, which in fact oppresses them both. Integral humanity will be fully achieved, Sartre states, only when human beings unite to control the practico-inert to make it satisfy their common needs.

There will be no integral man as long as the practico-inert alienates man, that is, as long as men, instead of being their product, are only the products of their products, as long as they do not unite into an *autonomous praxis* which will submit the world to the satisfaction of their needs without being enslaved and divided by their practical objectification. There will be no integral man as long as each man is not totally a man for all men. (RL, 135)[31]

Section 4. Morality of Praxis and Alienated Moralities

The brief fourth section of the Rome lecture is the least finished; the final two-thirds of it consists primarily of an outline of items to be filled in later. It is also the most repetitious of all the sections. Nonetheless, Sartre does address some new items and occasionally offers helpful amplifications or applications of positions adopted earlier.

Sartre begins his final section by stating that "The fundamental norm of praxis, or the pure future, is distinguished from alienated morals by its radical exigency." A couple of sentences later he refers to the "*radical morality* which comes from need" (RL, 139).[32] Although he does not pursue the point, it seems that he is cryptically suggesting how one might distinguish between the norms of alienated moralities and those of the true morality, which has integral humanity as its end. His proposal seems to be that true morality is more *radical* than alienated ones, for it is rooted in the most fundamental needs of our being. While all moralities ultimately arise from human needs, the content of alienated moralities does not express these needs or their goal in their purity. Instead, such moralities present a perverted norm and image of humanity, since they are limited and conditioned by the alienated systems in which they exist. Sartre appears to have in mind in these brief comments the distinction he made earlier in the paper between human beings and the needs they have as members of particular practico-inert systems, and human beings and the needs they have as members of the human species, called *nude* or *universal* man here.[33] True or pure or radical morality and its norm/goal, integral humanity, is founded on the latter; alienated moralities and their norms/goals on the former.

Unfortunately, his remarks are so brief that one cannot be sure. However, since it is crucially important for a morality based on needs that one be able to distinguish between true and alienated moralities, norms, and needs, I will return to this issue in a later chapter.

After the opening comments, the fourth section of the lecture consists primarily of the following: 1. Sartre supplies a little more content to his moral ideal, and 2. he offers practical moral advice to his audience about how to work in history toward achieving that ideal.

As for the first, Sartre says his ideal is a society in which human beings unite to dissolve the practico-inert as soon as it is formed. This would be a society where economic structures and alienated moralities do not produce human beings, but, through "communal decisions," humans produce themselves. "This means a solidarity," Sartre writes, "such that the entire human group, fighting against the division of labor renders to integral man the entire product of his work" (RL, 143). The ideal society is classless communism. It will perpetually crush all systems, including the system of socialism. Though socialism has as its object the creation of communism, the former is itself still a system with practico-inert structures. We must recognize this, Sartre advises, lest we take socialism as an end rather than a means.[34] We must also realize that the crystallization of praxis into practico-inert structures can never be totally avoided, and, even more, that in order to destroy alienating structures our praxis must itself create and use its own structures, organizations, and institutions (such as unions and parties). (Once again Sartre shows that he recognizes that practico-inert structures can be instruments for human fulfillment, not obstacles which thwart it.) Although revolutionary morality has integral humanity as its far-off goal, he adds, it has to limit itself at present to actions which here and now address the concrete historical needs of today's battles.[35]

This brings me to the second point, Sartre's practical moral advice. I call this advice *moral* because it is offered to "revolutionaries" to assist them in the concrete historical circumstances of their lives, that is, in an oppressive capitalist society, to take practical actions aimed at eventually realizing the moral ideal, human fulfillment in a classless communist society. Among these actions may be terror, which Sartre believes can be justified under certain conditions.

In my opinion Sartre's most significant recommendations and suggestions are the following.[36] Using the language and categories of

the *Critique*, he stresses the need for revolutionaries to join into groups pledged to continue to work against oppression. At the same time they must consider all social structures as provisional, for they must insist on the preeminence of the human over every practico-inert system, even those created to battle oppression. In other words, in the name of the fully human, revolutionaries must not only fight against the inert systems of their oppressors but also against those they construct, for both limit the true goal which is unconditional. This also means they must continually reflect upon their particular actions and policies and morally evaluate them in the light of their ultimate end. Given his insistence on the central role of the oppressed, it is not surprising to find Sartre declaring that it is especially necessary for revolutionaries to remain close to the exploited masses. Although at present they may need leaders and intellectuals to guide them and articulate their deepest needs, such leaders must be certain that their thoughts and actions are grounded in the experience of the oppressed. The leaders must always be willing to explain and rationally defend their actions to the masses, not simply impose them by force. They must admit that they are not infallible, the masses may know better, and they should even be willing to have the masses dissolve their leadership. Equally impor-tant, those who obey the leaders must see their leaders' orders as their own free decision. Although he does not use the term, it seems clear that Sartre has in mind here the *Critique*'s notion of *sameness*, for both leaders and the led are to see themselves as one in practice inasmuch as they consciously and willingly act together for the coming of true humanity.

Terror, or violence, even against those who act with me for true humanity, can be justified under certain conditions, Sartre explains:

1. It must be only provisional and cannot produce systems which keep human beings perpetually in a condition of subhumanity.
2. It can never be the first resort or easy way out. It must be the "sole possible means to make man."
3. It has a good likelihood of success.
4. It is born of the masses.
5. One struggles against it even in using it so that it is rigorously limited to what is absolutely necessary.
6. It must be denounced and presented as subhuman to those subject to it, so that it does not hide their true goal from them.

7. It must be "humanized" terror, meaning, as in the *Critique,* it must be rooted in fraternity, not just imposed by some authority. That is, it must be founded in a group whose members have pledged themselves to remain together to achieve liberation.

In general, Sartre says, all means to attain the end, integral humanity, are good, so long as they do not pervert it.[37]

The lecture ends with Sartre urging the creation of an "ethics of history," that is, "the identification of history with the dramatic development of morality" (RL, 162). True morality and its goal should guide human praxis and through it the direction of history. Socialist, or revolutionary, morality at present is precisely this, Sartre states: man's self-control of the historical enterprise in the light of his true end and norm—unconditional man in a communist society.[38]

This concludes my summary of Sartre's most extended account of his second ethics. I will devote a later chapter to a detailed comparison of it with the first ethics. The next chapter will consider works Sartre wrote in the decade or so following the Rome lecture, for they can provide further information about the second morality.

8

The Second Ethics Continued: After the Rome Lecture

The major work that Sartre published after his 1964 Rome lecture was his three-volume study of Flaubert in the early 1970s. I will devote the second section of this chapter to it. First, though, I will review many of the shorter pieces (essays, lectures, and interviews) Sartre published in the ten years following the lecture. Needless to say, I am interested in them and in *The Family Idiot* insofar as they can add to our knowledge of the second ethics.

Section 1. The Moral Ideal

A number of these works supply more information about the second ethics' ideal society. As he has so often before, Sartre frequently insists that we who live at this moment of history, in a world of scarcity and alienation where the masses are oppressed and dominated by a few, cannot possibly conceive in detail the nature of the morally ideal society. Nevertheless, especially after the French student and worker uprisings of 1968, he does offer some new notions about its structure, partly because he believes that something akin to it briefly came into existence on a small scale in those spring revolts.[1]

An essential ingredient of his ideal society—and this has been a constant theme since his early works—is that it is one without hierarchies or classes, and thus without power concentrated in an elite few who control the many. Instead of a ruling class, or state, Sartre wants complete equality, a government by the people in the fullest sense. All people should have the right to participate in the

economic, social, political governance of their country through "organs of decentralized power in work and in the entire social domain" (*ORR*, 108).[2] In the economic sphere these organs would involve collective ownership and management of the means of production. He points with approval to the workers' councils (existing in, for example, Sweden, Germany, and Czechoslovakia for a brief period) which elect their own management. He particularly cites Czechoslovakia where, in the spring of 1967, such councils sought to direct and control their production by cooperating with similar worker organizations in other countries.[3] Lest Sartre's ideals sound too farfetched, may I point out that a number of European countries presently have workers' organizations which exercise a great deal more control over their work and production than is traditionally the case with American workers and their organizations. In fact, in some countries such participation is required by law.[4] Perhaps Sartre has such organizations in mind, though he apparently wants their control over production to be much more complete than it is at present.

In the political sphere, Sartre advocates *direct* democracy, a society where the masses unite into a pledged group to express their wishes effectively. Even if a direct democracy has to take a representational form, he wants a new system in which, for example, a representative elected by 5000 people would "be nothing other than 5000 persons; he must find the means for himself to be these 5000 persons" (*ORR*, 307).[5] (No doubt the *Critique*'s notion of sameness is operative here.) Direct democracy would also involve "popular" courts, that is, a judiciary chosen by the people, similar to those that spontaneously arose in France in the late sixties.[6] At that time workers in factories and mines set up people's courts and publicly staged trials of their bosses and owners. Sartre often participated in such courts, as he did on an international scale in chairing the Russell tribunal which passed judgment on the United States' war in Vietnam.

Of course, even in a direct democracy, once policies are determined by the people, their implementation may be the task of a smaller number of expert technicians. Still, Sartre says, the practical applications must always be guided by the masses. At every opportunity those charged with applying policies must return to the people to make certain of their support and to ensure that they do not become isolated from their needs and desires. As in the Rome

lecture, Sartre asserts the need for continual revolution in society, a revolution against all tendencies toward institutionalism, centralization of power, and bureaucracy. He comments favorably on the Chinese cultural revolution which he views as just such an attempt to keep in touch with the masses.[7] In Sartre's direct democracy, the group would not be allowed to become an end in itself and so to degenerate into an inert bureaucratic institution. It would remain as a pledged group, always taking the free development of its members as its goal. Thus, even though he continues to refer to his ideal as socialism during this period (not communism, as in the Rome lecture), it is clearly a decentralized, debureaucratized, and democratized version. I should add that he also recognizes that socialism itself is not a univocal ideal. It will take different forms in different concrete societies with their particular histories, structures, and needs.[8]

In order for a direct democracy to work, Sartre says, there would have to be complete openness of human beings to each other. Human beings have to reveal their basic needs and desires: "A man's existence must be entirely visible to his neighbor, whose own existence must be entirely visible in turn, before true social harmony can be established" (SP-*L/S*, 13). All must be free to share their opinions and also to seek the knowledge that they need to participate effectively together in self-government. This means there must be "the widest social diffusion of truth" and, therefore, freedom of the press; no censorship nor control of the media or the system of education by an elite few. The people must be free to criticize any established body of truths about the human condition and the world in which they live. Rational persuasion based on love and esteem, not lies or other techniques of domination, must prevail, Sartre says.[9]

His reference to love and esteem indicates, I believe, a rather significant enlargement of his concept of human relationships. Recall that in my conclusion to Chapter 6 I pointed out that in the *Critique* the unity of persons, even in Sartre's ideal, the pledged group, is a practical one of individuals who act together for common goals. Furthermore, such individuals are united by terror and fear; even love, friendship, and fraternity were said to be based on the threat of violence. In post-*Critique* works, however, Sartre speaks of the group relationship as eliminating *all* thought that would conceive of the other human being as a threat to, or even indifferent to, oneself and his or her goals. Precisely because the unity of the group

overcomes the atomistic individualism that separates people, racism, sexism, and classism disappear.[10] Even more significantly, in the works we are now considering, Sartre shows that he is aware that relationships that are totally practical in character are not the same as friendship, "a relation which surpasses the action undertaken" (*ORR*, 77). He complains, for example, that the Communists do not value the latter and so discard individuals when they no longer have "use" for them. He indicates that his ideal human relations include kindness, respect, and love, none of which does he reduce to common praxis nor does he speak as if they are based on terror.[11] However, since these works contain no detailed discussion of human relationships, it is impossible to know precisely the extent to which he has changed. Our study of *The Family Idiot* will shed more light on this issue.

In order to achieve the mutual cooperation, respect, love, and sharing of knowledge and power that is to be present in Sartre's ideal society, it is absolutely necessary that the division of labor, which gives rise to narrow specialization and thus class distinctions, be abolished. Sartre has advocated this from his earliest works, and now he explicitly draws out some of its most challenging implications. In the ideal society there will be no intellectuals who specialize in knowledge, no workers who specialize in manual labor, no politicians who specialize in politics, nor others who specialize in producing or disseminating works of culture. In the ideal society all people will be both intellectual and manual workers.[12] He likes what he has seen in some Israeli kibbutzim: "a shepherd . . . who reads, reflects, writes while looking after his sheep" (*ORR*, 102). All people will be political in the sense that they will exchange reasons, motives, and principles as they come to a consensus understanding about what they are and how they should act. Though he admits he is vague about the form culture will take in such a society, he clearly believes that everyone will participate in it; the culture will be determined by the people themselves for the benefit of all. In present-day capitalism culture is a bourgeois monopoly and the masses are, therefore, deprived of their share of the intellectual and aesthetic life. The ideal classless society will preserve the great works of art of the past but in a new form impossible to describe at present, he says.[13] I might note in this connection that, as we shall see in his study of Flaubert, a basic reason Sartre's ideal society is to be composed of human beings

who are capable of being intellectuals, workers, and political and cultured people is that he believes that there are no innate talents or gifts which some people possess and others lack. All humans are literally created equal, Sartre believes, and it is only because of particular social structures that some become intellectuals or highly cultured or politically expert while others do not.

Sartre's reference to the role of culture in his ideal society is consistent with the importance he placed on it in the Rome lecture. Only through culture transmitted to us by our fellow human beings, he said on that occasion, do we actually become human. This indicated, I suggested in the previous chapter, that Sartre conceived human *needs* and, correspondingly, human *fulfillment* as involving far more than just biological satisfaction. This is verified in the works we are presently reviewing, for Sartre explicitly speaks of the need for freedom and sovereignty, the need for people to make sense of their lives, and the need to communicate (and, hence, the need for others).[14] He also implicitly refers to the need for a popular (rather than bourgeois) justice and equality.[15] However, although he indicates that he still considers them to be important, explicit references to needs in these works after the Rome lecture are few. Similarly, the language of integral humanity, or human beings with needs fulfilled, which he proposed as the ultimate goal and norm of his second ethics, is rarely used, although he frequently does repeat that *man* is the future of man, that *men* should be their own product, and that his goal is socialist *man*. No doubt one could, without much difficulty, infer from his sketch of the ideal society, a whole set of human needs that Sartre designs that society to satisfy: needs for knowledge and truth, for love and respect, for whatever is included under the heading of culture, not to mention for basic physical goods. Still, given their centrality in the Rome lecture, it is puzzling that the vocabulary of needs and their fulfillment is not more prominent in these works that follow it. (As we shall see, needs language is quite conspicuous in *The Family Idiot.*) Be that as it may, the fact remains that these works do shed light on Sartre's ultimate moral goal, particularly on its political dimensions. As for practical suggestions to achieve this goal, the major advice Sartre gives is to stress again that one must join with the oppressed masses in their moral fight for liberation. A new feature to such advice, however, is that he now frequently addresses it specifically to intellectuals.

For obvious reasons, the moral obligations and role of the intellectual in achieving the ideal society were a matter of deep concern to Sartre. He addressed the topic frequently in the lectures and interviews of this period, and his final advice, given after the student and worker revolts in the spring of 1968, sounds almost anti-intellectual. This is because the events of 1968 occasioned a radical change in his own conception of his role as an intellectual.[16] From 1940 to 1968, he explains, he was only a left-wing or classic intellectual; after 1968 he became a leftist intellectual. The difference, he states, lies in action, for no longer can the intellectual serve the masses by remaining in his study writing articles, signing manifestoes, occasionally joining protest meetings. He may continue to write to express the truth about the present moment of history— and Sartre himself addressed a variety of issues: Vietnam, China, Basques in Spain, Czechoslovakia's spring, Cuba, the changing political scene in France, to name just a few. But, in addition, the intellectual must bodily join the masses in demonstrations, hunger strikes, counterviolence against police violence, occupation of buildings, staging people's trials, writing and distributing revolutionary literature, to list some things Sartre himself did. The intellectual must, he stresses, put himself *directly* in the service of the oppressed. Accordingly, Sartre at this time said he was available for any political task asked of him. He was willing to use his "star" status or, rather, let it be used in any way that would help further the revolution. The intellectual's task is not, he says, to decide where battles are to be fought but to join with the masses wherever they fight. Nor should he speak or attempt to think *for* the masses by creating theories or programs for them to implement, for he has no privileged lucidity. Rather, he must place his talent directly at their disposal by becoming their mouthpiece or mediator and expressing their specific grievances, their needs and desires, and their concrete goals. Yet he can be their mouthpiece only if he actually joins with them in their group actions. This does not mean that the intellectual blindly supports everything the masses think, say, and do. He has a special role in sharpening their awareness, clarifying their needs and aspirations, and expressing these needs and aspirations precisely. He must also be willing to criticize the masses if they deviate from their principles. Still, his place is at their side, fighting their fight. "The intellectual must follow," Sartre writes,

he must understand what the contradictions of the masses are, or what their desires are, and he must follow them without exception . . . [although] it may well be that [he] has the means of specifying, of putting into precise language, what the mass wants. (*SBH*, 103)

In an interview with Marcuse, he is even stronger. The task of the intellectual is "to polish the worker's thought, but just polish it, not produce it."[17]

Besides the fact that, by the end of the period we are dealing with, Sartre's blindness made it impossible for him to continue the traditional intellectual projects he had been engaged in for so long, there are, I believe, at least two other reasons for his rejection of what he calls the classic role of the intellectual. In the first place he is keenly aware that the intellectual in our present society owes his or her privileged position precisely to the oppressive class structures that must be overthrown if the masses are to achieve their rightful place in society. As Sartre looks at it, present-day intellectuals (professors, writers, journalists, and so forth) earn their living, and often a rather comfortable living, within structures that systematically alienate the masses by rendering them almost powerless to control their destiny.[18] Clearly, then, if the intellectual is serious about overthrowing the oppressive class system, he must at the same time radically challenge his own traditional privileged role in maintaining it. The other, perhaps more important reason for Sartre's rejection of the traditional pursuits of the intellectual is, once again, his conviction that true thought and morality are found in the oppressed. After the events of 1968, this faith is even more firm than before, if that is possible! The following statement is typical: "the worker is moral . . . [because] he is an alienated person who demands freedom for himself and everyone" (*ORR*, 45). Even if the masses resort to revolutionary violence, Sartre believes they are moral:

> everywhere that revolutionary violence is born of the masses it is immediately and profoundly moral. . . . the worker and country people when they revolt are completely moral because they are not exploiting anyone. . . . theirs is an attempt to put together a moral society.[19]

He adds, "That is the reason the intellectual has nothing to teach them." Another reason the intellectual must adopt the point of view of the underprivileged is because, no matter how mystified or duped

they may be, they are the immense majority and have the only radical perspective on society, for they view everything from the bottom. To see bourgeois society from below, Sartre claims, is more profound for it sees it as it really is: violent and oppressive.[20]

Once again I admire Sartre's preferential option for the oppressed, and I completely agree that the continual violence they suffer exposes the lie in any claim that present societies offer a truly human life to all. Furthermore, insofar as they comprise the vast majority of people, it makes moral sense to give preference to the interests and point of view of the oppressed. I also agree that it is essential for intellectuals who wish to be of service to them to join intimately with the masses. Nevertheless, as I have said so many times before, Sartre's faith in their perceptions and moral evaluations seems excessive. For one thing, and he readily admits it, the masses or the oppressed are not a monolithic group but a conglomeration of groups, institutions, and serial individuals, and there are many differences among them.[21] For another I know of no empirical evidence that would support his claim that the oppressed generally have a truer understanding of society and are less selfish, less prone to oppression, and more committed to the freedom and well-being of all than others. Since Sartre, as usual, also admits that the masses may be so mystified and duped that they neither know nor act for their true interests, it seems unwarranted to claim that they best see society as it really is and that they always strive for a truly moral goal. Frankly, I suspect that Sartre's romantic faith in the radical goodness and perceptiveness of the oppressed is due, at least in part, from the fact that he himself, a petit bourgeois intellectual, not only never was a laborer but also never had, as far as I know, any close relations with members of that class, let alone with those who actually lived in poverty.

To complete our look at Sartre's works after the Rome lecture and the light they shed on his second morality, we turn next to his study of Gustave Flaubert, a work in which Sartre says one can find "concrete morality."[22]

Section 2. *The Family Idiot*

The Family Idiot was the final work Sartre published in his lifetime and is in one sense the culmination of his thought for it is a synthesis of existentialism, psychoanalysis, and Marxist sociology, which he

originally advocated in *Search for a Method*. Its goal is not only to study an individual who has powerfully affected the development of French literature, but to answer the question "what, at this point in time, can we know about a man?" Now "a man," Sartre states, "is never an individual; it would be more fitting to call him a singular universal" (*FI*, I, ix). That is, a person is both conditioned by the general cultural patterns and structures of his time and also a unique internalization of, and response to, these givens through his free projects by which he creates himself.

It would take us too far afield to attempt even a general summary of *The Family Idiot*. For my purposes I will not deal much with the particular details of Flaubert's life but with the more general points Sartre makes about the human condition. In other words, I will concentrate on the universal side of the singular universal Flaubert is and focus on those general notions that seem most relevant to his second ethics.

The first thing to note is the tremendous amount of social conditioning of the individual that Sartre admits. We have our origin in our prehistory, he writes, and this prehistory is first and foremost our infancy and the way our parents, especially our mother, related to us. The infant's "constitution" is fundamentally formed by its maternal relationship, and that constitution can never be totally outgrown: "through the very person of the mother . . . the child is made manifest to himself. . . . he will be fashioned in his irreducible singularity by what she is" (*FI*, I, 47, 50). In the particular case of Gustave Flaubert, Sartre reconstructs (there are almost no historical data) what probably happened. Gustave's mother did not love him because she wanted a girl and because she believed he would die soon, as two of three earlier sons had. She was only a "mother out of duty," who anticipated and met every need of her baby but without love. The result of such maternal attention was that Gustave's physical needs were filled before he could even express them but without tenderness: in other words, without fulfilling his "need to be loved." This frustration "forms" and "penetrates him and becomes within him an impoverishment of his life—an organic misery and a kind of ingratitude at the core of experience" (*FI*, I, 129–30). It is responsible for Gustave's lifelong lack of self-valuation and passivity.

If a child is loved by his mother, Sartre generalizes, "he gradually discovers his being-an-object as his being-loved." He experiences

himself to be of value, and this too he will carry with him all his life. Sartre's words about the necessity and "fittingness" of love for human development are worth quoting at some length:

> the Other is there, diffused, from the first day in that discovery I make of myself through my passive experience of otherness. That is, through the repeated handling of my body by forces which are alien, serving my needs. Even on this level, however basic, love is required. . . . It is fitting [NB] in these moments that the child . . . should apprehend himself in an external and internal ambience of kindness. The needs come from him but the first interest he attaches to his person is derived from the care whose object he is. If the mother loves him, in other words, he gradually discovers his being-an-object as his being-loved. . . . he becomes a *value* in his own eyes as the absolute end of habitual processes. The valorization of the infant through care will touch him more deeply the more this tenderness is manifest. . . . let a child once in his life—at three months, at six— taste this victory of pride; he is a man; never in all his life will he be able to revive the supreme voluptuousness of this sovereignty or to forget it. (*FI*, I, 129, n. 2)

The experience of being loved and, therefore, being of value is crucial, not only for one's self-esteem, but also for the broader experience that existence has a purpose and that life is worth living. "A child must have a *mandate to live*," Sartre writes, "the parents are the authorities who issue the mandate" (*FI*, I, 133). He means that the parents' love is necessary for the child (and later adult) to believe that his life has a purpose, a mission, a reason for being. Their love is necessary for him to accept himself as someone whose actions are significant and needed by others; their love "will transform [his] self-centeredness into a gift; experience will be felt as the *free exercise of generosity*" (*FI*, I, 134).

> Briefly, the love of the Other is the foundation and guarantee of the objectivity of the individual's value and his mission; this mission becomes a sovereign choice, permitted and evoked in the subjective person by the presence of self-worth. (*FI*, I, 135)

In Gustave Flaubert's case Sartre also attributes his lack of self-worth to his father who, disappointed that his son did not read at the appointed time, ridiculed him, calling him "the family idiot." The absence of self-love and self-valuation, caused by his parents, meant

that Gustave did not see himself as able to contribute anything to others or to the world, and this was the root of his lifelong boredom and ennui as well as his hatred of humanity. Sartre generalizes again that those who do not love themselves cannot love others, and their whole perception of the world will be colored by their lack of self-valuation; in their eyes reality itself will seem meaningless and hateful. This is the reason that Flaubert came to prefer the imaginary over the real, Sartre asserts.[23] In an interesting analysis with epistemological import, he also claims that Gustave's passivity and lack of self-love result in his not being able to affirm personally the alleged truths expressed by others. He never takes the initiative to personally seek to intuit the evidence which would verify or falsify their statements. Thus, he can only passively accept what people say; that is, he can only believe.[24]

Of course, there were others in his life who also influenced Flaubert's development, but none were as powerful as his parents, for they determined his basic constitution which could never be erased. Clearly, here, Sartre is asserting that some character traits are established in infancy before the individual has any free choice about it. He is acknowledging a limitation of human freedom *within* the individual greater than any he has heretofore admitted, for it occurs so early in his personal history. This is not to say that the individual is totally determined, but it is to say that his freedom is quite limited and that throughout his life he will have to respond to, as well as surpass, his given constitution. As Sartre puts it, "the structures of this family are internalized in attitudes and reexternalized in practices by which the child makes himself be what others have made of him" (*FI*, II, 3). In a 1975 interview on *The Family Idiot*, he is even stronger:

> in a certain sense, all our lives are predestined from the moment we are born. We are destined for a certain type of action from the beginning by the situation of the family and the society at any given moment. . . . Predestination is what replaces determinism for me.

But he hastens to add, "I do not mean to say that this sort of predestination precludes all choice." Options do remain, but only "conditioned options."[25] Stronger yet is his statement in an interview predating *The Family Idiot*'s publication where he says that freedom is "the small movement which makes of a totally conditioned social being someone who does not render back completely what his

conditioning has given him."[26] Such is the striking culmination of the evolution of Sartre's views on human freedom, an evolution whose starting point, as we saw, was a belief in the absolute and unlimited nature of that freedom!

What is the relevance of this for the second ethics? Just this: a human being is from the beginning radically dependent on others and on their conditioning. Thus, he or she will achieve human fulfillment (integral humanity), the goal of the second ethics, precisely to the extent that others, especially his or her parents, constitute or condition him or her in a positive way. Moreover, it is the concept of need, central to his second ethics, that Sartre repeatedly uses to make this point. The need to be loved is stressed continually, the need to be affirmed as valuable and treated as an end, never as just a means. As we have seen, such love is needed not only for the individual's own self-esteem but also for his or her positive valuation of reality. The lack of love causes Gustave Flaubert to feel always deficient and to attempt to escape from reality, and this leads him, throughout his life, to seek value not from himself but from others, as he tries to gain approval first as an actor, then as a dramatist, then as a poet, and finally as a novelist. *The Family Idiot* is hardly the first work in which Sartre stresses the human being's dependence on others. In fact, such dependency was a central ingredient of his first ethics. But in no other work did he push this dependency and the individual's psychological conditioning by others into infancy, nor did he describe it in such detail and so clearly express it in terms of the human need to be loved.

The Family Idiot not only emphasizes the necessity of others for one's self-valuation, it also stresses their import for one's self-knowledge. Flaubert is an individual who "is estranged by the false consciousness of self imposed on him" (*FI*, I, 496). Because of the passivity induced in him by his mother's loveless oversolicitousness and his father's judgment of retardation, Gustave does not perceive himself as an agent or possible actor on the world. He does not recognize himself as a free praxis capable of changing reality, and that is why he seeks to flee to the imaginary. Again Sartre makes the point generally ("my story is appropriate to *infants*, not to Gustave in particular" [*FI*, I, 132]) and puts it in terms of needs.[27] Infants, he says, must experience their needs as "sovereign demands" on the world and thus as rudimentary projects and actions. If they are to

recognize themselves as such, they need to be affirmed as agents or potential agents, that is, as persons who can effectively move themselves to act on the world to achieve their goals and satisfy their needs. At the same time, they need the love of others to be assured that they have something worth doing, that they have a mission or purpose in life. Lacking self-love and recognition of themselves as free agents with a purpose, they will become the passive objects of others and spectators of the world, and may attempt to escape into the realm of the imaginary like Flaubert. As I mentioned earlier, the inability to act or feel themselves agents will also have severe epistemological ramifications. It will mean that they will be unable to feel or satisfy their *need* to personally seek and grasp evidence in order to verify the truth or falsity of what is proposed to them about themselves and their world.[28]

Sartre's insistence on the dependency of one's self-awareness and knowledge on others is, of course, consistent with views he expressed in many works written after *Being and Nothingness.* By the time he writes *The Family Idiot,* he is a long way from his early view that each consciousness is lucidly transparent to itself prereflectively and that it has no need of others for its self-awareness. He easily acknowledges that, because of their early conditioning in the family, individuals may radically misunderstand themselves and their world; they may, for example, be hardly aware of their freedom. One reason Sartre so readily admits this now is that in his Flaubert study he unites the body and consciousness more than ever. As he describes it, a person's early conditioning by others is experienced not by a clear and lucid self-consciousness but bodily; and this conditioning is responded to, not by a pure free consciousness, but by an embodied self. Obviously, the infant experiences being loved through the touch, caress, and speech of others. Likewise, she experiences her own rudimentary praxis as she begins to manipulate her limbs and the physical objects of her environment. The point is that such experiences, though certainly not unconscious, do not take place in a completely self-transparent consciousness but in a thoroughly incarnate self whose self-awareness comes, to the extent that it does, only over time and because of others.

In Flaubert's case, as we have seen, the fact that in infancy he was not handled with love resulted in his lifelong passivity. As a result, when he later found himself in the intolerable position of wanting

to be a writer but having to obey his father and become a lawyer, he could not clearly and lucidly choose one alternative over the other: "choice . . . [was] from the start inaccessible to him" (*FI*, IV, 44). Instead, as evidence of the oneness of his consciousness and his body, he experienced and expressed his psychological tension physically through insomnia, nightmares, lack of energy, and, eventually, through nervous attacks and an illness (Sartre says it was hysteria) which made it impossible for him to fulfill his father's wishes. Both Flaubert and Sartre interpret these physical manifestations not simply as the effect of external causal factors but as also intentional and, thus, as conscious to some obscure degree. That is, although his behavior was not deliberately chosen or willed in full awareness, Flaubert bodily, Sartre says (and Gustave agrees), engaged in an organized secret "strategy" whose goal was to resolve his dilemma. And his illness did so by making further law studies impossible while giving him the leisure to write. Thus, Sartre describes here, in his final work, a oneness of consciousness and body by presenting bodily behavior itself as an intentional, and to that extent conscious, activity; an activity which, however, takes place beneath the level of explicit or lucid conscious deliberation and decision. Indeed, the extent to which such intentional behavior, purposeful but not clearly and deliberately chosen, is free remains obscure even to the individual performing it.[29] Needless to say, the degree of moral responsibility for such behavior is also obscure.

I should add that in spite of his strong identification of the self and consciousness with the body, Sartre persists in denying that the human person possesses any kind of genetic endowment, at least as far as intelligence or native interests and preferences are concerned. Intelligence, specific talents, and preferences are all, he claims, the result of the way society regards and develops the potentiality of its members: "the dunce and the prodigy are both monsters, two victims of the family institution and institutionalized education" (*FI*, III, 24). Gustave Flaubert, he says, was innately no more or less gifted or inclined to pursue science or art than his older brother who became a physician. Sartre offers, however, no evidence to support his view that environment is all, and, given his emphasis on the embodied character of the self and his admission that there are bodily "somatic givens" and "organic predispositions,"[30] his position seems highly questionable. Still, as I mentioned in Section 1, it no doubt explains why he believes that all human beings are equally able to be in-

tellectuals, workers, politically sophisticated, and cultured, and thus participate fully in the direct democracy of the classless society.

Finally, one finds in *The Family Idiot*, more than in any other work of the period of the second ethics, including the Rome lecture, Sartre returning to and stressing a topic central to his thought since his earliest novel, *Nausea*. This is the idea that all human beings, because they are contingent, unnecessary, and finite, seek a meaning to their lives, a sense and purpose, that would make them essential to something or someone, and so confer necessity on their existence. Humans desire the absolute, the infinite, Sartre says; they seek a mandate for their lives that could only come from an almighty, infinite being, a loving God who created them for a purpose in his grand design and who thereby justifies them. This is one of our "most fundamental needs," Sartre states, and he identifies it with the "religious instinct." It is, of course, unable to be satisfied: "Finitude makes them [creatures] mad for an unattainable infinite," he writes. "Being . . . created us in such a way that we can neither find it nor give up the search" (*FI*, I, 567).

One interesting thing about this desire or need for the infinite is that it does not appear to be completely identical to the earlier desire to be God. The "religious" need is described as a need for a mandate or justification given by God, not a need to be God, *ens causa sui*, and give to oneself one's own reason for being. Sartre portrays Flaubert as wanting to obliterate his personal finitude, not preserve it while becoming the infinite All.[31]

As Sartre presents him, Flaubert also realizes that his desire for the infinite can be satisfied by nothing and no one in this world, and so he seeks to fill it by rejecting the real in favor of the imaginary. He hoped (more an obscure felt intention than a clearly thought out project) that somehow by his unhappiness, his hatred of the world and of himself, and his failures, he would miraculously be granted artistic genius and would become the elect of the God he passionately desired (and needed) but denied. Thus Flaubert plays a cosmic game of loser wins and proposes a "theodicy of failure."[32] At the end of his life, however, as his world collapses around him due to France's defeat by Prussia, his imminent financial ruin, and the decrease of his creative power, Gustave realizes, Sartre says, that there is no escape from reality; literature, the imaginary, is not a means of salvation. The events of history, in particular the reality of others, block every avenue of escape from the real. To imagine is, in

the last analysis, simply "to deliver oneself to the Other, to place oneself at his mercy," and Flaubert apparently sees himself justly punished for doing so.[33]

Section 3. Conclusion

Thus the works of the decade after the Rome lecture, works which are in fact the last that Sartre wrote and published, make some important contributions to our understanding of the second ethics.

The various essays, speeches, and interviews of this period help to supply more content to the political dimension of Sartre's moral ideal. They make it clear that the city of ends of the *Notebooks,* the free milieu of free human relations of the *Critique,* the classless society mentioned in many works, is to be realized in a radically decentralized democratic socialism. This will be a society of mutual respect and open dialogue in which all people will attain the knowledge and exercise the power that will enable them to direct and govern the social, economic, political, and cultural structures they produce so that through them everyone can become *man.*

For its part *The Family Idiot* recognizes the centrality of human needs, first highlighted in the *Critique* and then made the foundation of morality in the Rome lecture. More than in any work he wrote, Sartre's study of Flaubert describes in great detail the overriding importance of the human need to be valued and loved by others and, thus, our complete dependency on each other in achieving human fulfillment or integral humanity. Along with its stress on our radical interdependence, *The Family Idiot* also emphasizes our thorough conditioning by others, begun in infancy. Again, more than any other work of Sartre's, it recognizes the internal and external limitations, sometimes severe, that our social and historical environment places on our freedom and on our very self-awareness of it. In its own way it, too, clearly presents the need to liberate human beings from human relationships and structures that prevent them from becoming fully human.

Finally, although in his study of Flaubert Sartre retrieves his belief that human beings desire an *absolute* meaning and justification which would remove their lives from contingency, it continues to maintain that this "religious instinct" cannot be satisfied. All attempts to flee reality to satisfy the need for infinity or God remain,

in the words of *Being and Nothingness,* doomed to failure. Sartre's final message in *The Family Idiot* continues to be that it is up to human beings and to human beings alone to confer meaning and purpose on their lives and on the world: "sense and non-sense in a human life are human in principle and come to the child of man from man himself" (*FI*, I, 134). Such meaning will come by human beings loving and supporting each other in *this* world, and working together to create their common humanity by constructing societies that fulfill the needs of all. "True humanism," Sartre says, "*should take these [needs] as its starting point* and never deviate from them" (*FI*, IV, 264). True humanism can be built only upon the mutual recognition by men of their human needs and of their right to their satisfaction.[34]

9

Comparison of Sartre's Two Ethics

Now that we have discussed Sartre's second ethics in some detail, we can undertake a comparison of it with his first. In general, as we know, Sartre himself said he moved from an abstract, idealistic first ethics to a realistic, materialistic second one, and I have tried to show that this development paralleled, and is grounded in, a corresponding evolution in his conception of human reality and freedom and their relation to the world. Just as his ontology progressed from a partial, one-sided, individualistic understanding of human beings in the world to a more complete, concrete, dialectical, and social conception, so did his ethical thought.

I think it is also worth noting that although neither his first nor his second ethics were finished by Sartre, the reasons are somewhat different in each case. Sartre deliberately ceased to work on his first morality because he came to consider it seriously defective. The second ethics remains unfinished, however, primarily because he chose to devote himself first to completing his work on Flaubert. As I mentioned earlier, Sartre told his biographers in 1969 that the second ethics was "entirely" composed in his mind and that the only problems remaining concerned the writing of it.[1] Unfortunately, his blinding stroke in the mid seventies left both *The Family Idiot* and the ethics forever unfinished.

This chapter will compare the two ethics on the following points: 1. their goals; 2. their conceptions of human consciousness; 3. their bases of moral norms/values; 4. the justifications they offer for their ultimate goals and values; 5. and their social dimensions. It will conclude with a look at some of the issues Sartre left unresolved.

Section 1. The Goal of Each Ethics

By his own admission, Sartre's first ethics was out of touch with the concrete reality of human beings immersed in a historical world. Its abstract character was inevitable since it was initially based upon *Being and Nothingness'* partial view of human existence and freedom, a view that frequently simply identified the two and maintained that each human being's freedom (often equivalent to human consciousness) was absolute and unlimited no matter what the circumstances. While the *Notebooks for an Ethics* took important steps toward a concrete understanding of human reality, its proposal that freedom be chosen as one's primary goal and value was very obscure, as I pointed out in Chapters 4 and 5. Granted, Sartre realized in the *Notebooks* and in other works written soon after *Being and Nothingness* that, negatively speaking, to liberate freedom meant to remove obstacles and limitations to it. Yet the question remained, what is liberated freedom for; what is its positive goal? To say that it is for freedom is not particularly enlightening. Similarly, to advocate authentic love and generosity towards others, as *Notebooks* did, and to argue that we should value their *concrete* freedom, was a move in the right direction, but it was still rather meager advice since one never specified just what facticity and free possibilities of others should be supported. The early Sartre certainly did not believe we should love and value every free choice or project others select, particularly if they are the choice of ugliness over beauty, ignorance over knowledge, deceit over truth, possessions over life. However, even though it involved the promotion of whatever leads to a classless society or city of ends, the moral goal, freedom for all, continued to be quite vague.

The goal of the second ethics, integral humanity or human plenitude, is significantly more concrete and richer in content. One reason for this is that, while it includes freedom as probably its most important ingredient, it recognizes that a human being is much more than freedom. As we saw, the Sartre of the sixties and seventies often speaks as if freedom is our most fundamental human need, but at the same time he recognizes that human reality also has many other needs. He insists on the importance of the body and its needs (for example, for protein, for vitamins, for life). He emphasizes our need for others, in particular for their love and valuation. He refers to our need for knowledge, for a meaningful life, and for culture, and insists

that without the latter we would not become human. Without doubt, freedom is essentially and centrally involved in the fulfillment of all these needs, for we desire not just relations with others but the freedom to choose our relationships and to create our social structures; we want not simply culture but the freedom to produce our own culture; not just knowledge and meaning but the freedom to pursue and attain them ourselves as well as the freedom to choose our own way to physical nourishment and well-being.[2] Still, the goal of integral humanity, the fulfillment of the human organism in *all* its dimensions, has far more content than the abstract freedom of the first ethics. As a result, the second ethics is able to be more specific than the first about what concrete acts or practices or policies are morally desirable—namely, those which promote, directly or indirectly, the fulfillment of the various needs of the human organism, including especially, but not exclusively, the need for freedom.

Section 2. The Nature of Human Consciousness

Another significant development in Sartre's thought which has important ethical ramifications occurs in his notion of human consciousness and its self-awareness. I have referred earlier to this evolution, but since it is so important I would like to return to it here.

As we have seen, in his early ontology Sartre identified consciousness' spontaneity and transcendence with freedom and insisted on the total lucidity and transparency of consciousness to itself on a prereflective level. From this it followed that in the first ethics the notion of pure reflection, conversion, was absolutely central. That is, the first, and most important, moral act was reflectively to accept and choose the freedom that one is always (prereflectively) aware that one is. Not to do so and to strive instead for the impossible goal one "naturally" desired, namely to be God, was to be in bad faith, for it involved unsuccessfully lying to oneself. Such a lie involved the pretense that one was not ontologically free and so not able to choose anything other than God as his or her goal, even though one prereflectively "knew" all along that he or she was free and could choose that freedom. The author of *Being and Nothingness* did not allow for the possibility that people could genuinely be mistaken

about, or ignorant of, their freedom or be unable to choose it. Accordingly, he saw no need for the assistance of others in order for a person to become reflectively aware of his or her freedom and be able to choose it. In fact, *Being and Nothingness* asserted that others could not add to nor subtract from an individual's self-awareness.

However, as I pointed out in Chapters 3 and 5, already at the end of *Being and Nothingness,* and more so in the *Notebooks for an Ethics,* Sartre's position begins to waver. Almost in spite of himself, he occasionally admits that some people, primarily the oppressed, duped and mystified by their oppressors, are not aware of their freedom and cannot easily become so through no fault of their own. He also comes to recognize, first in the section of *Being and Nothingness* devoted to existential psychoanalysis, then even more clearly in his 1952 study of Genet, that the role of others is absolutely crucial in a person's coming to self-awareness and choice. The *Critique* too stresses the impact of others and of social structures on one's self-knowledge and choice and admits that there are degrees of transparency to one's self-awareness.

The second ethics continues in this path which culminates in *The Family Idiot.* As far as self-transparency is concerned, we noted in the previous chapter that Sartre discusses incidents of Flaubert's behavior where, although his acts are organized and goal-directed (intentional) and even rational solutions to intolerable dilemmas, they are not clearly chosen but are, to a great extent, hidden, unrecognized, and unknown to Gustave himself. No doubt the most famous example in his life was the episode in which he fell to his brother's feet in their carriage in a cataleptic state. Sartre insists that this behavior was not totally the product of a neurophysiological illness caused by external factors. It was also an intentional, goal-directed, bodily response to a situation in which Gustave could not deliberately disobey his father by failing his law exam, although he wanted to be a writer. Moreover, this strategy achieved its goal, for as a result of his nervous "illness" he was excused from law studies and able to pursue writing. Again, the "illness" was not something lucidly and deliberately chosen by Flaubert; it was rather, Sartre says, a *secret* strategy at best only dimly recognized and consented to.[3] In fact, due to his parental upbringing, Flaubert was hardly aware at all that he could be an agent and freely choose and initiate a course of action. *The Family Idiot* thereby illustrates the later Sartre's belief that the role of others is of utmost importance if one is to achieve both the

awareness of oneself as an agent and the ability to function as one. To repeat, I believe this is significantly different from the early Sartre's concept of pure reflection, or conversion, central to his first morality, which seemed to have no need of others but could be performed by individuals simply if they willed to do so.

Perhaps the following will make the contrast sharper. While the goal of Sartre's first ethics, freedom for all in the city of ends, is something that could be attained (to the degree that it could) only gradually by mutual effort over many centuries, an individual's choice of freedom as his or her goal seemed to be something he or she could personally execute at any time. This is because in Sartre's early ontology human consciousness was considered to be at every moment lucidly, prereflectively, aware of its spontaneity/freedom, and this freedom was absolute and unlimited. The view that generally dominates Sartre's early thought is that ultimately nothing can prevent a human being from being aware of and choosing his or her freedom, that is, from exercising a pure reflection and conversion— except that person's own free choice. That explains why at this stage Sartre is so prone to label in bad faith anyone who remains in accomplice or impure reflection by not explicitly recognizing or affirming his or her freedom. Even the oppressed, he states, are prereflectively aware of their ontological freedom and thus are in bad faith if they do not assert it.[4] It is also part of the reason he believes that the "apocalypse," a utopia where everyone is converted and all choose each others' freedom, is theoretically possible.[5]

Now the original belief in lucid self-consciousness and total freedom comes under challenge quickly, so that when he works on his second ethics, in the early sixties, Sartre has clearly modified his view.[6] By that time he holds not only that its goal, integral humanity, is attainable, to the degree it is, only gradually by collective group efforts over time, but also that the individual's awareness of that goal and his or her ability to choose it develops socially and historically. Only with the help of others and only gradually, if at all, do human individuals become aware of their real needs, their ability to act as free agents to satisfy these needs, and their true end. Even more, only gradually, through the love and encouragement of others, will they have the strength actually to choose the moral ideal, mutual human fulfillment. Indeed, Sartre's later works are replete with references to individuals and collectives which, due to their socialization in the family or to repressive social structures, remain "subhuman" because

they are perpetually duped and mystified. They never achieve the awareness of nor the ability to choose their own and others' freedoms, true needs, or real ends. We might put it this way—in the second ethics conversion is not an individual conscious act which a person can perform at any time if he or she chooses; it is a historical and social praxis, requiring, perhaps, a development over a lifetime. In a 1971 interview Sartre acknowledged that it was only later that he came to realize that nonaccessory or pure reflection "was the critical work one can do on oneself *during one's entire life,* through praxis."[7]

Section 3. The Basis of Moral Values or Norms

In *Being and Nothingness* Sartre is critical of ordinary, everyday moralities and the nonreflective experience of values of which they consist for being unaware that all values issue from human freedom.[8] His second, realistic morality, on the other hand, begins with a phenomenological analysis of precisely that everyday moral experience in order to ascertain the ontological structure of its moral norms and values. In other words, far from denigrating ordinary human moral experience, such experience is the very "reality" in which the realistic ethics is grounded. This difference in attitude toward ordinary moral experience leads to a fundamental difference between Sartre's first and second moralities when it comes to the ultimate source of moral values or norms. To put it simply, the second ethics is willing to admit that there is a given, imposed (objective?) character to true moral norms, one that is not totally reducible to the values and imperatives held by an individual, society, class, or group. The first ethics, for its part, claims that all values or norms are ultimately nothing but the free creations of human persons and rejects any version of the spirit of seriousness which maintains that some "things" possess intrinsic value.[9]

This difference is due to the fact that in the second ethics Sartre designates human needs as the ultimate source of true norms/values, not human freedom. Because human beings are a specific kind of organism with specific needs, certain kinds of objects are necessary for them to fulfill their needs. Inasmuch as humans do not freely

choose their needs, they do not freely choose the general *kind* of thing which fulfills their needs. Of course, human needs specify only the *general* type of object which satisfies them (eg., protein), and so we remain free to choose among the particular things of that type (eg., to eat fish or eggs or meat). We can also choose not to satisfy a need. Nevertheless, the kind of object that fulfills a particular organic need is set *by that need*, not by our freedom, and it is precisely such objects, Sartre says, that we morally experience as having to be attained, that is, as norms and values. This is the reason that Sartre states in the Rome lecture that moral norms are, and are experienced as, "given," "assigned," even "imposed" on us.[10] Integral humanity itself is our ultimate moral norm, not because we freely decide that it is, but because it is in fact the fulfillment of our needs. This end, he states, "is imposed [NB] on each as his single possible end, unsurpassable" (RL, 67).

To be sure, there is a sense in which moral norms in the second morality are grounded in human freedom, for there is a sense in which needs themselves involve freedom for Sartre.[11] As felt exigencies which negate and transcend the given state of affairs toward a not existing future, needs manifest the freedom of the organism from the given, he claims. This alleged freedom, the human ability to (consciously) transcend what is toward nonexistent goals, has, of course, been asserted by Sartre from his earliest works. Recall that he even claimed that emotions and desires were free because they were intentional, that is, goal-directed. As I have argued so many times above, however, such freedom does not involve alternatives. Freedom of transcendence is not a freedom to choose among two or more possibilities, and for that reason I have repeatedly voiced serious reservations about it. Just because passions, desires, and needs are goal-directed does not make them free, in my opinion. They would be free only if I could choose to exercise them or not, or choose their object out of a number of possibilities. My fear of danger, my desire for sex, my need for water are not something I freely choose, anymore than are my skin color or genetic structure. Sartre may use expressions like *negate, reject, refuse,* and *transcend* the given when referring to their intentional character, but such terms are no substitute for solid argument. Yet the only argument that he offers (in *Being and Nothingness*), namely, that what is cannot cause what is not, is, I have contended, inadequate. (See above, Chapter 2, Section 4, Conclusion.)

Thus, I repeat, to root basic moral norms in human needs is significantly different from rooting them in freedom, for it means that such moral norms are not something that humans freely create as values. The objects which fulfill our human needs are experienced by us as norms, as values—whether we like it or not, whether we choose them to be so or not. It is not up to my free choice whether or not oxygen, for example, is something which fulfills a need I have and, thus, is valuable for me. It follows that in Sartre's second ethics true (rather than alienated) moral norms/values possess an "objectivity" that they did not and could not have in his first ethics. Granted, in both moralities it is true that "human reality is that by which value arrives in the world" (*BN*, 93). Sartre never waivers on this point. No human values/norms exist in some eternal, transcendent Platonic heaven, nor are they given or imposed by some superhuman absolute being. That said, the fact remains that by making human needs, rather than human freedom, the ultimate source of true moral norms/values, the second ethics grants them a certain independence from human freedom, for it can neither create nor remove their normative or value character.

This difference has important ramifications when it comes to the issue of the universality of moral norms/values. In both *Existentialism and Humanism* and the *Notebooks for an Ethics*, as we saw, Sartre maintained that moral values had a universal character to them.[12] In the latter work, for example, he stated that when I experience something (justice, for example) to be a moral value or good I experience it to be not just a value for me but also a value for others. However, as I argued earlier, if one makes all values the creations of individual human freedoms, there is no way to justify the experience that certain values have, or should have, a universal character, for there is no reason to believe that particular values should apply to anyone who does not personally choose them to be of value.

For its part the Rome lecture never explicitly raises the question about the universality of moral norms. Nevertheless, inasmuch as Sartre sharply distinguishes there between norms that are grounded in the needs of human beings as members of the human species, called true norms or norms of true morality, and norms whose source is a particular society, class, or culture, he has provided the basis for claiming that some norms, namely "true" ones, are universal. Norms that are rooted in needs present in all members of the human species

extend, of course, to all human beings. As we have seen, Sartre himself refers to protein, oxygen, culture, communication, knowledge, love, and a meaningful life as things needed by all human beings. From a moral perspective, then, such objects are normative or valuable for all humans; they should be attained by each and every one for his or her fulfillment, his or her integral humanity.

Of course, it remains true that human beings do not have to *reflectively* choose to value those objects that they naturally experience as values, those objects that their needs seek for fulfillment. An individual can personally decide to value something that frustrates his or her human needs; for example, he or she may choose to value starvation, heroin addiction, ignorance, hatred, slavery. That is exactly what occurs, Sartre says, when people adhere to false and alienating moral norms and images of human reality. Recall, in this connection, that the early Sartre distinguished between values that were prereflectively desired by human beings (the main one of which was the value of being a *causa sui*, God) and values that were freely and reflectively chosen. This distinction was central to the first morality, for pure reflection was precisely the decision not to value one's "natural," prereflective goal, being God, but to choose freedom instead.

The later Sartre, of course, wants people to reject the norms and values present in the alienated moralities that are dominant in today's society and are unreflectively accepted by so many. These values do not promote integral humanity, the fulfillment of true human needs. On the other hand, he wants us reflectively to choose the norms/values of true morality, those that we as human beings naturally, prereflectively seek to fulfill our human needs. As I noted above, Sartre's second morality looks more positively on the prereflective human experience of moral norms/values than does the first, for prereflectively experienced values can be essential for human well-being. The problem comes in determining which norms/values found in moral experience are alienating and which are true and promote integral humanity. The later Sartre, like the earlier, does not think that we can, or should, try to attain that which is "naturally" valued by our most fundamental need or desire, namely, infinity or God. This means, apparently, that only those prereflectively experienced values should be chosen which can actually be realized and thus fulfill a human need and promote human fulfillment. Still, the

larger question remains: how is one to determine which prereflective values found in human experience do promote human fulfillment and which do not? I will return to this important issue below.

Section 4. Justification for the Ultimate Goal of Morality

Each morality offers significantly different reasons to support its primary goal. In the first ethics Sartre argued that freedom should be chosen as one's ultimate value because such a choice was most *consistent* with the very structure of human reality (often simply identified with freedom) and more precisely with the fact that freedom is the source of all values. However, since nothing possessed any inherent value in Sartre's early ontology, there was, and could be, no objective moral or logical requirement for one to choose to be consistent with human reality or freedom in the first place. I argued, therefore, that the choice to value or not to value consistency was itself, in the final analysis, arbitrary and, in principle, unjustifiable.[13]

If we ask for reasons for selecting integral humanity, the fulfillment of human needs, as the moral goal and norm of the second ethics, Sartre's response in the Rome lecture is to cite Marx who, he says, states that "need does not necessitate any justification" (RL, 98).[14] I understand Sartre to mean that the very fact that our needs demand to be satisfied makes their satisfaction, integral humanity, normative and our primary task and goal. No reason has to be given to justify our seeking that end which is required by our needs. Along the same line, integral humanity is also said by Sartre to be the *unsurpassable* goal of all human praxis. This means there is no more primary goal for human existence and, therefore, that there is no more ultimate norm or goal that would have to be invoked in order to justify seeking it. This does not mean that integral humanity is a purely arbitrary goal. It is not as if we are free to decide what our ultimate end and primary value is and so must find reasons to justify selecting this one or that one. For the later Sartre our ultimate end is dictated by our ontological structure as an organism whose every act and goal is rooted in its needs and seeks their fulfillment. Because *man* with needs satisfied is "given," "imposed" on us, as our ultimate norm and end, we neither need, nor can we find, any reason for valuing this goal other than the fact that our needs require it. I

believe that this is what Sartre means when he cites another statement of Marx's, "need is its own reason for its satisfaction" (RL, 97).[15]

Since Sartre's reasoning in the Rome lecture is so cryptically presented, let me try and unpack it a little more. I believe that he is claiming that in the last analysis it does not make sense to ask for reasons why one should choose integral humanity as his or her ultimate moral norm and goal. To demand such reasons is to look for what cannot, since no norm or goal is more fundamental than it, and need not, since needs create all values and norms, be given. That is to say, only by appeal to some value/norm, let us say, freedom, less basic and less primary than integral humanity, could one attempt to defend or reject the primacy of the latter. Yet freedom (or anything else) is a value or norm in Sartre's second ethics only because it is needed, and ultimately it is needed only because it is (or is considered to be) part of, or a means to, that end which is human fulfillment. It follows that any value/norm one might appeal to in order to justify accepting the need-given norm and goal which is integral humanity, would itself have value only if integral humanity possessed a more basic value. If one were to reflectively choose not to value integral humanity and not to accept its normative character, then neither freedom nor anything else would have a value or normative character.

I must say that I find Sartre's reasoning here dense but compelling. At the very least he has offered in his second morality, albeit quite briefly, more solid justification for his primary moral norm and goal than he did in his first.

Section 5. The Social Dimension of Each Morality

In his first ethics Sartre invoked a version of universalization and the notion of dependency in order to argue that we should will the freedom of others.[16] Neither in the Rome lecture nor in any other work of the period of the second ethics does he explicitly formulate a comparable argument to demonstrate that we should seek the human fulfillment of others along with our own—although it is clear that integral humanity for all in the classless society is his goal. Nevertheless, in the Rome lecture statements are made which seem to imply a kind of universalization argument, and there are also many

references to interdependency and calls for human beings to join together to achieve the mutual satisfaction of their needs. Additionally, and no doubt most important, the later Sartre places far more emphasis than does the early Sartre on each individual's thoroughgoing need for, and hence dependency on, others if he or she is to achieve fulfillment. I will discuss these items to show how they can be woven together to argue that the integral humanity or fulfillment of other human beings as well as our own should be our moral goal.

Since, Sartre says, all human praxis is rooted in need and seeks human fulfillment, all my choices and actions (at least implicitly, for it may not be my explicit goal) tend to produce *man*. This goal is the deep meaning and direction (*sens*) of all human activities. Now if all my acts have man-with-needs-satisfied as their ultimate end, it would seem to follow, as Sartre claimed in his first morality, that when we choose and act, we inevitably (implicitly, at least) propose an image or ideal of what man should be, that is, an ideal of integral humanity or human fulfillment. Of course, this ideal can be given different contents; oppressors, for example, view only themselves and their class as truly human and present that alienated goal to the oppressed. However, integral humanity for Sartre includes autonomy and freedom as probably its most important features. It follows, then, that if one chooses and seeks Sartre's kind of integral humanity as his or her moral goal and, in effect, proposes it as the human ideal for others to seek, it would be inconsistent to attempt to thwart others' freedoms or allow third parties to do so. Of course, in the concrete order where some use their freedom to destroy others, it may be necessary to restrict some freedoms in order to promote many others. That must be determined in each particular situation, and in an earlier chapter we set forth criteria Sartre offers to determine when violence against others is justifiable.

Let us join the notion of dependency to the foregoing "universalization" argument. From *Saint Genet* and the *Critique* on, we have seen Sartre's recognition of the tremendous impact social structures have on the human individual. In general, my need for human fulfillment in a universe dependent on the praxis of others "requires," Sartre says in the Rome lecture, either "the destruction of, or unification with, that praxis."[17] Since the preceding argument rules out destruction, at least of those who are genuinely interested in cooperation, union is the only morally legitimate alternative.

Accordingly, Sartre repeatedly advises human beings to join together, both oppressors and oppressed, to control effectively the practico-inert products and systems they create and to direct them to the satisfaction of their needs. Both *Critiques* describe in painful detail what happens when social structures escape the command of the very humans who created them, but this will continue to happen so long as people relate to each other primarily as serial individuals. Only by consciously joining with our fellow humans and together, in groups, acting to attain our integral humanity, Sartre says, can we ever hope to become our own product rather than be the product of our product. A laissez-faire attitude towards others is simply not enough, for if we each go our separate ways we will make something that is outside of the control of many and thus has the potential to dominate them and thwart their goals. Furthermore, if we ignore others, we have no reason to expect their cooperation in achieving our ends. We should assist others in achieving their fulfillment, then, because the human fulfillment of each of us depends upon us working together to achieve that common end.[18] As the Rome lecture puts it: "There will be no integral man so long as each man is not totally a man for all men" (RL, 135).[19]

We can put this argument more explicitly in terms of needs, as Sartre does in *The Family Idiot* and other late works. As we saw, in his study of Flaubert Sartre offers an extensive description of every person's need for others for his or her self-awareness and self-love, including self-esteem. In order for humans to love and value themselves and to love and value life itself, they need to be loved, especially by their parents. Likewise, in order for them to become aware that they are free agents able to direct their lives to fulfill their needs, they need to be positively affirmed as agents by others. Thus, their fulfillment demands that human beings be recognized, loved, and respected by others. It would seem to follow, then, that for the satisfaction of their common needs human beings should love, respect, and affirm each other's humanity, at least of all those whose lives significantly affect theirs.

In concluding this point, let me repeat that these arguments about our moral obligations to others are not set forth in so many words by Sartre himself in his second ethics, although it is not especially difficult to construct them as I have done from his writings. I might add that the whole area of human relationships was one that

Sartre returned to and was rethinking in the last years of his life. In fact he was doing so as part of his work on a new, third ethics. (See my Appendix.)

Section 6. Unresolved Issues

I trust I have made it clear that I believe that in a number of important respects Sartre's realistic ethics is a significant improvement over his idealistic version, primarily because the second ethics is based on a more concrete, richer, and more thorough understanding of human reality and its relation to other human beings and to the world. Still, I think that there are some serious difficulties, or at least lacunae, in the second ethics and I will conclude by calling attention to them.

For one thing it would have been very helpful if Sartre had offered more analysis of his crucial notion of needs, the root of all moral norms. Among other things how does one distinguish between "true" or "primary" human needs and "false," "artificial" ones?[20] This distinction is made by Sartre, and he sharply criticizes capitalist societies for creating the latter and encouraging people to satisfy them at the expense of the former. He speaks, for example, of the worker who exhausts himself in attempting to earn enough to possess all the luxuries which promise the good life and ruins his health in the process. Sartre's point is familiar enough in our consumeristic society where people are enticed by advertising to pursue the satisfaction of "needs" (he would say artificial or false needs) which are created by that same advertising—needs for gas-guzzling cars, cigarettes, the latest gadgets and styles, for example—to the neglect or detriment of needs for physical health, for loving and caring human relationships, and for freedom and autonomy. The problem is that he does not clearly explain the basis for his distinction between true or primary and false or artificial needs.

Sartre comes closest to addressing the issue in some remarks he makes in his Rome lecture. As I pointed out in Chapter 7,[21] he suggests there that the difference between the norms/values which are present in alienated moralities, and those of true moralities, is that the former are based on false, the latter on true, needs. This distinction in turn seems to rest on the difference between needs which are "radical," that is, which are fundamentally *rooted* in the

human organism and are demands for "nude man" (RL, 109), and needs which are produced by alienated social systems (and are literally "artificial," human artifices) and thus seek man only as defined by that system. Of course, the difference between "radical" (or primary) and "artificial" needs is itself grounded in the difference between the characteristics and needs human beings possess as members of the human species, referred to as *universal* or *nude* man in the Rome lecture, and the characteristics and needs they have as members of a particular culture, social system, or class.[22] As we know, Sartre frequently criticizes those who identify humanity with a particular class, system, or ideology. Man, he says, should be defined as "belonging to a species" (RL, 88), not to a class, and in at least one place he suggests that, if we root out (*extirper*) the different social and cultural "details" which vary from class to class, we will reach "that which makes up the human reality . . . common to men" (*ORR*, 342).

Though Sartre does not say so, I would think we could use a similar approach to arrive at true human needs. We could attempt to take away all the variable social and cultural characteristics and behaviors of human beings to reach the universal human needs common to all members of the human species.[23] It is obvious, for example, that Sartre believes that our needs for protein, for freedom, for knowledge, for love, for a meaningful life are proper to us as human beings while needs for things like Izod shirts, the latest Nintendo game, a Cadillac car, or heroin are not. The difference is that the latter "needs" are found only in certain individuals, classes, societies, or cultures; the former are found in all human societies and cultures and apparently in all human beings. These, then, are the "true" human needs whose satisfaction and fulfillment is the goal of true morality and of Sartre's second ethics.

Does this mean that in his second ethics Sartre has come to accept the idea that there is a common human nature or essence present in all human beings? Not likely, since in the *Critique*, *The Family Idiot*, and interviews of this period, he continues to explicitly reject such notions.[24] Still, even the early Sartre insisted that there is a "universal human condition" (*EH*, 46) common to all; that there are "certain original structures . . . in each For-itself which constitute human reality" (*BN*, 456); that there is an "ensemble of abstract relations" (*BN*, 519) of "general techniques" (*BN*, 512), "general structures" (*BN*, 513), and "abstract characteristics" (*ASJ*, 60) incarnated in

each individual which "constitute [the] meaning and essence [NB]" of his or her "belonging to the *human race*" (*BN*, 512–13). *Search for a Method* even affirms both positions in a space of four pages![25] On the one hand, it states that modern anthropologists have shown that there is no common essence or human nature, that is, no "fixed collection of determinations" present in all humans in all societies. On the other hand, it also maintains that every human can on principle comprehend any other human being because of the common "existential structures" which are present in all humans.

If Sartre has an answer to this dilemma, I believe it lies in his notion of the singular or individualized universal, for he states in the *Critique* that that is what the concept of man is, as indeed are all the concepts of history.[26] Such concepts, he insists, do not refer to eternal, nontemporal, universal essences which transcend human history like Platonic forms. The only things that are real are concrete historical individuals.[27] In fact, this is so true for Sartre that in the *Critique* he designates his position as nominalism and is reluctant to attribute an ontological status even to the all-important social relationships such as groups and organizations which human beings establish among themselves.[28] Although only individuals are real in Sartre's nominalism, they are, he admits, singular *universals* or *universal* singulars. That is, they are concrete particular "incarnations" of the "schematic and formal" abstract characteristics of their class, their culture, and, ultimately, of their species. They are "concrete universals."[29] To repeat, these abstractions have no actual existence apart from their instantiations in particulars. Nor are particulars just a collection of general features; they are singular and as such are richer than any general description of them can capture. Nevertheless, concrete individuals are not so singular that they have no general similarities with other individuals. Indeed, a pure singular would be unintelligible and would have nothing socially communicable. Furthermore, it is obvious that members of the same class, race, culture, and so forth have many characteristics in common, and Sartre in the *Critique* and elsewhere describes a number of them. The common characteristics that are especially important in the second ethics are, of course, those proper to human beings insofar as they are members of the human species—characteristics which *Search for a Method* calls our common "existential structures," and which other works refer to as the "general structures," "general techniques," and "ensemble of abstract characteristics" common to all humans. Still,

one might wonder how common "existential structures" or "abstract characteristics," which Sartre accepts, differ from a human nature or essence, which he rejects.

Frankly, I do not think that Sartre has a clear answer to this question, but I suspect it has a lot to do with the degree of fixity or determination that he believes is part of (all?) traditional concepts of human nature. It seems to me that often, when Sartre rejects human nature, he is not denying that there are *very general* features common to all human beings. After all, he admits that such features exist, for he describes *all* human beings as free, conscious, material organisms, which need physical goods as well as knowledge, love, and self-respect and which must act to fulfill their needs and create a meaningful life by cooperating with others.[30] In denying human nature, then, Sartre means, I believe, to reject the presence of any *particular* set of innate features, character traits, and talents as well as preprogrammed tendencies, desires, instincts, and so forth, such as seem to be present in animals, for example. In *Search for a Method,* for example, he equates human nature with a "fixed collection of determinations" (*SM*, 169). No doubt he (correctly) believes the presence of such particular features in human beings would seriously compromise their freedom.[31] Also, by denying a human nature Sartre means to reject any position which holds there is a timeless, eternal human essence of which individuals are simply ontologically inferior particularizations. Additionally, he also means to deny the view that concrete humans are integrally or fully human from the beginning, that they are fixed as human independent of history and the forces of circumstances. As we have seen, the later Sartre insists that the relation among humans, and between humans and the world, is dialectical and that human development is an ongoing historical process. However, I doubt that these explanations fully cover all of Sartre's statements about human nature, for there are places where his nominalism is so strong that he appears, at least theoretically, to deny any reality to features common to every human being or to anything else. For example, in his discussion of incarnation in the second *Critique,* where he explicitly addresses the issue, he seems ultimately to totally reduce all universal or general features of the singular universal to the singular. Note the following statement: "Universality . . . is only an economy of means. But it does not refer to any species or genus" (*CDR*, II, 194).[32]

In the final analysis, then, perhaps the safest thing to say is that Sartre's nominalism, his emphasis on the singular side of the singular universal, results in his not adequately accounting for the reality of the universal features he admits are incarnated in every singular.[33] Thus, no matter how often he speaks of the human species and refers to the *universal* existential structures or conditions, or to the abstract, schematic characteristics, *common* to human beings, no matter how extensively he describes the *general* features of groups, classes, societies, and cultures, the precise ontological status of such features or structures remains unclear. As a result, the basis of his second ethics, universal human needs that are part of our common existential structure as human beings, remains somewhat problematic.

On another point, the fact that Sartre holds that there are specific needs intrinsic to all human organisms presents difficulties for some of the ways he describes his moral ideal in the Rome lecture. I am referring to all of those places where he speaks of the goal of integral humanity as "an unconditioned future" and as systemless or "beyond all systems." For example, he states that the goal of history and of morality is fully autonomous man dissolving the practico-inert as soon as it is produced.[34] Similarly, he says that "mankind is a mankind to be created—but not by building a system (not even a socialist system), but by destroying every system" (DF, 251).

Perhaps such remarks, though very explicit, should not be taken literally, for even in the Rome lecture he admits that the crystallization of praxis into practico-inert structures can never be totally avoided nor destroyed. Furthermore, in none of his works after that lecture does Sartre speak of his moral ideal, the classless society, direct democracy, or socialism, as totally unconditioned or systemless. Besides, his insight in his second *Critique,* that humans are conditioned not only by the practico-inert structures they impose on nature but also by the structures inherent in nature (or in being-in-itself), has to mean that it is *in principle* impossible for human beings to attain a pure, unconditioned state in which all the practico-inert would be dissolved—for human products exist in a being or beings, nature, that is not itself a human product.

In addition, the fact that Sartre identifies the unconditioned future goal with integral humanity, humans with their needs fulfilled, inevitably gives it structure and conditions. Human needs themselves set conditions, for they are given structures of the universal human condition and their satisfaction comes only by attaining their proper

objects. The needs for protein and for love, for example, are determinate in the sense that only certain things, food with protein, loving human beings, will satisfy them. Granted there are many foods with protein and many ways to experience love; the specific needs leave much room for particular choices. Still, the needs in question do set conditions, for they specify, and thus limit, the *kinds* of objects or action that satisfy them. Humans do not have total, unconditional freedom to satisfy their needs in just any way they please.[35]

No doubt, the most important thing, as Sartre often asserts, is that human beings be able to control (not dissolve or destroy) their products and nature in order to use them to promote human fulfillment and thus to become their own product. The problem with this is, and we noted it earlier, that Sartre's general perspective, especially in the *Critique,* is to view our relation to the practico-inert negatively, as if it were entirely and inevitably in opposition to free human praxis, just as in his early ontology freedom was generally looked upon as opposed to facticity and the relation between being-for-itself and being-in-itself was fundamentally negative. This perspective continues in the Rome lecture and it explains, I believe, the passages cited above where Sartre describes his ideal as a pure, unconditioned humanity or a pure unconditioned future beyond *all* practico-inert systems. In that impossible state each human being would literally be nothing but its own product. Of course, that is just another version of the *ens causa sui,* the impossible dream of a totally free and independent human causing and justifying all of its own being. Yet this should not surprise us for Sartre insists to the end that human beings never cease to desire the absolute. The religious instinct remains for him one of our "most fundamental needs."[36]

However, as I noted in the previous chapter, the character of this fundamental need or desire seems to change for Sartre. The early desire to *be* God, an *ens causa sui* which is the total cause of its own being, is not the same as the desire and need *for* God described in *The Family Idiot.* Even though it is equally unfulfillable, the latter desire/need fully admits human dependency on the "Other," while the former is precisely a desire to overcome all such dependency. If I am correct in thinking that what Sartre says about Flaubert's religious instinct is meant to apply to all human beings, it indicates the distance he has come in acknowledging the thoroughly dependent character of human reality. In the Flaubert study our fundamental need is described as a need to *receive* meaning and justification from

another, not to give it to ourselves by becoming a self-cause. Thus, not only is the totally autonomous human being an idealistic myth for the later Sartre, he also no longer believes that that is what humans basically need or seek. What we want is a justification for our existence given by an infinite Being, a need which is, of course, unable to be satisfied in Sartre's universe. His final word, then, would seem to be that we must accept our radical dependency along with the limitations of our human condition. No matter how deeply we desire/need an absolute, we must acknowledge the fact that we live in a totally human realm and that the only salvation available to us will come from freely acknowledging our intrinsic dependency on being, on nature, on the practico-inert in all its forms, and especially on other equally dependent human beings.

Perhaps an unqualified acknowledgment of the limitations and the essential dependency of human beings could even lead one in directions Sartre himself did not choose to take. From early on Sartre rejected the traditional attempts to answer the perennial question: why is there something (namely, radically dependent, unnecessary beings) rather than nothing? A primary reason for his rejection was that he correctly saw that absolute human freedom and autonomy were incompatible with a fundamental ontological dependency on a Creator. The later Sartre, however, since he insists that the human being's essential dependency on other persons and on their love is not inimical to its freedom but, in fact, absolutely necessary for its flourishing, has, therefore, less reason to be suspicious of attempts to account for the reality of radically contingent beings by means of a loving Creator-person.

Let me conclude by simply pointing out what I consider to be a couple of the particular strengths of Sartre's second ethics. For one thing, it seems to me that by grounding his later ethics in common human needs, Sartre offers a viable alternative between discredited attempts to locate morality in absolute, eternal essences, on the one hand, and, on the other, rampant particularity and relativism, which offer humans no universal moral norms and goals at all.[37] At a time when so many political, ethnic, racial, and gender groups (as well as some postmodern philosophers) seem to exhibit a perverse delight in emphasizing the numerous and obvious differences among human beings and the problems in understanding, communication, and cooperation that result from such diversity, I welcome the later Sartre's focus on the common humanity that unites us. We frequently

hear today that our world is becoming ever more unified, but so often this seems to refer only to the existence of an interconnected world economy or to the ease with which we can travel to, and communicate with, geographically distant regions. Politically, culturally, racially, sexually diverse human beings hardly seem to be becoming more unified in their specific ideals and goals or in undertaking common actions for the welfare of all people. On the contrary, from the beginning to the end of this century, countless peoples have continued to do exactly what Sartre decried, to identify humanity with only the members of their nationality, class, race, sex, and so forth, and relegate outsiders to a subhuman status. Sartre's efforts to construct a second ethics that roots its values in the existential structures, especially the needs, common to *all* members of the human species avoids such tribalisms. Without a doubt it is important for individuals and groups to appreciate and celebrate their distinctive features and their special, unique contributions to the human family but surely not at the price of ignoring or minimizing their common humanity. I believe Sartre is totally correct when he suggests in his last major work that a genuine humanism will be established on this planet only when we mutually recognize our common human needs, most especially our needs for each other.[38]

Appendix

Sketches of the Third Ethics

It seems appropriate to add to this study some remarks about the ethics that Sartre was working on at the time of his death, even though we do not know a great deal about that ethics. Although he gives no date on which he began a new, third attempt at morality, it apparently occurred in the mid 1970s. This is not to imply that there was a radical conversion between the second ethics and the third, for it seems more likely that what took place was a gradual evolution or progression of Sartre's moral thought. I say this because there appears to be a great deal of similarity between the second and what is available of the third ethics. Indeed, it was only gradually that Sartre himself came to realize that the ethics he was working on in the late seventies was different enough from its predecessor to be considered distinct. It was not until 1977–78 that Sartre actually referred to a *third* ethics; before then he spoke only of two.[1]

Because of Sartre's blinding stroke in 1974 which left him unable to read, the third morality, entitled "Power and Freedom," consists of tape-recorded interviews, or dialogues, with a young ex-Maoist, Benny Lévy. To date almost none of this material has been published or made available in any way, and, therefore, statements about the third morality must remain tentative. All that we actually have of the taped interviews with Mr. Lévy is one lengthy excerpt published a month before Sartre's death.[2] However, there are also three other interviews with Sartre which took place between 1976 and 1980 which help shed light on the content of the third ethics.[3] Using these sources, we can say that Sartre describes his last morality as having the following characteristics:

1. Moral experience is fundamentally the experience of obligation. Of course, such experience was precisely what Sartre phenomeno-logically investigated in the Rome lecture. The difference, and it is significant, is that in the Rome lecture moral obligation was the

experience of moral *norms*, while in the Lévy interview Sartre directly connects it to the experience of the other *person*. "Essentially," he says, "morality is a matter of one person's relationship to another." The very presence of another "constrains" and "obliges" me: "each consciousness seems to me now simultaneously to constitute itself as a consciousness and, at the same time, as the consciousness of others and as consciousness for the other. It is this reality—the self considering itself as self for the other, having a relationship with the other—that I call moral conscience" (*D*, 405). While his first ethics made freedom the sole source of value, his new position, Sartre suggests, sees the other as an *already existing* value.[4]

2. Sartre's discussion of the interpersonal dimension of morality is part of his rethinking of the nature of human relationships and, more generally, of all of his previous ontology.[5] In three separate interviews he refers to the reexamination of human relations that he is undertaking in his third ethics. The main thing, he says, is that the third morality is a morality of the we, not the I. "My previous works never left the I if you will, and this one is a morality of the WE." The we is to be understood ontologically, for, going beyond anything he ever said before, he now states, "Ontologically, consciousnesses are not isolated, there are planes where they enter into one another—planes common to two or to *n* different consciousnesses. . . . [Human beings'] perceptions or their thought are in relation one with others, not only by exposure to the other, but because there are penetrations among consciousnesses" (*O*, 15). This fundamental ontological bond is called *fraternity*, and Sartre says it is first an affective and practical relation with others that is constituted by the fact that we "belong to the same species" and *feel* that we have a "common origin and end."[6] Sartre's point deserves highlighting. Throughout this book, we have traced the development of his understanding of human relations, starting from the antagonistic subject/object dichotomous relationships of *Being and Nothingness*. We saw that the *Notebooks for an Ethics* allowed, and even encouraged, positive subject/object to subject/object relations, such as authentic love and generosity, and spoke of the union involved in them. Similarly, the *Critique of Dialectical Reason* described and praised relationships of oneness (sameness) in which human beings acted in common in groups. However, both the *Notebooks* and the

Critique stressed that the union or oneness involved in authentic love or in groups was not ontological, that is, was not union on the plane of being, but practical, that is, union on the plane of action, and in the pledged group that union was so fragile that it was held together only by terror. In his final interviews, however, Sartre claims that there is an internal *ontological* bond among human beings insofar as they are members of the same species. This union is said to be more basic than, and at the origin of, all societal bonds.

3. Just as the second ethics rooted true morality and true values in needs common to all members of the human species, the third ethics stresses the unity humans have as members of the same species. The bond among humans insofar as they are human is, Sartre maintains, a more fundamental unity than the bonds of production or of classes which Marxists stress: "What unites them [workers] more profoundly than bonds of production, what makes them mean something to each other that is more than their being producers is the fact that they are human beings." (*D*, 411). "This," he adds, "is what we must study," for it is the basic union from which arise all societies, political organizations, and structures. It is because human beings feel a fundamental oneness with each other, he explains, that they subsequently join together to create various social and political classes, groups, and systems. Whether Sartre believes that the species bond is also more fundamental than, and the source of, one's bond with his or her parents and family is not discussed, although it is interesting to note that he does refer to our "fraternal" union with other members of our species as familial.[7] One final point. While the second ethics emphasized the values and goals proper to humans as such (nude man), Sartre often also claimed that these values and goals were actually sought by the oppressed class—and I roundly criticized him for doing so. In his third ethics, as I have just noted, it is unequivocally clear that primacy is given to the needs, values, and goals human beings have insofar as they are one with other members of their species. Class unity is derivative and secondary. This brings us to my fourth point, Sartre's references to human needs.

4. As in the Rome lecture, Sartre refers in the Lévy interviews to the "specific needs" that all humans have and states that the goal of the third ethics, like the second, is "to engender Man, to achieve

human beings," that is, "complete human beings."[8] Similarly, "the creation of the human being" is said to be "the goal that all men have within them" (*D*, 413), because humans "have certain seeds that tend towards man" (*D*, 404). (No doubt these "seeds" are human needs.) Accordingly, "Our goal," he writes "is to arrive at a genuine constituted body in which each person will be a human being and in which collectivities will be no less human" (*D*, 403). As in the second ethics, Sartre stresses the dependency of human beings on each other to achieve this end. He refers to each human being's "desire for society," which is, he says, as fundamental as the human desire to live.[9] Accordingly, we must create a society "in which we can live for others and for ourselves," which means "one must try to learn that one can only seek his being, his life, in living for others." And he adds, poignantly, "In that lies the truth. There is no other."[10]

5. Like the second morality, the morally ideal society of the third ethics demands true or direct democracy.[11] This would mean a society in which no group or individual had power over others, a society of persons freely relating to each other in the "form of a we" or "fraternity." In it all people would freely join together in groups to make common decisions about policies and practices to guide their common activities. Such a democracy, Sartre says, would not only be a kind of government and way of delegating power but a way of life. It would be "the existence of men who live for one another" (*D*, 421). It would be socialism grounded in freedom; it would be the classless society or city of ends, which has been Sartre's moral-political goal almost from the beginning.

NOTES

PREFACE

1. *The Foundation and Structure of Sartrean Ethics* (Lawrence, KS: University Press of Kansas, 1979).

2. *The Ethics of Ambiguity*, trans. B. Frechtman (New York: Citadel Press, 1967); *Pyrrhus et Cinéas* (Paris: Gallimard, 1944); *Sartre and the Problem of Morality*, trans. R. Stone (Bloomington: Indiana University Press, 1980).

3. *Sartre's Political Theory* (Bloomington: Indiana University Press, 1991).

CHAPTER 1

1. Some places where Sartre refers to the general evolution of his thought are the following: SP-*L/S*, pp. 44–48; "Interview with Jean-Paul Sartre," trans. S. Gruenheck, in *The Philosophy of Jean-Paul Sartre*, ed. P. Schilpp (La Salle, IL: Open Court, 1981), pp. 12–13; "The Itinerary of a Thought," trans. J. Matthews, in *Between Existentialism and Marxism* (London: NLB, 1974), pp. 33–35; "Conversations with Jean-Paul Sartre," interview with S. de Beauvoir, trans. P. O'Brian, in *Adieux: A Farewell to Sartre* (New York: Pantheon, 1984), pp. 173, 352 ff, and the entire *SBH*. A recent excellent study of the development of Sartre's thought on consciousness, freedom, and their relation to circumstances is by T. Busch, *The Power of Consciousness and the Force of Circumstances* (Bloomington: Indiana University Press, 1991).

2. *D*, pp. 403–4; *CDR*, I, pp. 741 and 800; *ORR*, pp. 78–79; *BN*, pp. 625–26; and, of course, there is the title of his famous lecture, "L'Existentialisme est un humanisme."

3. In *O*, pp. 14–15, Sartre explicitly refers to three moralities. Other places where he refers to more than one of his moralities are the following: *SBH*, pp. 77–81; SP-*L/S*, pp. 60, 74–75; *ORR*, pp. 78–79; "An Interview with Jean-Paul Sartre," interview with L. Fretz, trans. G. Berger, in *Jean-Paul Sartre, Contemporary Approaches to His Philosophy*, ed. H. Silverman and F. Elliston (Pittsburgh: Duquesne University Press, 1980), pp. 233–34; "Conversations with Jean-Paul Sartre," p. 182.

4. This was publicly stated by Professor Robert Stone at the Sartre Society of North America's meeting in Dayton, Ohio, Fall 1991. Professor Stone reported that he received this information personally from Arlette Elkaïm-Sartre.

5. Two recent studies of Sartre's ethics that are devoted almost entirely to his first morality are by L. Bell, *Sartre's Ethics of Authenticity* (Tuscaloosa: University of Alabama Press, 1989), and by D. Detmer, *Freedom as a Value: A Critique of the Ethical Theory of Jean-Paul Sartre* (La Salle, IL: Open Court, 1988). Needless to say, earlier works by H. Barnes, *An Existential Ethics* (Chicago: University of Chicago Press, 1978), N. Greene, *Jean-Paul Sartre, The Existential Ethics* (Ann Arbor: University of Michigan Press, 1966), and M. Warnock, *Existentialist Ethics* (London: Macmillan Press, 1967), are devoted entirely to Sartre's first ethics. A review of *The Philosophers' Index* listing of articles published since 1980 on Sartre's ethics reveals that only two or three, at most, deal with his second ethics.

6. *O*, p. 14; *SBH*, p. 80. In Fretz's "An Interview with Jean-Paul Sartre," pp. 234, 237–39, Sartre says he is returning to his starting points, his first intuitions.

7. *FI*, II, pp. 3–7; SM, p. 106.

8. S. de Beauvoir, *The Prime of Life*, trans. P. Green (Cleveland: World Publishing Co., 1962), p. 112. See also, *SBH*, pp. 26–27.

9. "Intentionality: A Fundamental Idea of Husserl's Phenomenology," trans. J. Fell, in *Journal of the British Society for Phenomenology* 1, No. 2 (May 1970): 4–5.

10. *Ibid*, p. 4. I have slightly modified Fell's translation.

11. *TE*, pp. 93–94, 105; "Intentionality . . . ," p. 5.

12. *TE*, pp. 90–91.

13. *Imagination*, trans. F. Williams (Ann Arbor: University of Michigan Press, 1962), pp. 2 and 116. Though *Imagination* was published in 1936 before *Transcendence of the Ego* (1938), the latter was written earlier, in 1934, according to Sartre's bibliographers. See M. Contat and M. Rybalka, *The Writings of Jean-Paul Sartre, A Bibliographical Life*, vol. 1,

trans. R. McCleary (Evanston: Northwestern University Press, 1974), pp. 8–9.

14. *Imagination*, p. 115. A more complete treatment of Sartre's arguments for the freedom of consciousness in these early works can be found in my article, "Neglected Sartrean Arguments for the Freedom of Consciousness," *Philosophy Today* 17 (Spring 1973).

15. *The Emotions, Outline of a Theory*, trans. B. Frechtman (New York: The Philosophical Library, 1948), Chapter Three.

16. Let me make it clear that I am not denying that emotional *behavior* contains some measure of freedom. For example, I can choose to dwell on, even magnify, my fear, or I can attempt to deflect or suppress it. I can flee or confront the fearful object. My quarrel with Sartre is over his claim that emotions themselves, e.g., my fear in the face of a mugger with a gun, are freely chosen. Actually, Sartre makes this claim even more clearly in *BN*, "My fear is free and manifests my freedom" (p. 445), than in *The Emotions*.

17. In his 1974 interview with Simone de Beauvoir, Sartre concedes that in his early works he identified freedom and consciousness: "Conversations with Jean-Paul Sartre," pp. 351–52.

18. *TE*, pp. 64–65, 100–103. *The Emotions* also mentions purifying reflection, pp. 79 and 91.

CHAPTER 2

1. *BN*, Introduction, section VI. As will become clear later in the chapter, I am not claiming that Sartre's notion of being-in-itself is simply equivalent to nonconscious being, though I do believe that that is its primary meaning. Being-in-itself gradually becomes an extremely broad notion for Sartre, referring to anything other than consciousness as free spontaneous activity. Thus, it also designates consciousness' own past, its ego, and its facticity, including its body.

2. *BN*, pp. 23–28. This argument for freedom is given rather briefly here. Its expanded form, in Part IV of *Being and Nothingness*, will be discussed in Section 3 of this chapter.

3. He does so for example at *BN*, pages 27 and following.

4. *BN*, Part I, Chapter Two.

5. *BN*, pp. 48–49, 56–58, 66–67.

6. *BN*, pp. 48, 49, 54.

7. *BN*, pp. 67, 70, for example, are very clear.

8. Sartre's position is especially problematic when it comes to the temporal dimension of human existence. In his discussion of temporality, he asserts that "the for-itself is a presence present to all its ekstatic [i.e.

temporal] dimensions" (*BN*, 157). In other words one is always prereflectively aware of his/her past. This is the case of the coward who must be lying rather than forgetful if he/she denies his/her cowardice.

9. *BN*, p. 58. See the whole of section III of *BN*, Part I, Chapter Two.

10. *BN*, pp. 65–69.

11. *BN*, Part II, Chapter One, section III.

12. *BN*, p. 328.

13. *BN*, pp. 312, 316–19, 330.

14. *BN*, pp. 326–30. The best analysis of Sartre's position that I am aware of is the unpublished doctoral dissertation of Dr. Stephen Dinan, *Causality and Consciousness in Sartre's Theory of Knowledge*, Dept. of Philosophy, Marquette University, 1973. It is available from University Microfilms at the University of Michigan, Ann Arbor, Michigan.

15. *BN*, Part I, Chapter Three, sections I and II. See, for example, pp. 174–79, 182. Note this extremely explicit passage: "if consciousness exists in terms of the given, this does not mean that the given conditions consciousness; consciousness is a pure and simple negation of the given, and it exists as the disengagement from a certain existing given." (p. 478)

16. *BN*, pp. 201–3.

17. Detmer, *Freedom as a Value*, Chapter 1, contains the most thorough treatment of the relation of freedom and facticity in *Being and Nothingness* that I know of.

18. See for example *BN*, pp. 439–40, 453, 476–81.

19. Totally false is R. Frondizi's claim that Sartre "offers no proof whatsoever of man's freedom," p. 383 of his "Sartre's Early Ethics: A Critique," in *The Philosophy of Jean-Paul Sartre*.

20. *BN*, pp. 476, 478, 481.

21. *BN*, pp. 61, 391, 443–45, 472.

22. *BN*, pp. 482–83, 488–89. See also pp. 495–99, 509.

23. *BN*, pp. 217, 509. For a thorough discussion of this point, see Part I, Chapter One, section IV and Part II, Chapter Three, section II.

24. *BN*, pp. 492–93, gives this argument regarding my place; p. 497, my past; p. 506, my environment; p. 520, my fellow man.

25. *BN*, pp. 509, 520, 531, 549, 555.

26. *BN*, Part IV, Chapter One, section II, D. See especially pages 520, 524–27, 530–31.

27. Detmer, *Freedom as a Value*, Chapter 1, argues that Sartre's apparently contradictory claims—that freedom is absolute, total, and unlimited on the one hand, yet limited or conditioned on the other—can be explained by distinguishing ontological freedom (which is absolute, etc.) from practical freedom (which is limited, etc.). His attempt is a valiant one but, I believe, unsuccessful because he seems to have a minimalistic notion of Sartre's ontological freedom. Absolute freedom for Detmer simply

means that "no situation can *completely determine* how I will interpret that situation or what project I will form with respect to that interpretation, or how I will act in attempting to carry out that project." (p. 64) I believe Sartre's assertions about human freedom being total, absolute, unlimited, wholly free, and so forth are much stronger and mean just what they say, namely, that freedom is not limited or conditioned *at all* by its facticity or situation because it escapes, transcends, nihilates, denies, and disengages itself from it. Such statements are, I submit, simply incompatible with others in which he recognizes some limits to human freedom.

28. Actually, Sartre's claim that every intentional conscious act is a choice seems to me to be wrong. But I will defer discussion of this point until later.

29. Detmer, *Freedom as a Value*, pp. 69–70, claims that Sartre rejects a purely internal freedom of consciousness. Granted that consciousness is not an internal thing for Sartre, the fact remains that the early Sartre does identify it with total unconditioned (therefore, free) spontaneity and with the freedom of transcendence, as I have shown. I am basically in agreement with Merleau-Ponty's criticism of Sartre. On this topic one could profitably consult M. Whitford, *Merleau-Ponty's Critique of Sartre's Philosophy* (Lexington, KY: French Forum, 1982).

30. In his interview with de Beauvoir, Sartre admits that his early view that one is free in every situation was, like the Stoics', based upon an identification of freedom and consciousness: "Conversations with Jean-Paul Sartre," pp. 351–52, 358.

CHAPTER 3

1. *BN*, pp. 283–85; 175–77.
2. *BN*, pp. 257, 262, 271–73, 289, 291, 296.
3. *BN*, pp. 263 and ff; 267–68, 273–75.
4. *BN*, pp. 241–43, 271–75, 283–89.
5. Sartre says much the same thing in *BN*, pp. 524–25.
6. *BN*, pp. 290–93, 296, 302.
7. I am indebted to W. McBride for pointing out that this is a more accurate translation of Sartre's word *autrui*. See his *Sartre's Political Theory*, p. 219, note 60.
8. Some recent authors who have claimed that the early Sartre held that human beings are inevitably in conflict include the following: P. Caws, *Sartre* (Boston: Routledge & Kegan Paul, 1979); R. Aronson, *Jean-Paul Sartre—Philosophy in the World* (London: NLB, 1980); C. Brosman, *Jean-Paul Sartre* (Boston: Twayne, 1983); T. Flynn, *Sartre and Marxist*

Existentialism (Chicago: University of Chicago Press, 1984); W. Schroeder, *Sartre and His Predecessors* (Boston: Routledge & Kegan Paul, 1984); J-L. Chrétien, "Une morale en suspens," *Critique* 39 (November 1983); F. Elliston, "Sartre and Husserl on Interpersonal Relations," in *Jean-Paul Sartre, Contemporary Approaches to His Philosophy*, ed. H. Silverman and F. Elliston (Pittsburgh: Duquesne University Press, 1980); R. Good, "A Third Attitude Toward Others: Jean-Paul Sartre," *Man and World* 15 (1982).

9. *BN*, pp. 407–8.

10. *BN*, pp. 361–63.

11. Sartre himself criticized his first ethics as too individualistic. See *O*, pp. 14–15, and *D*, p. 405.

12. Sartre must be speaking about pure reflection here, since only it grasps conscious acts as they really are. *BN*, pp. 155–56, makes this clear and also states that such reflection grasps everything at once "without relief."

13. *BN*, p. 574. See also pp. 52–53.

14. *BN*, pp. 568, 570, 574.

15. Busch's *The Power of Consciousness and the Force of Circumstances in Sartre's Philosophy* is an excellent study of Sartre's development on this point.

16. *BN*, Part II, Chapter One, section III, especially pp. 92–94.

17. A number of authors have pointed out the relativistic consequences of Sartre's denial of objective moral values: Caws, *Sartre*; M. Warnock, *Existentialist Ethics*; H. Veatch, *For an Ontology of Morals* (Evanston: Northwestern University Press, 1971); Frondizi, "Sartre's Early Ethics: A Critique"; Chrétien, "Une moral en suspens"; H. Spiegelberg, "Sartre's Last Word on Ethics in Phenomenological Perspective," *Research in Phenomenology* XI (1981).

18. *BN*, pp. 84–91, 626.

19. I believe that for Sartre to speak of man's fundamental project to be God as free and as a choice but at the same time as a choice man must make ("he can choose only to be God" [*BN*, 506] and also p. 599) is extremely misleading if not contradictory. It is worth mentioning, however, that when Sartre first presents his view that human beings necessarily desire God as their ultimate value (pp. 84 and ff) he never says this desire is a choice. I discuss one possible reason for this difference in *The Foundation and Structure of Sartrean Ethics*, Chapter 2, section B. Sartre also sometimes asserts that "Choice and consciousness are one and the same thing" (*BN*, 462). I argued in the previous chapter that his identification of consciousness and freedom is wrong.

20. *BN*, pp. 94–95. See also pp. 37–39.

21. The only other place in *BN* where Sartre speaks of choosing

freedom, rather than God, as one's end is in some very brief remarks about play, pp. 580–81. Nothing concrete is suggested there either, for a study of play, he says, belongs to ethics and supposes a definition of pure reflection. Bell's *Sartre's Ethics of Authenticity* has a number of interesting things to say about Sartre's concept of play. See especially her fifth chapter.

CHAPTER 4

1. *NE*, pp. 100, 138, 157, 226, 440 and ff, 468, 482–99, 512, 527–37; "Cartesian Freedom," trans. A. Michelson, in *Literary and Philosophical Essays* (New York: Collier Books, 1955), pp. 183, 190; "Introduction to *Les Temps Modernes*, trans. F. Ehrmann in *Paths to the Present: Aspects of European Thought from Romanticism to Existentialism*, ed. E. Weber (New York: Dodd, Mead, and Co., 1960), p. 441 [hereafter cited as *LTM*]; and throughout "Consciousness of Self and Knowledge of Self," trans. M. E. and N. Lawrence, in *Readings in Existential Phenomenology*, ed. N. Lawrence and D. O'Connor (Englewood Cliffs, NJ: Prentice-Hall, Inc., 1967).

2. *NE*, pp. 100, 156–57, 365, 440, 468, 497, 530–31. Almost all of these passages and those in the preceding note occur when Sartre is undertaking a very abstract discussion of creation. See also "Cartesian Freedom," pp. 189–90.

3. *NE*, pp. 12, 51–52, 95–96, 117, 140, 285–88, 328–34, 420, 431–32, 474, 501–8, 530–31, 535.

4. Some examples are *LTM*, p. 441; *ASJ*, pp. 60, 90, and throughout chapters 2 and 3; WIL, pp. 89, 194, 235.

5. *NE*, pp. 139–41.

6. "Cartesian Freedom," pp. 183–84.

7. *NE*, pp. 57–58, 69, 76–81, 94–95, 132, 168.

8. "Cartesian Freedom," p. 190.

9. *NE*, pp. 91, 138–41, 436–38. A similar distinction between abstract and concrete freedom is found in WIL, pp. 70, 139, 191. In an extremely interesting analysis, which I will not go into here, Sartre maintains that it is the violent person who considers himself to be pure transcendent freedom and who unsuccessfully denies and tries to destroy both his and the world's facticity. (*NE*, pp. 175–77)

10. *NE*, pp. 431–33, 463, 466, 502–3, 505–8, 532.

11. He also refers to the dialectical relation of freedom and its situation on pp. 326–27 and 466–67, where he says it is the only way to make concrete freedom intelligible. The dialectical relation is also strikingly presented in *LTM*, pp. 264–65.

12. *NE*, pp. 431–33.

13. *NE*, pp. 77, 326–27, 335, 356, 533.

14. *NE*, pp. 74–83, 166–68, 340 ff, 450 ff. Actually much of his criticism seems more properly directed against Engels. MR thoroughly criticizes Marxist determinism.

15. *NE*, pp. 75 ff.

16. *NE*, pp. 117–33.

17. For example, WIL, pp. 72–73, 140, 222–24; *LTM*, p. 261; MR, pp. 224, 253–55; *ASJ*, pp. 148–50.

18. "Cartesian Freedom," p. 181.

19. "Consciousness of Self and Knowledge of Self," pp. 124–25.

20. *LTM*, p. 264.

21. *NE*, pp. 16, 25, 202, 213, 339–40, 393–98, 508–11.

22. *LTM*, p. 264.

23. *NE*, pp. 17, 103, 138, 143, 165–66, 388, 393–98.

24. *NE*, p. 471. See also the texts of the previous note.

25. *NE*, pp. 4–6, 11–12, 409–11, 470–84, 512, 559–60.

26. *TE*, pp. 102–3

27. Like *BN*, *NE* refers to my prereflective project to be God as free and as a choice even though I can do nothing but seek this goal, for "it is the very structure of my existence" (pp. 559–60). I can only repeat my earlier criticism. To speak of freedom of choice when no other options are possible is self-contradictory.

28. I. Mészàros, *The Work of Sartre* (Atlantic Highlands, NJ: Humanities Press Inc., 1979), p. 242, and L. Bell, *Sartre's Ethics of Authenticity*, p. 122 ff, claim that Sartre's position is that humans should in some way attempt to become God even though the goal is unattainable. Mészàros says we should become an *ens causa sui* "symbolically"; Bell says Sartre wants us to keep this goal as a regulating idea. In my opinion such positions are directly contrary to Sartre's own words in *NE*, which I have just cited, and to those at the close of *BN*, where he suggests we "put an end to the reign of this value." In fact, *NE* explicitly labels *inauthentic* any attempt to become God symbolically, p. 521.

29. *TE*, pp. 101–3.

30. *BN*, pp. 160, 581.

31. *NE*, pp. 12–13, 119, 469, 480–81, 511–14, 554–57. See also texts cited in note 34 below.

32. The following raise this objection: Mészàros, *The Work of Sartre*, pp. 205, 218–19; J. Collins, *The Existentialists* (Chicago: Gateway, 1968), pp. 83–84; T.Z. Lavine, *From Socrates to Sartre* (New York: Bantam, 1984), pp. 373–74.

33. *ASJ*, pp. 138–41.

34. *NE*, pp. 470–82, 491–94. On p. 4 he makes it clear that

authenticity is not an end in itself: "If you seek authenticity for authenticity's sake, you are no longer authentic."

35. *NE*, pp. 482–86, 494–99, 527–32.

36. *NE*, 448–49, 514–15. The posthumously published *Truth and Existence*, trans. A. van den Hoven (Chicago: University of Chicago Press, 1992), became available to me just as I was completing this manuscript. An initial reading of it leads me to suggest that consciousness' creation/ revelation of Being as a world spoken of in *NE* is what Sartre calls truth, meaning human reality's unveiling/revealing of Being as it is, in *Truth and Existence*, pp. 3–17, 29–30. Also note the following from *NE*, p. 484: "The For-itself springs up so that Being may become Truth."

37. *NE*, pp. 127–29, 449. See also the texts cited in notes 34 and 35. In *Truth and Existence* Sartre speaks of the enjoyment which comes when we are willing to "assume the world *as if* we had created it . . . to make ourselves responsible for the world as if it were our creation" (p. 30).

38. *WIL*, pp. 49, 59–65.

39. *NE*, p. 15; *EH*, pp. 54–56.

40. Some of these critics are given in note 17 of Chapter 3.

41. *NE*, pp. 290, 393, 465.

42. *NE*, pp. 10, 88–89, 166, 168–69, 290, 402–3.

43. *NE*, pp. 102, 159–62, 166, 290, 406–7.

44. MR, p. 246. I might add that Simone de Beauvoir, throughout her work *The Ethics of Ambiguity*, which she says is based on Sartre's ontology, takes freedom to be the supreme moral value. See especially p. 24 ff.

45. *NE*, pp. 126–29, 439–40, 448–49, 482–86, 495–99, 533–37. One very clear passage is the following: "to make there be Being is to incorporate the maximum of being in an attempt to make the meaning of human life appear." (*NE*, p. 486)

46. *NE*, pp. 153, 481–86, 533–36.

47. *NE*, pp. 89–91, 467, 482, 485.

48. See also *NE*, pp. 439–40, 448–49, 491–99, 528.

49. *NE*, pp. 485–86.

50. *EH*, p. 51.

51. Some who have addressed the argument are the following: Flynn, *Sartre and Marxist Existentialism*, Chapter 3; Bell, *Sartre's Ethics of Authenticity*, Chapter 3; Veatch, *For an Ontology of Morals*, pp. 76–77.

52. Bell, *Sartre's Ethics of Authenticity*, pp. 55–56.

53. *Ibid.*, pp. 57–58.

54. *Truth and Existence* does designate "authentic knowledge" (p. 30) as the willingness to accept truth, i.e., to unveil (rather than ignore or falsify) Being, which means "letting-it-be-as-it-is." Sartre also calls the choice to prefer falsity or to ignore being a choice of bad faith. However, since he rejects the spirit of seriousness, there is still no way he can

consistently maintain that truth itself possesses some objective or intrinsic value.

55. Flynn, *Sartre and Marxist Existentialism*, pp. 37–39.

56. See the authors I have cited in note 32. Others who advance these or related objections are as follows: Frondizi, "Sartre's Early Ethics: A Critique," p. 380; R. Bernstein, *Praxis and Action* (Philadelphia: Pennsylvania State University Press, 1971), p. 152; R. Jolivet, *Sartre: The Theology of the Absurd*, trans. W. Piersol (New York: Newman Press, 1967), pp. 62–63; Alvin Plantinga, "An Existentialist Ethics," *Review of Metaphysics* 12 (December, 1958): 248–50.

57. NE, pp. 122, 483–88, 494–99, 506–8, 513–15.

CHAPTER 5

1. *NE*, pp. 9 and 499.

2. *NE*, pp. 10, 20.

3. *NE*, pp. 10–11, 49, 88–89, 102–3, 140–41, 161–70, 407, 414, 418, 470–71, 499–500, 505–9. These goals are also mentioned in WIL, pp. 140, 218–23; *ASJ*, pp. 148–50; MR, pp. 253–54.

4. *NE*, pp. 126–29, 141, 280–82, 418, 499 ff.

5. *NE*, pp. 85, 274 ff, 384; *ASJ*, pp. 151–53.

6. Sander Lee criticizes my position in "The Central Role of Universalization in Sartrean Ethics," *Philosophy and Phenomenological Research* 46 (September 1985): 59–72. As far as I can tell, Lee offers no reasons to support his view that the only morally relevant aspects of a situation are those that in principle can be duplicated. Caws, *Sartre*, pp. 120–21, advances the same criticisms of Sartre that I do.

7. In her review of my book, *The Foundation and Structure of Sartrean Ethics*, in *Man and World* 14 (1981): 226.

8. *NE*, pp. 11–12, 328, 359–60, 366–67, 387–88, 472–73.

9. *NE*, pp. 16, 25, 191–204, 212–13, 236–37, 339–40, 393–97, 413, 508–12; WIL, pp. 133, 229; *ASJ*, pp. 134–35.

10. *NE*, pp. 15–16, 189–94.

11. R. Stone, "Freedom as a Universal Notion in Sartre's Ethical Theory," *Revue Internationale de Philosophie* nos. 152–53 (1985): 16, claims that if the other is enslaved, he cannot "recognize" me as a free subject but only as a being devoid of subjectivity. Thomas Flynn, *Sartre and Marxist Existentialism*, pp. 40–46, appears to make a similar claim when he says that my concrete freedom requires its free "recognition" by other freedoms if I am to discover truths about myself. As my discussion indicates, I agree, but only if the term *recognition* is given one particular meaning.

12. *NE*, pp. 282–84, 499–500.

13. Sartre's hints are found in the following places: *NE*, pp. 96, 141–42, 195, 199, 208, 282–84, 327–30, 499–500; MR, pp. 250, 254–55. For Simone de Beauvoir's argument in *Pyrrhus et Cinéas*, see especially the last two sections of Part II.

14. Again, *BN*'s section on existential psychoanalysis is an interesting exception to the rest of that work.

15. *NE*, pp. 275–88, 292, 506.

16. *NE*, pp. 9–11, 47–48, 402–3, 499–501, 506–8. Sameness will become a central notion in the *Critique of Dialectical Reason*.

17. *NE*, pp. 325–411, 159–68, 561–74.

18. *NE*, pp. 6, 325, 328, 339–40, 366, 381–85.

19. *NE*, pp. 384 ff.

20. *NE*, pp. 132–33, 331–32; MR, pp. 237 ff.

21. *NE*, pp. 195ff.

22. See texts cited in note 3 of this chapter.

23. For some of his criticisms of his first morality, see *O*, pp. 14–15; *D*, p. 405; *SBH*, pp. 76–81; *ORR*, pp. 78–79; Fretz's "An Interview with Jean-Paul Sartre," p. 233. See also M. Contat and M. Rybalka, *The Writings of Jean-Paul Sartre*, pp. 228, 295.

24. *NE*, pp. 12–13, 98, 115–16, 137, 144–45, 162, 165, 278, 555–57. For *BN*'s notion of value, see above, Chapter III, Section 3. WIL, pp. 56, 64–65, also gives some of these characteristics of value.

25. *NE*, pp. 555–58. For his rejection of the spirit of seriousness, see pp. 8, 12–13, 60–61, 119, 279, 402–3, 480, 511. For his classification of values as nonbeing, see note 24 above and pp. 168, 449.

26. *NE*, pp. 556–57. See also p. 400. *EH*, pp. 29–30.

27. *NE*, pp. 275, 555–56.

28.For a more detailed criticism of the early Sartre's notion of value, see my *The Foundation and Structure of Sartrean Ethics*, pp. 35–37, 61–63.

29. *NE*, pp. 95, 115–16, 390. Yet in at least one place, where he discusses Hegel's notion of freedom (pp. 167–68), Sartre does recognize that the power to transcend the given is not free if its future goal is determined.

CHAPTER 6

1. *Saint Genet, Actor and Martyr*, trans. B. Frechtman (New York: Mentor Book, 1963). See especially the first and last chapters. The quotations in my text are from pp. 14 and 634.

2. See M-A. Burnier, *Choice of Action: The French Existentialists on the Political Front Line*, trans. B. Murchland (New York: Random House,

1968); M. Poster, *Sartre's Marxism* (New York: Cambridge University Press, 1982) and *Existential Marxism in Postwar France* (Princeton: Princeton University Press, 1975); and Aronson, *Jean-Paul Sartre*. Flynn's *Sartre and Marxist Existentialism* is an excellent study of the development of Sartre's "existentialism" in its relation to Marxism. For Sartre's own comments about this period, see *SBH*, pp. 77–80 and *SM*, p. 17 ff.

3. *SM*, Chapter 1. Toward the end of his life, Sartre will not ally himself so closely with Marxism.

4. An excellent recent work is McBride's *Sartre's Political Theory*, Chapters 3 and 4. Other useful works are by J. Catalano, *A Commentary on Jean-Paul Sartre's Critique of Dialectical Reason*, volume I (Chicago: University of Chicago Press, 1986), and W. Desan, *The Marxism of Jean-Paul Sartre* (Garden City, NY: Doubleday, 1966).

5. *CDR*, I, pp. 81–90, 176–81.

6. *CDR*, I, p. 79 ff.

7. *SM*, pp. 91, 150–51, 171 n. 3; *CDR*, I, pp. 79–83, 87.

8. *SM*, p. 91 ff; *CDR*, I, pp. 70–71, 83–88, 97, 422, 549, 579 n. 68. Clearly the "matter" of human consciousness is not the same type of matter that Sartre rejected in MR. That matter was simply Cartesian matter, inert extended parts outside of parts. On this topic see Barnes, "Sartre as Materialist," in *The Philosophy of Jean-Paul Sartre*, ed. P. Schilpp.

9. *SM*, pp. 32–33, n. 9, 91 ff; *CDR*, I, pp. 36–39, 44, 51, 57–66, 74–76, 93, 227–28, n. 68; 805–6. It is the translucidity of praxis that is the epistemological starting point of the *Critique*, for it provides, Sartre says, the apodictic certitude of the experience of the dialectical relation of ourselves and the world (p. 51).

10. *CDR*, I, p. 51 ff.

11. *CDR*, I, Introduction. Indeed, Sartre's larger goal is to show that in spite of all its diversity there is a single dialectic in human history (p. 69).

12. *CDR*, I, Book I, Chapters 1 and 3.

13. *CDR*, I, Book I, Chapters 3 and 4.

14. See Sartre's whole discussion, *CDR*, I, pp. 324–31. If I understand him correctly, he admits that in a situation where there are no real possibilities for change, the so-called freedom of transcendence is purely formal, pp. 329–30.

15. *SM*, pp. 56–65.

16. *CDR*, I, Book I, Chapter 4.

17. *CDR*, I, Book II, Chapter 1. For a more complete discussion of the group and the pledge group consult my book *The Foundation and Structure of Sartrean Ethics*, Chapter 5.

18. See also *CDR*, I, pp. 373, 392, 402.

19. *CDR*, I, pp. 378, 386–87, 393–94, 400, 403.

20. *CDR*, I, pp. 379–81, 396–98, 424.

21. *CDR*, I, pp. 110–15, 378.
22. *CDR*, I, pp. 436–37.
23. *CDR*, I, Book II, Chapter 2.
24. *CDR*, I, Book I, pp. 422, 424, 435, 436.
25. *CDR*, I, Book II, Chapter 4 contains an extensive discussion of the ontological reality of the pledged group. Although Sartre admits it is more than just a collection of individuals, he hesitates about giving it any extra-individual reality of its own.
26. *CDR*, I, pp. 438–41.
27. *CDR*, I, pp. 65–69, 583, 635. See also Book I, Chapter 3, section 3.
28. *CDR*, I, p. 438.
29. *CDR*, I, pp. 306–7, n. 89.
30. See for instance *CDR*, I, pp. 90–91, 114 ff, 151, 226–28, 326, 331–32, 665–68.
31. While it may be true, as McBride points out (*Sartre's Political Theory*, pp. 159–60, 169–70), that almost all human beings on earth are so interconnected that no one can make history without affecting others to some degree, it does not necessarily follow from this kind of unity that there is one history in the sense of a single overall meaning and direction to all of these different interacting praxes and their products.
32. *CDR*, II, pp. 121 ff. An excellent summary and analysis of *CDR*, II is R. Aronson's *Sartre's Second Critique* (Chicago: University of Chicago Press, 1987). His Chapter 5 covers the material I summarize in the next paragraph.
33. *CDR*, II, pp. 150–56, 168, 183.
34. *CDR*, II, pp. 144, 163–65, 180.
35. *CDR*, II, Book III, Part II, Chapter 9.
36. *CDR*, II, pp. 307–9, 314–15, 322–26.
37. *CDR*, II, pp. 383–92.
38. Aronson, *Sartre's Second Critique*, pp. 216–18.

CHAPTER 7

1. *SBH,* pp. 77–81; *ORR* pp. 78–79.
2. This is clearly an exaggeration since in *The Ghost of Stalin*, trans. M. Fletcher (New York: Braziller, 1968), published in France in December 1956 and January 1957, he "condemns" the Soviet Union for its suppression in Hungary, and the French Communist Party for supporting it. Nonetheless, he does still advocate support for both in order to democratize and deStalinize them.

3. *SBH*, p. 81; *O*, p. 14; Contat and Rybalka, *The Writings of Jean-Paul Sartre*, I, p. 449.

4. There are only two articles that I know of which deal at some length with the Rome lecture. Both are by R. Stone and E. Bowman: "Dialectical Ethics: A First Look at Sartre's Unpublished *1964 Rome Lecture Notes*," *Social Text* no. 13–14 (Winter-Spring, 1986): 195–215, and "'Making the Human' in Sartre's Dialectical Ethics," in *Writing the Politics of Difference*, ed. H. Silverman (Albany: SUNY Press, 1991), pp. 111–22. The latter is to a great extent a condensation of the former. I take this opportunity to thank professors Bowman and Stone for initially acquainting me with the Rome lecture. Our continual trialogue about it has been most helpful. The only other possible source of material for the second ethics are the notes Sartre made in preparation for lectures at Cornell University in 1965. These lectures were never given and the notes are not yet available. Two articles offer some general discussion of them: R. Stone and E. Bowman, "Sartre's 'Morality and History': A First Look at the Notes for the Unpublished 1965 Cornell Lectures," Chapter 2 in *Sartre Alive*, ed. R. Aronson and A. van den Hoven (Detroit: Wayne State University Press, 1991); J. Simont, "Autour des Conférences de Sartre à Cornell," in *Sur les écrits posthumes de Sartre*, ed. P. Verstraeten (Bruxelles: Université de Bruxelles, 1987).

5. One portion of the Rome lecture has been translated as "Determinism and Freedom" and published in Volume II of *The Writings of Jean-Paul Sartre*, pp. 241–52. Selections from the French text are published in F. Jeanson, *Sartre* (Paris: Desclée de Brouwer, 1966), pp. 137–38, and B. Lévy, *Le nom de l'homme: dialogue avec Sartre* (Lagrasse: Verdier, 1984). Apart from citations of these published pages, all my references to the 1964 Rome lecture are to Sartre's handwritten manuscript which is available at the Bibliothèque Nationale, Paris, under the title, "Conférence a l'Institute Gramsci, Rome, 1964." Unless otherwise noted, translations of it are my own, but I acknowledge the invaluable assistance of Patrice O'Rourke Linn.

6. De Beauvoir's statement is in a letter to R. Stone, cited by him in "Making the Human," p. 319, n. 13.

7. The passage is translated by Bowman and Stone, "Making the Human," p. 111.

8. RL, pp. 41, 65, 69, 72.

9. DF, pp. 242–45. Of course, none of this is original and Sartre knows it. He himself refers to Kant (p. 248).

10. DF, p. 245; RL, pp. 41 and 45.

11. DF, pp. 246–52.

12. RL, pp. 24–32; DF, p. 250. For more detail on Sartre's analysis of

the thalidomide case, see Stone and Bowman, "Dialectical Ethics," pp. 198–202.

13. DF, pp. 251–52; RL, pp. 41–44.

14. RL, pp. 44–48.

15. RL, pp. 48–62, 64. Some of the passages are in Jeanson, *Sartre*, p. 137. See also Stone and Bowman, "Dialectical Ethics," pp. 201–5.

16. Sartre's analysis is on pp. 67–72.

17. In section III, pp. 76 and 103, he admits that all oppressed classes have not acted for integral humanity. In *ORR*, p. 167, he admits that the masses are not always the prime movers of history. Of course, since Sartre's Rome audience is a group of Marxists or Marxist sympathizers, he need only appeal to the general Marxist positions on these matters. If I understand them correctly, Stone and Bowman, "Dialectical Ethics," argue that the exploited classes seek a human future for all beyond oppression because 1. their labor involves reordering the world, not just repetition of the past (p. 199), and 2. they fundamentally struggle against the dominant class and against the inhuman systems it supports (pp. 202–4). I confess I do not see how these reasons support Sartre's conclusion that the oppressed in fact seek a human future without exploitation for *all*. These two points seem perfectly compatible with the oppressed seeking only their own self-interest in a new inhuman system where they become the oppressors.

18. RL, pp. 74–95.

19. Translations are from Stone and Bowman, "Dialectical Ethics," p. 207.

20. See Jeanson, *Sartre*, pp. 137–38; Lévy, *Le nom*, p. 109; Stone and Bowman, *ibid*.

21. The statement is in Jeanson, *Sartre*, p. 138, and is translated by Stone and Bowman, "Dialectical Ethics," p. 207.

22. RL, pp. 100–101.

23. RL, p. 132.

24. RL, p. 82.

25. RL, pp. 88, 102, 106, 109, 126, 144.

26. RL, pp. 88, 97, 133–34.

27. RL, pp. 47 and 146, speaks as if history *is* moving toward integral humanity; pp. 59–60 and 162–164 appear to say it *should* move toward that goal.

28. SP-*L/S,* p. 83.

29. RL, pp. 110–24, 135. See also texts cited in note 17 above.

30. RL, pp. 124–28, 133–34. Also see Stone and Bowman, "Dialectical Ethics," pp. 209–10.

31. The passage is in Jeanson, *Sartre*, p. 138.

32. The passage is in Lévy, *Le nom*, p. 135.

33. RL, pp. 149, 162. See also the texts cited in note 25 above.

34. RL, pp. 140–43, 146, 162.

35. RL, pp. 144–48, 157–58.

36. RL, pp. 152–57.

37. RL, pp. 159–64. It is interesting to note that none of the conditions Sartre presents involves distinguishing between violence against innocent people and violence against aggressors seeking to destroy human beings. Yet such a distinction seems crucial to any moral evaluation.

38. RL, pp. 163–64.

CHAPTER 8

1. SP-*L/S*, p. 52; "Interview with Jean-Paul Sartre" in *The Philosophy of Jean-Paul Sartre*, p. 22.

2. The quotation is actually from Pierre Victor (Benny Lévy), one of Sartre's interviewers, but Sartre says he agrees with it. See also *ORR*, pp. 306–7; "Czechoslovakia: The Socialism That Came in from the Cold," trans. J. Matthews, in *Between Existentialism and Marxism* (London: NLB, 1974), p. 86; "France: Masses, Spontaneity, Party," trans. J. Matthews, in *ibid.*, pp. 135–36; SP-*L/S*, p. 78.

3. "Czechoslovakia," pp. 112–15. See also *ORR*, pp. 234–36, 251–53.

4. G. Hunnius, et al., *Workers Control* (NY: Vintage Books, 1973), Part III; M. Carmoy and D. Shearer, *Economic Democracy* (Armonk, NY: M.E. Sharpe Inc., 1980); D. Jenkins, *Job Power* (NY: Penguin, 1974).

5. See the entire discussion, *ORR*, pp. 305–7. See also *ORR*, p. 108; "Elections: A Trap for Fools," trans. P. Austin and L. Davis, in *Life/Situations*, pp. 204–10.

6. "The Maoists in France," in *Life/Situations*, p. 171; "Justice and the State," *ibid.*, p. 197; "Sartre Accuses the Intellectuals of Bad Faith," interview with J. Gerassi in *New York Times Magazine* (October 17, 1971), p. 119.

7. "What's Jean-Paul Sartre Thinking Lately?" interview with P. Bénichou, trans. P. Southgate, in *Esquire* 78 (December 1972), p. 208.

8. *Ibid.*; *ORR*, pp. 47–48, 76, 234–35, 345–52; SP-*L/S*, pp. 52, 84; "The Itinerary of a Thought," in *Between Existentialism and Marxism*, p. 57. Sartre's articles on Czechoslovakia, "Czechoslovakia: The Socialism That Came in from the Cold," and on the Basques in Spain, "The Burgos Trial," in *Life/Situations*, clearly show his recognition that socialism is an analogous notion.

9. SP-*L/S,* p. 63; "The Maoists in France," p. 171; "Czechoslovakia," pp. 114–15; *ORR,* pp. 300–305.

10. SP-*L/S,* pp. 167–68; "Elections: A Trap for Fools," pp. 200–202; *ORR,* pp. 139–46; 168–71; "The Maoists in France," pp. 166–69.

11. *ORR,* pp. 77, 185–86; SP-*L/S,* pp. 11–13, 62–63, 69.

12. *ORR,* pp. 71, 288, 300–305; "The Maoists in France," p. 167; "Interview with Jean-Paul Sartre," in *The Philosophy of Jean-Paul Sartre,* p. 33; "What's Jean-Paul Sartre Thinking Lately?," p. 282.

13. *ORR,* pp. 71, 325; "The Itinerary of a Thought," pp. 62–63; "I am no longer a realist," interview with P. Verstraeten, trans. B. Kingston, in *Sartre Alive,* p. 97.

14. "The Purposes of Writing," in *Between Existentialism and Marxism,* pp. 30–31; "France: Masses, Spontaneity, Party," p. 129; SP-*L/S,* pp. 83–84; "Justice and the State," p. 179.

15. "Justice and the State," pp. 178–79; *ORR,* p. 76.

16. "Sartre Accuses the Intellectuals of Bad Faith;" *ORR,* pp. 40, 83; SP-*L/S,* p. 53; *SBH,* pp. 96–97, 102–3; "A Friend of the People," in *Between Existentialism and Marxism,* pp. 294–96; "I am no longer a realist," pp. 84, 96.

17. Quoted by Aronson, *Jean-Paul Sartre,* p. 322.

18. "France: Masses, Spontaneity, Party," pp. 124–25.

19. "The Maoists in France," p. 170.

20. "A Plea for Intellectuals," in *Between Existentialism and Marxism,* pp. 255–56; "The Maoists in France," p. 167.

21. "France: Masses, Spontaneity, Party," pp. 119–23. See also *ORR,* pp. 45, 336–37.

22. *SBH,* p. 77. An excellent summary of *The Family Idiot* is Barnes's *Sartre & Flaubert* (Chicago: University of Chicago, 1981).

23. *FI,* I, pp. 132–45.

24. *FI,* I, pp. 154–58, 163.

25. "On the Idiot of the Family," in *Life/Situations,* pp. 116–17.

26. "The Itinerary of a Thought," p. 35. See also "Conversations with Jean-Paul Sartre," in *Adieux,* pp. 352–54, 358–59.

27. *FI,* I, pp. 129–37.

28. *FI,* I, pp. 151–58, 163; *L'Idiot de la famille* (Paris: Gallimard, 1972), III, p. 223.

29. *FI,* I, pp. 183–84, 355; IV, Chapters 16 and 17; *L'Idiot,* II, 1771–810. Sartre speaks of Flaubert as both "victim and agent" of his illness (*FI,* IV, 31). Also see Barnes, *Sartre & Flaubert,* pp. 204–31, 415–18.

30. *FI,* I, pp. 48, 107–10.

31. In a lengthy section entitled "The Other Ideology" (*FI,* I, pp. 487–592), Sartre discusses Gustave's desire and need for the infinite as well as

his inability/unwillingness to believe in God, and he (Sartre) generalizes about the religious instinct and need in all humans. See especially, pp. 496–99, 505, 520–21, 531, 542–49, 555–56, 559–60, 566–67, 587. See also *FI*, II, pp. 412–13. There are many parallels between this section of *The Family Idiot* and *The Words*, trans. B. Frechtman (New York: Braziller, 1964), pp. 61–65, 112, 156–59, where Sartre speaks of his own desire for God, or for something like God, to justify his existence.

32. Much of Sartre's interpretation is based on his analysis of the particular version Flaubert authors of a medieval tale, "The Legend of St. Julien the Hospitaler" (*FI*, III, 329–57). That analysis is part of a 200-page detailed discussion of the various ways Flaubert plays, or, better, devotes his life to, the game of loser wins (pp. 151–357).

33. The quotation is from *L'Idiot*, III, p. 585. My comments basically agree with Barnes's interpretation of Sartre's less than clear final section of *L'Idiot*, III, p. 445 ff, in her *Sartre & Flaubert*, pp. 297–309. However, one thing that challenges the view that Flaubert eventually gave up the game of loser wins is that "The Legend of St. Julien" (in which he symbolically presented his faith in loser wins, according to Sartre) was written late in Flaubert's life. Nevertheless, whatever the case with Gustave Flaubert, it is abundantly clear that Jean-Paul Sartre does not applaud the former's attempt to achieve salvation by escaping the real and fleeing to the imaginary.

34. *FI*, II, p. 413.

CHAPTER 9

1. Contat and Rybalka, *The Writings of Sartre*, p. 449. See also *SBH*, p. 81.

2. Bowman and Stone, "Making the Human," pp. 116–20, does a good job of linking freedom or autonomy and needs in Sartre's second ethics.

3. Chapters 16 and 17 of *FI*, IV discuss the nature of Flaubert's illness and the extent of his understanding and consent to it.

4. This is stated in *NE*, p. 397, near the conclusion of his discussion (pp. 384–98) of resignation.

5. *NE*, pp. 413–14, 470–71. See also pp. 49, 88–89.

6. In various later interviews, Sartre indicates he has substituted the notion of "*le vecu*" (lived experience) for his earlier concept of a perfectly transparent, prereflective self-awareness. *Le vecu* is a whole of whose surface one is conscious but whose depth is opaque and hidden from consciousness ("On *The Idiot of the Family*," pp. 127–28). It is "the

ensemble of the dialectical process of psychic life, insofar as this process is obscure to itself." It is present to itself, like all psychic phenomena, but "this presence is so opaque and blind before itself that it is also an absence from itself" ("Itinerary of a Thought," pp. 39–42). Insofar as it is present to itself, *le vecu* is not pre- or unconscious, Sartre continues to insist, though I suspect this may be simply a holdover from his early view, that a consciousness unconscious of itself is self-contradictory. (See "Interview with Jean-Paul Sartre," in *The Philosophy of Jean-Paul Sartre,* pp. 22–23.) In any case it is clear that it is only with much effort and assistance that one can come to an increased awareness or knowledge of this dim and deep region of experience.

7. "On *The Idiot of the Family,*" p. 122. The emphasis in the text is mine.

8. *BN,* pp. 38–39, 626.

9. Terminologically, where the first morality speaks of value, the second prefers the term *norms,* of which values are a subdivision; values are "normative qualities attached to human conduct or its consequences" (DF, 241). I will use the two terms interchangeably in this discussion to refer to the general kind of "thing" that is the object of moral experience.

10. RL, pp. 67, 98, 145.

11. RL, p. 109.

12. See above Chapter 5, Section 4.

13. See above Chapter 4, Section 2b.

14. Translation is by Stone and Bowman, "Dialectical Ethics," p. 214.

15. Stone and Bowman, "Dialectical Ethics," p. 209, have a slightly different translation.

16. See above Chapter 5, Section 2.

17. RL, p. 101. The passage is in Jeanson, *Sartre,* p. 138.

18. RL, pp. 117–19, 134–43.

19. Jeanson, *Sartre,* p. 138. The whole passage is quoted in my text above, Chapter 7, p. 125.

20. "France: Masses, Spontaneity, Party," pp. 124–25.

21. Chapter 7, the beginning of Section 4.

22. RL, pp. 88, 106, 109, 149, 162. See also *FI,* IV, pp. 263–64.

23. Attempts to come up with cross-cultural universal human needs have been made by many authors, and numerous lists have been set forth. Among the most famous is that proposed by A. Maslow and those by various people writing under the auspices of the United Nations. For useful suggestions as to how to get at universal needs, see K. Lederer et al., ed., *Human Needs* (Cambridge: Oelgeschlager, Gunn and Hain, 1980), and D. Braybrooke, *Meeting Needs* (Princeton: Princeton University Press, 1987). Both books contain lists of universal needs offered by various people or groups and, it is worth noting, the lists contain remarkable similarities.

24. *CDR,* I, pp. 51, 56–57; *L'Idiot,* III, pp. 210–13; *D,* p. 403.

25. *SM,* pp. 169–73. *L'Idiot,* III, seems to do much the same, for while it denies "human nature" it speaks of the "ontological structure of human reality" (p. 224).

26. *CDR,* I, pp. 49–51, 56, 57.

27. *CDR,* II, pp. 28–29, 34–35.

28. Sartre refers to his nominalism in *CDR,* I, p. 37. Chapter 4 of *CDR,* II, discusses the ontological status of the group. See my Chapter 6, Sections 3c and 4 above.

29. *CDR,* II, p. 22. The example Sartre uses is boxing. An individual match is a particular "incarnation," "embodiment," "concrete temporalization," "realization" (all his terms) of an "ensemble of meanings and practices" and of "the whole of boxing as an incarnation of all fundamental violence" (pp. 20–30, 40–41). *BN* also speaks of the "incarnation" (p. 519) of the general human structures, techniques, and abstract relations in each member of the human race.

30. Note the following statement from *ASJ* that clearly admits universal human features at the same time that it denies a common nature:

> What men have in common is not a "nature" but a condition, that is, an ensemble of limits and restrictions: the inevitability of death, the necessity of working for a living, of living in a world already inhabited by other men. Fundamentally this condition is nothing more than the basic human situation, or if you prefer, the ensemble of abstract characteristics common to all situations. I agree, therefore, with the democrat that the Jew is a man like other men, but this tells me nothing in particular—except that he is free, hates, just as do all men. (p. 60)

31. In *EH,* p. 34, he calls the belief in a fixed human nature *determinism.*

32. *CDR,* II, pp. 189–95. See also *CDR,* I, pp. 49 and 56.

33. I completely agree with Aronson's criticism of Sartre on this point in *Sartre's Second Critique,* pp. 51–73, 152–53, 224–25.

34. *RL,* pp. 39, 46–47, 59–63, 66.

35. As my text shows, I disagree with Bowman and Stone's contention ("Making the Human," pp. 121–22) that "Needs for Sartre contain no imprint of their satisfying object." They claim that both the means to satisfy a need *and the end* of that satisfaction are "invented." I do not understand how we invent the end or goal of our need for protein. Is that end, protein, not set by our specific organic structure?

36. *FI,* I, p. 531. Also see passages referred to in note 31 of my Chapter 8, above, as well as *D,* pp. 398–400.

37. In fact finding a middle ground was an explicit goal of his Rome lecture. See above Chapter 6, Section 1.

38. *FI,* II, p. 413. See also, *FI,* IV, pp. 263–64.

APPENDIX

1. *O,* pp. 14–15, is the first place Sartre says that he attempted three ethics.

2. There has been a fair amount of controversy about the Benny Lévy interviews. Simone de Beauvoir and others charged that in them Lévy "extorted" statements from Sartre. Yet there is clear evidence that Sartre himself encouraged the publication of these interviews just as they are. Furthermore, many of the most important points Sartre makes in them about his third ethics are not substantially different from things he said in other, noncontroversial interviews which took place in the last years of his life. For a review of this controversy, see Busch, *The Power of Consciousness,* pp. 96–101, and McBride, *Sartre's Political Theory,* pp. 202–8.

3. The interview with Lévy is in *D.* The three other interviews are *O,* "Man muss für sich selbst und für die anderen leben," interview with R. Neudeck in *Merkur* (December, 1979), and Fretz's "An Interview with Jean-Paul Sartre."

4. Undoubtedly, Sartre's statements about morality and the other person reflect some influence of Levinas on him. Benny Lévy is a personal friend of Levinas, and he frequently referred to him in his conversations with Sartre. I thank Professor Michel Rybalka for this information.

5. *O,* pp. 14–15, 17; *D,* pp. 403–6; Fretz's "An Interview with Jean-Paul Sartre," pp. 233–39.

6. *D,* pp. 412–15

7. *Ibid.*

8. *D,* pp. 414, 403. In "Man muss für sich selbst," Sartre also refers to needs, p. 1218.

9. *D,* pp. 400, 405. No doubt the desires issue from our needs.

10. "Man muss für sich selbst," pp. 1221–22.

11. Fretz's "An Interview with Jean-Paul Sartre," p. 233; "Man muss für sich selbst," pp. 1217–18, 1221; *D,* p. 410.

BIBLIOGRAPHY

This bibliography contains the works I have referred to in this book. A complete, annotated bibliography of all of Sartre's writings through 1973 is available in volume 1 of the work by M. Contat and M. Rybalka cited below. In 1979 a major update was published in *Obliques* 18–19, pp. 335–47. Since 1987, each year in June *Le Groupe d'Études Sartriennes* publishes a *Bulletin d'information,* which contains a bibliography of all works by and on Sartre published the previous year. For information contact Michel Contat, ITEM, C.N.R.S., 61, rue de Richelieu, 75002 Paris. Two very extensive international bibliographies of secondary literature on Sartre are F. and C. Lapointe, *Jean-Paul Sartre and His Critics: An International Bibliography (1938–1975)* (Bowling Green, Ohio: Philosophy Documentation Center, 1975), and R. Wilcocks, *Jean-Paul Sartre: A Bibliography of International Criticism* (Edmonton: The University of Alberta Press, 1975). The latter contains a bibliography of bibliographies.

WRITINGS OF SARTRE:

"An Interview with Jean-Paul Sartre." Interview with L. Fretz, trans. G. Berger. In *Jean-Paul Sartre, Contemporary Approaches to His Philosophy.* Ed. H. Silverman and F. Elliston. Pittsburgh: Duquesne University Press, 1980.

Anti-Semite and Jew. Trans. G. Becker. New York: Schocken Books, Inc., 1948. Originally published as *Réflections sur la Question Juive* (Paris: Paul Morihien, 1946).

Being and Nothingness. Trans. H. Barnes. New York: Philosophical Library, 1956. Originally published as *L'Être et le Néant* (Paris: Gallimard, 1943).

Between Existentialism and Marxism. Trans. J. Mathews. London: New Left Board, 1974. Essays were originally published in *Situations VIII* and *Situations IX* (Paris: Gallimard, 1972). (Among the essays in this book are the following cited in my notes: "The Purposes of Writing," "The Itinerary of a Thought," "Czechoslovakia: The Socialism That Came in from the Cold," "France: Masses, Spontaneity, Party," "A Plea for Intellectuals," "A Friend of the People.")

"Cartesian Freedom." Trans. A. Michelson. In *Literary and Philosophical Essays.* New York: Collier Books, 1955. Originally published as "La liberté cartésienne." In *Situations* I (Paris: Gallimard, 1947).

"Consciousness of Self and Knowledge of Self." Trans. M. E. and N. Lawrence. In *Readings in Existential Phenomenology.* Ed. N. Lawrence and D. O'Connor. Englewood Cliffs: Prentice-Hall, Inc., 1967. Originally published as "Conscience de soi et connaissance de soi." *Bulletin de la Société française de Philosophie* (April-June 1948).

"Conversations with Jean-Paul Sartre." Interview with S. de Beauvoir, trans. P. O'Brian. In *Adieux: A Farewell to Sartre.* New York: Pantheon Books, 1984. Originally published as *La Cérémonie des adieux* (Paris: Gallimard, 1981).

Critique of Dialectical Reason, vol. I. Trans. A. Sheridan-Smith. London: New Left Board, 1976. Originally published as *Critique de la raison dialectique,* tome I (Paris: Gallimard, 1960).

Critique of Dialectical Reason, vol. II. Trans. Q. Hoare. London: Verso, 1991. Originally published as *Critique de la raison dialectique,* tome II (Paris: Gallimard, 1985).

"Determinism and Freedom." Trans. R. McCleary. In *The Writings of Jean-Paul Sartre.* vol. II. Ed. M. Contat and M. Rybalka. Evanston: Northwestern University Press, 1974. This is the only translated and published portion of Sartre's Rome lecture in English. It was originally published as "Détermination et liberté." In *Les Écrits de Sartre.* Ed. M. Contat and M. Rybalka. (Paris: Gallimard, 1970).

The Emotions: Outline of a Theory. Trans. B. Frechtman. New York: The Philosophical Library, 1948. Originally published as *Esquisse d'une théorie des émotions* (Paris: Hermann, 1940).

Existentialism and Humanism. Trans. P. Mairet. London: Methuen Ltd.,

1973. Originally published as *L'Existentialisme est un humanisme* (Paris: Les Editions Nagel, 1946).

The Family Idiot, vols. 1–4. Trans. C. Cosman. Chicago: University of Chicago Press, 1981, 1987, 1989, 1991. Originally published as *L'Idiot de la famille: Gustave Flaubert de 1821 à 1857,* tomes I et II (Paris: Gallimard, 1971).

The Ghost of Stalin. Trans. M. Fletcher. New York: Braziller, 1968. Originally published as "La Fantôme de Staline." In *Situations* VII (Paris: Gallimard, 1965).

"I am no longer a realist." Trans. B. Kingston. In *Sartre Alive.* Ed. R. Aronson and A. van den Hoven. Detroit: Wayne State University Press, 1991. Originally published as "Je ne suis plus realiste." Interview with P. Verstraeten in *Gulliver* no. 1 (November, 1972).

L'Idiot de la famille: Gustave Flaubert de 1821 à 1857, tomes II et III. Paris: Gallimard, 1971, 1972.

Imagination. Trans. F. Williams. Ann Arbor: University of Michigan Press, 1962. Originally published as *L'Imagination* (Paris: Librairie Felix Alcan, 1936).

"Intentionality: A Fundamental Idea of Husserl's Phenomenology." Trans. J. Fell. In *Journal of the British Society for Phenomenology* 1, no. 2 (May, 1970). Originally published as "Une idée fondamentale de la phénoménologie de Husserl: l'intentionnalite." In *Situations* I (Paris: Gallimard, 1947).

"Interview with Jean-Paul Sartre." Trans. S. Gruenheck. In *The Philosophy of Jean-Paul Sartre.* Ed. P. Schilpp. La Salle: Open Court, 1981.

"Introduction to *Les Temps Modernes.*" Trans. F. Ehrmann. In *Paths to the Present: Aspects of European Thought from Romanticism to Existentialism.* Ed. E. Weber. New York: Dodd, Mead, and Co., 1960. Originally published as "Présentation des Temps modernes." In *Situations* II (Paris: Gallimard, 1948).

"Jean-Paul Sartre et M. Sicard: Entretien." *Obliques* 18–19 (1979).

"The Last Words of Jean-Paul Sartre." An interview between Benny Lévy and Sartre, trans. A. Foulke. *Dissent* (Fall, 1980). Originally published as "L'Espoir, maintenant . . ." in *Le Nouvel Observateur* (March 10, 17, 24, 1980).

Lecture given in Rome, May 1964, at the Gramsci Institute, now available at the Bibliothèque Nationale, Paris. The B.N. has entitled it "Conférence a L'Institut Gramsci, Rome, 1964."

Life/Situations: Essays Written and Spoken. Trans. P. Auster and L. Davis. New York: Pantheon Books, 1977. Originally published as *Situations* X (Paris: Gallimard, 1975). (Among the contents of this book are the following pieces cited in my notes: "Self-Portrait at Seventy," "On The Idiot of the Family," "The Burgos Trial," "Justice and the State," "The Maoists in France," "Elections: A Trap for Fools").

"Man Muss für sich selbst und für die anderen leben." Interview with R. Neudeck in *Merkur* (December 1979).

"Materialism and Revolution." Trans. A. Michelson. In *Literary and Philosophical Essays*. New York: Collier Books, 1962. Originally published as "Matérialisme et révolution." In *Situations* III (Paris: Gallimard, 1949).

Notebooks for an Ethics. Trans. D. Pellauer. Chicago: University of Chicago Press, 1992. Originally published as *Cahiers pour une morale* (Paris: Gallimard, 1983).

On a raison de se révolter, discussions. A collection of interviews with Ph. Gavi and P. Victor. Paris: Gallimard, 1974.

Saint Genet, Actor and Martyr. Trans. B. Frechtman. New York: Mentor Books, 1963. Originally published as *Saint Genet: Comédien et Martyr* (Paris: Gallimard, 1952).

"Sartre Accuses the Intellectuals of Bad Faith." Interview with J. Gerassi. *New York Times Magazine* (October 17, 1971).

Sartre by Himself. Trans. R. Seaver. New York: Urizen Books, 1978. Originally published as *Sartre: Un film realisé par A. Astruc et M. Contat* (Paris: Gallimard, 1977).

Search for a Method. Trans. H. Barnes. New York: Random House, 1958. Originally published as *Questions de méthode* (Paris: Gallimard, 1957).

The Transcendence of the Ego. Trans. F. Williams and R. Kirkpatrick. New York: Noonday Press, 1957. Originally published as *La Transcendance de l'ego* (Paris: J. Vrin, 1965).

Truth and Existence. Trans. A. Van den Hoven. Chicago: University of Chicago Press, 1992. Originally published as *Vérité et Existence* (Paris: Gallimard, 1989).

"What Is Literature?" and Other Essays. Trans. B. Frechtman. Cambridge: Harvard University Press, 1988. Originally published as "Qu'est-ce que la littérature?" In *Situations* II (Paris: Gallimard, 1948).

"What's Jean-Paul Sartre Thinking Lately?" Interview with P. Bénichou, trans. P. Southgate. *Esquire* 78 (December 1972).

The Words. Trans. B. Frechtman. New York: Braziller, 1964. Originally published as *Les mots* (Paris: Gallimard, 1964).

SECONDARY SOURCES:

Anderson, Thomas. *The Foundation and Structure of Sartrean Ethics.* Lawrence: University Press of Kansas, 1979.

————. "Neglected Sartrean Arguments for the Freedom of Consciousness." *Philosophy Today* 17 (Spring 1973): 28–39.

Aronson, Ronald. *Sartre: Philosophy in the World.* London: New Left Books, 1980.

————. *Sartre's Second Critique.* Chicago: University of Chicago Press, 1987.

Barnes, Hazel. *An Existentialist Ethics.* Chicago: University of Chicago Press, 1978.

————. *Sartre & Flaubert.* Chicago: University of Chicago Press, 1981.

————. "Sartre as Materialist." In *The Philosophy of Jean-Paul Sartre.* Ed. P. Schilpp. La Salle, IL: Open Court, 1981.

Bell, Linda. *Sartre's Ethics of Authenticity.* Tuscaloosa: University of Alabama Press, 1989.

Bernstein, Richard. *Praxis and Action.* Philadelphia: University of Pennsylvania Press, 1971.

Bowman, Elizabeth, and Robert Stone. " 'Making the Human' in Sartre's Unpublished Dialectical Ethics." In *Writing the Politics of Difference.* Ed. H. Silverman. Albany: State University of New York Press, 1991.

Braybrooke, David. *Meeting Needs.* Princeton: Princeton University Press, 1987.

Brosman, Catherine. *Jean-Paul Sartre.* Boston: Twayne, 1983.

Burnier, Michel-Antoine. *Choice of Action: The French Existentialists on the Political Front Line.* Trans. B. Murchland. New York: Random House, 1968.

Busch, Thomas. *The Power of Consciousness and the Force of Circumstances in Sartre's Philosophy.* Bloomington: Indiana University Press, 1990.

Carmoy, Martin, and Derek Shearer. *Economic Democracy.* Armonk, New York: M.E. Sharpe Inc., 1980.

Catalano, Joseph. *A Commentary on Jean-Paul Sartre's Critique of Dialectical Reason.* Chicago: University of Chicago Press, 1986.

Caws, Peter. *Sartre.* London: Routledge and Kegan Paul, 1979.

Chrétien, Jean-Louise. "Une morale en suspens." *Critique* 39 (November 1983): 856–71.

Collins, James. *The Existentialists*. Chicago: Gateway Press, 1968.

Contat, Michel, and Michel Rybalka. *The Writings of Jean-Paul Sartre*, 2 vols. Trans. R. McCleary. Evanston: Northwestern University Press, 1974.

De Beauvoir, Simone. *The Ethics of Ambiguity*. Trans. B. Frechtman.New York: Citadel Press, 1964.

———. *The Prime of Life*. Trans P. Green. Cleveland: World Publishing Co., 1962.

———. *Pyrrhus et Cinéas*. Paris: Gallimard, 1944.

Desan, Wilfrid. *The Marxism of Jean-Paul Sartre*. Garden City, NY: Doubleday and Co., Inc., 1966.

Detmer, David. *Freedom as a Value: A Critique of the Ethical Theory of Jean-Paul Sartre*. La Salle, IL: Open Court, 1988.

Dinan, Stephen. *Causality and Consciousness in Sartre's Theory of Knowledge*. Unpublished doctoral dissertation. Available from University Microfilms. Ann Arbor: University of Michigan, 1973.

Elliston, Fred. "Sartre and Husserl on Interpersonal Relations." In *Jean-Paul Sartre, Contemporary Approaches to His Philosophy*. Ed. H. Silverman and F. Elliston. Pittsburgh: Duquesne University Press, 1980.

Flynn, Thomas. *Sartre and Marxist Existentialism*. Chicago: University of Chicago Press, 1984

Frondizi, Risieri. "Sartre's Early Ethics: A Critique." In *The Philosophy of Jean-Paul Sartre*. Ed. P. Schilpp. La Salle, IL: Open Court, 1981.

Good, Robert. "A Third Attitude Toward Others: Jean-Paul Sartre." *Man and World* 15, no. 3 (1982): 259–63

Greene, Norman. *Jean-Paul Sartre: The Existentialist Ethic*. Ann Arbor: University of Michigan Press, 1966.

Hunnius, Gerry, et al., eds. *Workers Control*. New York: Vintage Books, 1973.

Jeanson, Francis. *Sartre and the Problem of Morality*. Trans. R. Stone. Bloomington: Indiana University Press, 1981.

———. *Sartre*. Paris: Desclée de Brouwer, 1966.

Jenkins, David. *Job Power*. New York: Penguin Books, 1974.

Jolivet, Régis. *Sartre: The Theology of the Absurd*. Trans. W. Piersol. New York: Newman Press, 1967.

Lavine, T.Z. *From Socrates to Sartre*. New York: Bantam Books, 1984.

Lederer, Keith, et al., eds. *Human Needs*. Cambridge: Oelgeschlager, Gunn and Hain, 1980.

Lee, Sander. "The Central Role of Universalization in Sartrean Ethics." *Philosophy and Phenomenological Research* 46 (September 1985): 59–72.

Lévy, Benny. *Le nom de L'homme: dialogue avec Sartre*. Lagrasse: Verdier, 1984.

McBride, William. *Sartre's Political Theory*. Bloomington: Indiana University Press, 1991.

Mészàros, Istvan. *The Work of Sartre*. Atlantic Highlands: Humanities Press, 1979.

Plantinga, Alvin. "An Existentialist's Ethics." *Review of Metaphysics* 12 (December 1958): 235–56.

Poster, Mark. *Existential Marxism in Postwar France*. Princeton: Princeton University Press, 1975.

———. *Sartre's Marxism*. New York: Cambridge University Press, 1982.

Schroeder, William. *Sartre and His Predecessors*. Boston: Routledge & Kegan Paul, 1984.

Simont, Juliette. "Autour des Conférences de Sartre à Cornell." In *Sur les écrits posthumes de Sartre*. Ed. P. Verstraeten. Bruxelles: Université de Bruxelles, 1987.

Spiegelberg, Herbert. "Sartre's Last Word on Ethics in Phenomenological Perspective." *Research in Phenomenology* XI (1981): 90–107.

Stone, Robert. "Freedom as a Universal Notion in Sartre's Ethical Theory." *Revue Internationale de Philosophie* nos. 134–35 (1985): 139–48

Stone, Robert, and Elizabeth Bowman. "Dialectical Ethics: A First Look at Sartre's unpublished *1964 Rome Lecture Notes*." *Social Text* nos. 13–14 (Winter-Spring 1986): 195–215.

———. "Sartre's 'Morality and History': A First Look at the Notes for the Unpublished 1965 Cornell Lectures." In *Sartre Alive*. Ed. R. Aronson and A. van den Hoven. Detroit: Wayne State University Press, 1991.

Veatch, Henry. *For An Ontology of Morals*. Evanston: Northwestern University Press, 1971.

Warnock, Mary. *Existentialist Ethics*. London: Macmillan, 1967.

Whitford, Margaret. *Merleau-Ponty's Critique of Sartre's Philosophy*. Lexington: French Forum, 1982.

INDEX

Since the following works by Sartre are discussed not only in entire chapters devoted to each but also throughout this book, references to them have not been indexed: *Being and Nothingness,* the two *Critiques of Dialectical Reason,* and *Notebooks for an Ethics.* Also, works when referred to only by abbreviation have not been indexed.